Edited by Cheryl Weber
Designed by Molly Shields
Cover design by Jack Chappell
Cover: Twilight reflections, the Colorado River near Hells Hollow
in Grand Canyon National Park, a UNESCO World Heritage Site

Front and back cover photos: John Annerino
Photo permissions:
www.johnannerinophotography.com

Credits: Map courtesy of Lieutenant George M. *Wheeler's
Western Survey, 1871–1873*, Library of Congress

Historical black-and-white photos courtesy of Library of
Congress, US Geological Survey Photographic Library,
National Archives and Records Administration, National Park
Service, Grand Canyon National Park Museum Collection,
California Historical Society, and Robert N. Dennis Collection
of Stereoscopic Views, New York Public Library's Digital
Collections. Illustrations courtesy of the Library of Congress
and Grand Canyon National Park

Type set in Avance/ZapfEllipt BT

ISBN: 978-0-7643-5760-2
Printed in the United States of America

Published by Schiffer Publishing, Ltd.
4880 Lower Valley Road
Atglen, PA 19310
Phone: (610) 593-1777; Fax: (610) 593-2002
E-mail: Info@schifferbooks.com
Web: www.schifferbooks.com

For our complete selection of fine books on this and related
subjects, please visit our website at www.schifferbooks.com.
You may also write for a free catalog.

Schiffer Publishing's titles are available at special discounts
for bulk purchases for sales promotions or premiums. Special
editions, including personalized covers, corporate imprints, and
excerpts, can be created in large quantities for special needs. For
more information, contact the publisher.

We are always looking for people to write books on new and
related subjects. If you have an idea for a book, please contact
us at proposals@schifferbooks.com.

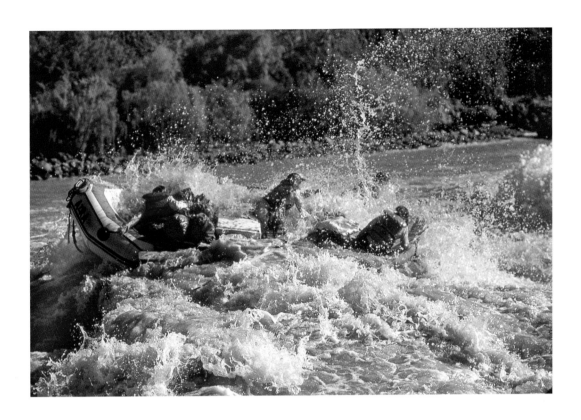

For Wendover Brown for her inspiration and support over the years. For Pete Schiffer, Cheryl Weber, and the good folks at Schiffer Publishing, who made this book a reality. For my family for their love and prayers. And for all those kindred spirits and Native peoples who still hear the call of the canyons.

Remember to walk a mile in his moccasins

And remember the lessons of humanity taught to you by your elders.

We will be known forever by the tracks we leave

—Mary T. Lathrap, 1895,
Walk a Mile in His Moccasins

Hidden among the drifting sand dunes of the Painted Desert in
Arizona, ancient tracks and handprints were pecked into this
cave floor by elders and shamans ages ago.

INTRODUCTION

Over the course of twenty-five years, I'd set out to run, hike, climb, and raft the Grand Canyon of the Colorado River. In the process, I also toiled, suffered, stumbled, crawled, was pummeled by river currents, and nearly perished from thirst. But those hardships come with the territory, and I couldn't complain. On the contrary, I was greeted with the sublimity of water, stone, and light at nearly every turn. I discovered trails first trod by ancient peoples wearing yucca fiber sandals and buckskin moccasins, miner trails that were later forged by prospectors and their sturdy mules, white water rapids braved by explorers in leaky wooden boats, and vistas and adventures first recorded by pioneer photographers, artists, writers, poets, and architects.

My research unveiled their extraordinary accomplishments, tribulations, and discoveries, and they were nothing short of inspiring. After reading John Wesley Powell's *Report of the Exploration of the Colorado River of the West and Its Tributaries: Explored in 1869, 1870, 1871, and 1872*, I set out to follow their trails into the far corners of the great abyss, from the heights of supernal temples first climbed by ancient hunters on spirit quests, to the depths of tributary gorges that had been trod as migration corridors long ago. If I looked and was not overcome with fatigue or wonder, which were often served up in equal doses, I could see evidence of their passing: a cascade that pioneer photographers had trekked seventy miles to capture on a stereograph card; a petroglyph panel that had been etched and prayed to by generations of Hopi who risked life and limb on dangerous pilgrimages; a towering watchtower that had been erected on the edge of a mile-high rim by a visionary architect who'd modeled it after the sandstone castles of ancient people she'd studied; and Colorado River rapids that tested the courage and fortitude of river explorers who felt like they were probing the ends of the earth.

This book, composed of contemporary color images, historical albumen silver prints, maps, and essays, is about my discoveries tracing the paths of those who came before me. I was only one pilgrim in a long list of others who'd been guided to a canyon that was many things to many people: a scenic wonder; a no-man's land to be surveyed and mapped; an open-pit mine of gold, silver, copper, and asbestos; and a prison to escape. No one but the Native peoples who'd dwelled in and around the great abyss and its mesas for more than a millennium would understand the nature and sanctity of the place for many moons to come.

To underscore the dichotomy between then and now, I've organized this book into distinct adventures interwoven with historical vignettes. Some of the photography includes my modern interpretation of historical stereographs. My objective was to use the pioneer photographers' vantage points, called "camera stations," to see how they'd inspire my own interpretation, not to rephotograph their stereograph views through their eyes. The bibliography includes the primary sources I used for my research. The literature cited includes the quotes and literary sources I selected to illuminate the images and essays.

At a time when images, words, and information move at the speed of light, I remain a professed book man. I like the heft of a book, the sound and feel of turning a page, the visual appeal of color photographs and classic fonts printed on paper, and the craftsmanship of designing and binding. Few have mastered the art like Schiffer Publishing.

Thank you for embarking on this journey of adventure and discovery.

A pyramid of stone in Vermilion Cliffs National Monument towers above the Colorado River near Lees Ferry, Arizona.

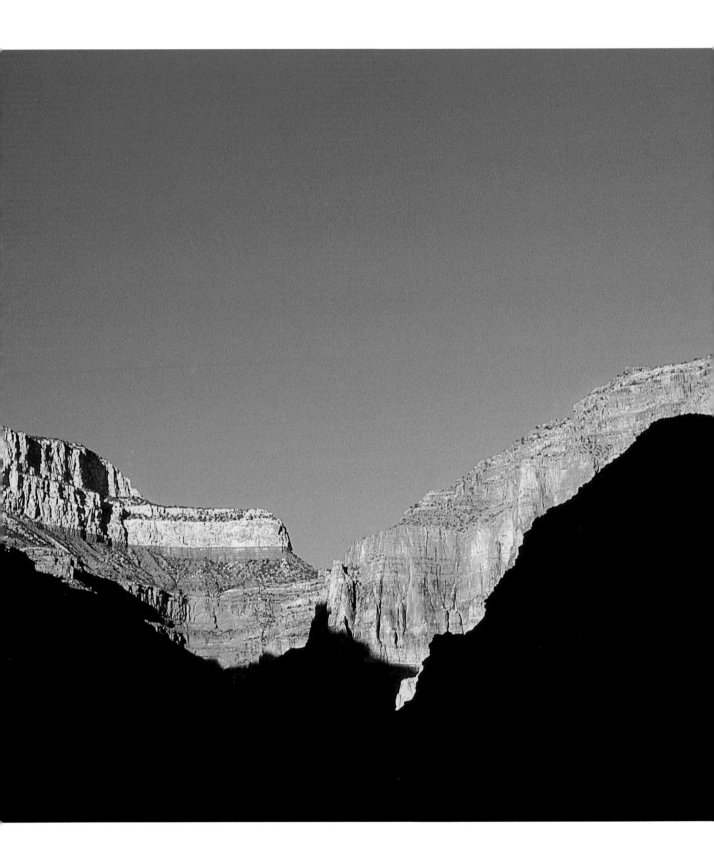

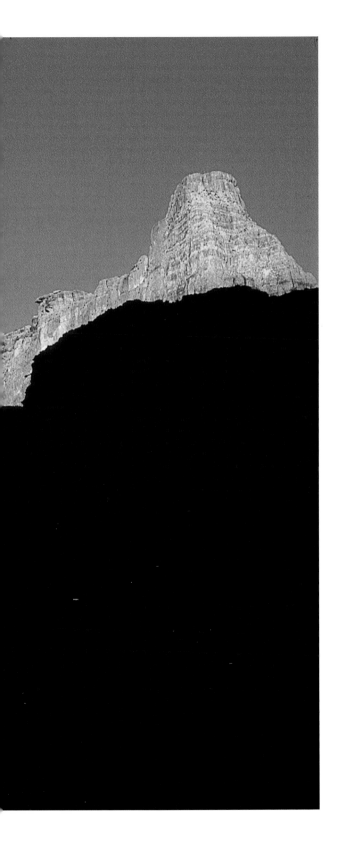

1

RIM TO RIVER

Journeys down Ancient Trails

There's no sense in going further—it's the edge of cultivation,"

So they said, and I believed it—

Till a voice, as bad as Conscience, rang

"Something hidden. Go and find it. Go and look behind the Ranges—

"Something lost behind the Ranges. Lost and waiting for you. Go!

—Rudyard Kipling, 1898, The Explorer

Viewed from the depths of the Colorado River's Granite Gorge, plateau light crowns the supernal heights of the North Rim's Kaibab Plateau.

We drove out of a sprawling desert covered with forests of saguaro cactus and wound our way up the basalt cliffs of Black Canyon and over the golden grasslands of Yellow Jacket Mesa. The day was filled with promise as we descended into the lush cottonwood groves of the Verde River valley. That's where the real climb began. Shifting into low gear, we switchbacked along the brink of the Mogollon Rim and drove past cathedrals and minarets of glowing red rock on the southern escarpment of the Colorado Plateau. The Four Corner States of Utah, Colorado, New Mexico, and Arizona encompass a mile-high province of slick rock canyons, snow-dusted laccolithic peaks, and mesas and monuments. The historic logging and cattle town of Flagstaff, Arizona, was a gateway to the Colorado Plateau's wonders, perched at the crossroads of transcontinental highway Route 66 and the Atchison, Topeka, and Santa Fe Railway. We stopped to fill up the gas tank at a bustling service station where a statue of Paul Bunyan stood sentinel, cradling his wooden axe. All that was missing was a statue of Babe the Blue Ox. We veered north through forests of pine, spruce, and aspen beneath the elegant flanks of the San Francisco Mountains, often referred to as Kachina Peaks after the Hopi *katsinas*, or spirit beings. They were a beacon for the Southwest's Native peoples who journeyed here from the four directions to pay homage to their deities that dwelled atop the barren, tundra-covered peaks. After crossing the mountain meadows of Kachina Peaks, we drove through once-molten fields of lava, cinder cones, and craters surrounded by piñon, juniper, and ponderosa pine trees until we arrived at a point on the rim of the Grand Canyon named for a lonely hermit.

My college professor had invited me on this journey to hike the Grand Canyon. I'd never been there, nor did I have any interest, really, in roaming afoot in a crowded national park. I was absorbed in my own work—college studies by day and teaching outdoor education by night. On weekends I led students on sojourns to captivating destinations elsewhere, such as the jaguar-prowled trails of southern Arizona's Chiricahua Mountains, a forested island in the sky that was once the domain of Geronimo. In the Sonoran Desert's back of beyond, we climbed the seldom-seen spires of the Eagletail Mountains, called "feathers," during balmy days of spring wildflowers. Then there were

the supernal trails of the San Francisco Mountains' Kachina Peaks Wilderness, the highest in the state, which beckoned us during sunlight and storm. Sheltered in flimsy tube tents, we sometimes scaled the peaks during the harshest snows of winter. Why drive all the way to the Grand Canyon? I was about to find out.

Our car parked, we visited a quaint little cottage with a stone chimney that looked like it was about to topple into the abyss. The retreat was constructed from a mosaic of handlaid stones and rustic timbers, and it was nestled in the rim rock of the South Rim. The fireplace was the size of a small cave. It was draped with deer hides, bearskins, and Navajo blankets, and it sported a wooden water keg and a hollowed-out log chair. The front desk placard indicated the cobblestone cottage was built in 1914 by an ingenious architect named Mary Elizabeth Jane Colter under the direction of the Fred Harvey Company. The California School of Design–educated Colter had named the whimsical dwelling Hermit's Rest, after one of the canyon's romantic figures. I would learn more about him.

We strolled back to the car, hoisted our heavy packs out of the trunk, and walked to the edge of the rim rock. I peered into Hermit Canyon, and the view was dizzying. My father had once driven our family through the Salt River Canyon, but this view was like nothing I'd ever seen. We started down the steep Hermit Trail, which wound down through an alluring geological layer called Coconino sandstone. The color and texture of the aeolian rock strata looked like the freeze-dried vanilla ice cream some hikers carried in their packs at the time. The trail was more of a flagstone stairway than the dusty trail I had imagined, and I wondered if the engineers took their cue from the yellow brick road of the silent movie *The Wonderful Wizard of Oz*. The trail, built by the Civilian Conservation Corps and the Santa Fe Railroad during the Depression-era 1930s, offered a sturdy path for giddy, mule-riding tourists to enjoy the Santa Fe Railroad's inner canyon hospitality at Hermit Camp near the Colorado River. I still couldn't see the river thousands of feet below, or how we were going to reach it. But my soft-spoken professor, who preferred to be called Galen, pointed out the ancient tracks of salamanders. I traced them

across the fossilized sand dune with my fingertips as we hiked down the handlaid stone path.

When we arrived at the foot of the petrified dunes, we stopped at a junction of three trails. The Hermit Trail, Galen showed me, led along the east rim of Hermit Canyon. The Boucher Trail wound around the head of Hermit Canyon and followed its west rim. And the shortest foot path, the Waldron Trail, climbed up to the head of Hermit Creek to a rustlers roost called Horsethief Tank. We dropped our packs next to the wooden signpost and detoured up the Waldron Trail to a hidden petroglyph. It was beyond my expectations of stick figure men, bighorn sheep, and spiral mazes. It resembled a stylized form of the canyon's migratory monarch butterfly. "We weren't the first," Galen told me. Ancient peoples, whom archaeologists classify as Archaic, had traveled into the canyon along Hermit Creek four thousand years ago. Over time, I would discover just how deep and how far they had traveled throughout the Grand Canyon region.

We picked up our packs and followed the left fork of the Boucher Trail. I was surprised that we hadn't seen a soul, and I mentioned it to Galen. "This isn't the Bright Angel Trail," he said. I assumed he was referring to the thousands of people and dude-carrying mules that crowded the trail each year. That was the one factor that had kept me and my students at bay. I'd learn soon enough that he was referring to this particular trail's rugged dangers, wild beauty, and quiet solace. At the next trail junction, we came to the Silver Bell Trail. It was built by a French Canadian prospector named Louis de Bouchere.

Boucher, as his name was soon anglicized, came to the canyon in 1892 from Sherbrooke, Quebec, Canada, in search of mineral wealth that he and dozens of other wanderlust-struck prospectors had hoped to mine from the canyon depths. Boucher named his trail for the silver bell he'd hung around the neck of his white mule. Together, they had forged the Silver Bell Trail from *Eremita Mesa* (Little Hermit Mesa) through fissures and sandstone cliffs to where we stood. The "hermit," as he was mistakenly caricatured, lived far from the bustling new South Rim developments that drew formally attired tourists who rode mules up and down the Bright Angel Toll Road. Many queued up to promenade on muleback in front of the cameras of Grand Canyon photographers Emory and Ellsworth Kolb. Physicist Alfred Einstein, the Harvey Girls, President Theodore Roosevelt, conservationist John Muir, and nature writer John Burroughs were among them. Far from the spotlight of the pioneer paparazzi, Boucher lived alone in his canyon wilderness. To my surprise, we would be alone too.

We turned north on the Boucher Trail and followed the west rim of Hermit Canyon, tracing

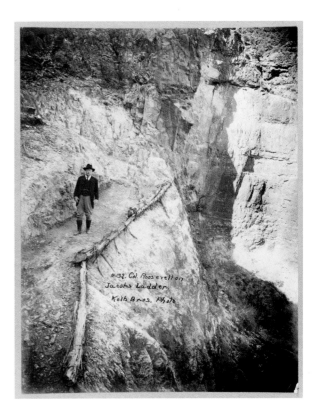

Rough Rider Theodore Roosevelt descends a rocky trail down switchbacks called Jacobs Ladder through Garden Creek Canyon. *Photo by the Kolb Brothers, May 19, 1911. Courtesy of Library of Congress.*

the very edge of the yawning precipice. I tiptoed at first, moving along what looked like a desert bighorn sheep trail where one misstep could send me screaming into the hereafter. Coursing through the cinnamon-colored dust, pea gravel, and boulders of the Esplanade sandstone, the trail curled like a lariat along the lip of the abyss through piñon, juniper, and Utah agave, and I suddenly realized it was the most dangerous trail I had ever walked on. The thousands of feet of exposure beneath the trail were breathtaking and pulse pounding, and the beauty of it was that I still had no idea where we were headed. In this case, it was follow the leader, the antithesis of what I'd practiced as an outdoor education instructor and guide at the time. The canyon was a complete mystery to me, and I savored the fresh air, scent of juniper, and views of strange-sounding landmarks that could be seen across the Colorado River on the North Rim of the Grand Canyon: Tower of Ra, Tower of Set, Osiris Temple . . . *What did those names mean?*, I'd wondered.

"That's where we're headed," Galen smiled, pointing at a band of tawny cliffs above us. "Dripping Springs."

We left our packs trailside, carried our water bottles and lunch, and scrambled up a steep, brushy trail to the foot of an immense alcove. Fresh water dripped from maidenhair ferns and tinkled into a shallow pool of water. I relished the cool, sweet water. I sipped it with cheese, nuts, and crackers as I gazed back up across the canyon to Hermit's Rest to measure our progress. At one time, Boucher operated a small, tent-framed tourist camp at Dripping Springs for hearty travelers who ventured off the Bright Angel Trail tourist track to camp in the wilds and enjoy home-cooked meals and colorful canyon tales as they marveled at the sight of goldfish swimming in Boucher's clear pool of drinking water. The affable Boucher had brought them from Kansas to amuse his guests.

We headed back down to the trail, picked up our backpacks, and hiked north along the edge of the rim rock toward Yuma Point. Hand-painted clay *ollas* (pots) discovered near Dripping Springs, I'd learned, indicated the trail we'd followed was used by ancient peoples called Ancestral Puebloans to hunt and gather between 1000 and 1150 CE. Along the trail, they also harvested the hearts of century plants they roasted in wood-fired stone ovens. We trudged down the trail into a steep canyon and climbed over a pass near the rocky knob of Whites Butte. It was named for horse thief James White, who fled down the Colorado River on a log raft into the colorful lore of the Grand Canyon. Galen traced his finger across the distant topography and pointed out the rugged line of descent through ledges, broken cliffs, and boulders we'd be tracing to reach Boucher's winter camp and guest house. It was located on a creek out of sight far below. As we picked our way down through precarious, boulder-strewn ledges where one misstep could send us cartwheeling, I puzzled over how the white-beard-ed trailblazer had chiseled a mule trail through the wrinkled walls of what our map spelled out as Travertine Canyon—how in the world had Bouch-er ridden or led a mule down the steep, friable cliffs? His exploits rivaled those of mule skinners and prospectors like John Hance, who blazed his own dangerous trails through miles of impossible cliffs in hopes of hauling out burro and mule loads of fabled riches. Like Boucher, Hance discovered that the more lucrative pay dirt came from the wallets of tourists he guided into the canyon.

During lean patches of prospecting, Boucher sometimes "wrangled dudes" for Hance, who had become famous for his own trail work that was praised by Rough Rider William "Buckey" O'Neill in 1893: "God made the cañon, John Hance the trails. Without the other, neither would be complete."

By late afternoon, we had arrived at the charming Boucher Creek, and it was music to my ears. The sound of running water would have been music to the ears of any indigenous desert peoples who survived on the margins and thanked their spirits for the fickle bounty. Only here, the little creek was at the bottom of the Grand Canyon at a riverine oasis and stone cabin, where Boucher once tended a fruit-and-vegetable-filled garden and orchard at the foot of cliffs and buttresses that rose to greet the morning sun. To my surprise, the Colorado River was still nowhere in sight. We would head down Boucher Creek to the river the next morning, Galen assured me. Boucher had fished the river and caught heavy "silver salmon," or pikeminnows; he fed guests who braved his trail. I was tired from the steep, sketchy, and circuitous route through seldom-traveled canyon

country, so I turned in early and slept peacefully to the melodies of song birds, trickling water, and gentle breezes. The professor had schooled me in ways I could not have imagined at the time. The journey, I would someday learn, changed my life forever, and it would bring me back to the canyon time and again.

Compared to the Boucher Trail, the Thunder River Trail was an altogether different kind of adventure I would explore years later with my students. Located on the distant North Rim, it could be reached only by driving a rugged, washed-out, sometimes confusing labyrinth of backcountry roads far from the nearest ranger station. The ancient footpath turned cattle track led across a crimson desert, we had been told, to a roaring waterfall that spewed out of burnt-orange cliffs and created the "shortest river in the world." Who could resist such a destination? Not me, and not my students. They were just as eager to discover new canyon country as I was.

Viewed from a deserted, wind-scoured rim near the ancient village of Indian Hollow, the red desert stretched beneath our feet and swept south across deep, braided tributary canyons that rumbled with whitewater and cascades that plummeted into the Colorado River via two divergent streams, Tapeats Creek and Deer Creek. We were headed to the headwaters of Thunder River, where the thought of icy drinking water gushing out of a limestone precipice enticed us farther down the rustic trail and deeper into the red desert that reminded one student of Australia's Outback. To the hungry hikers among us, it evoked images of cheesy red enchiladas, a favorite post-hiking meal we sometimes banqueted on when we returned to civilization. "The Enchilada Formation," they called it, a play on what geologists had classified as the Esplanade Formation.

The elusive and dusty path meandered around shallow water pockets that croaking spadefoot toads absorbed like sponges. We probed deeper and deeper into unfamiliar territory, wandering and wondering how, only decades earlier, Arizona Strip cowboys had tracked down and rounded up wild maverick cattle and herded them back up to Indian Hollow. The landscape colors shifted between lavender, pink, and red, depending on the movement and shading of partly cloudy skies that resembled the brushstrokes of Maynard Dixon.

Weaving in and around mysterious, mushroom-shaped sandstone hummocks and hoodoos, we glimpsed ethereal, ghost-white pictographs of shamans that shimmered in the afternoon heat waves and danced to the phantom tunes of the wind rustling through the hollows, and then we suddenly arrived at the rim of Surprise Valley.

Still beyond our view was Thunder River, but we could smell the water in the burning desert, and when we finally heard the whispers of falling water, then the cacophony of echoes, we stopped and stood on a perch that overlooked the frothing waterfall. It gushed out of water-polished fissures—slits, really—creating the steep whitewater course of Thunder River. It rumbled like an endless flash flood that could not be dammed down its quarter-mile course into Tapeats Creek. "Let's go," one of the students said eagerly. We hurried down the last stretch of the rocky trail into the cool, misty thermoclime of a wind-bent grove of cottonwood trees. As if on cue, we dropped our packs, sat down in the damp glade, took off our boots and sweaty socks, and soaked our hot, tired, stinking feet in last winter's snowmelt. Rainbows of cold mist beamed overhead and streamed down our smiling, salt-streaked faces. The students sighed and chattered with joy and relief that we had finally reached our canyon Shangri-la in the heart of the sun-baked desert.

Euphoric at the sight and sound of Thunder River, one of the students sprang an idea that riveted everyone's attention: "Why don't we go into the cave?"

Why *don't we* go into the cave, I wondered. I pondered the idea, then asked my students: "Why don't we *go into the cave?*"

"Yeah," the chorus sounded, "Let's go!" There were few reasons not to. We were right there. Who knew when we'd be able to drive all the way back across the state to Indian Hollow and hike down to Thunder River again. There were two portals, I'd learned beforehand. There was a point, I could see, where we could safeguard each other with a rope and squeeze into the first portal above the wild falls. "But we can't all go at once," I said. Put to an open discussion and vote, some students chomped at the bit to go, others offered to stay, and others wanted to wait and see what we discovered. We decided the teacher, one assistant, and two students would go first. We'd scout out the entrance to

see if it was safe. If it was, and there was time enough, I'd lead another threesome into it.

We weren't the first to enter the mysterious subterranean river cave.* Cave explorers known as speleologists had surveyed more than a thousand other caves throughout the Grand Canyon that were hidden from view in secret passages. Hundreds had been mapped and recorded, including Thunder River Cave, and three other caves whose names intrigued me: Vanishing River Cave, Abyss River Cave, and Silent River Cave. Another cave, surprisingly, was the longest ever discovered in the region. It required a free-hanging, hundred-foot rappel in order to swing into the mouth of the cave that revealed eight miles of passages—as long as John Hance's Old Hance Trail and William Wallace Bass's South Bass Trail. Only the cognoscenti were privy to the canyon caves' secret locations. That is, except for Thunder River Cave, which few had ever visited. The first party to explore what they called a "Kaibab stream cave" during spring of 1960 used wet suits and one-man US Navy surplus rafts. They'd managed to paddle three-quarters of a mile across its cold, dark subterranean lake. We had no such ambitions, or gear.

After drying our feet and relacing our boots, four of us carefully climbed up the slippery, moss-covered limestone to a ledge where we could belay one another into the cave portal. The portal was perched alongside the mouth of the powerful hydrant of the thundering falls that blocked out all other sounds. The force of the water shook the pedestal on which we stood, and there was little doubt it could sweep us away if any of us made the wrong move. It was unnerving if you didn't focus on the task. "Look at me, stay focused, and keep coming!" I tried to shout above the roar, encouraging each of my students into the mouth of the cave. It was, well, nothing short of a wonder when the four of us peered out from the mouth of the cave into the breadth of the Grand Canyon while frothing whitewater rumbled and cascaded beneath us.

Moving like crabs, we braced our backs and hands against the wall, bridged our legs and feet against the opposite wall, and wriggled, squirmed, and shimmied above the ink-black river, deeper and deeper into the narrows. We stopped for a minute to catch our breath and get our bearings.

"You want to keep going?" I asked.

"Yeah, let's go," they rallied. We turned a corner, away from the ambient daylight that lit the mouth of the cave, and ventured into complete darkness. We couldn't see each other's faces unless we shone our headlamps directly at one another, but it was blinding. So I watched their shadows hover and move over the black water. It was a bit otherworldly as we worked our way along a subterranean river trail toward an indefinable point of no return. We were at the threshold of pushing the limits of our fears of the unknown, claustrophobia, and what Rudyard Kipling wrote in *The Explorer*: "Something hidden. Go and find it . . . Lost and waiting for you. Go!"

One by one, our bright headlamps were swallowed by the deep darkness, narrowing from wands of light to pinpricks. We were completely cut off from the outside world, and we felt the damp chill. Beneath us, the water hummed and pulsed like an artery through the cold, ebony narrows. We were, as some spelunkers called it, "inside Earth." We weren't at their skill level, and we were vulnerable. We were vulnerable to unchecked precipitation that seeped through the forest floor into underground aquifers and percolated through the primordial seabed of Kaibab limestone that created this stream cave. Our sense of vulnerability was compounded by the monumental plate tectonics that helped create the Grand Canyon. A sudden blast of water leaking through the limestone aquifer overhead could flush us out of Thunder River like a circus cannon. Or a sudden shift or fracture in the unstable limestone tunnel could bury us alive in a canyon cave-in that would never give up our bodies. During the summer of 1959 cave reconnaissance of the Kaibab Plateau's Silent River Cave, a magnitude 5 earthquake struck Fredonia, Arizona, sixty miles north of Thunder River. The "awesome rumble" reverberated through the once-"silent" cavern and rattled veteran canyon cavers like ivory dice in a leather cup.

We were as deep in the Grand Canyon as we could safely go, and we yearned to explore the underground lake in the coal-mine-dark chamber beyond our flickering headlamps. But we dared not venture farther. Our batteries were running low, and the light wouldn't last much longer. Carefully retracing our crab crawl through the subterranean flash-flood-scoured river passage,

we made our way through the watery crypt until we reached the mouth of the cave. Backlit by daylight, my students had shape-shifted from primeval shadows emerging from dark waters to golden Adonises of light. One by one, we poked our heads out of the cave into the warm air and sunshine and hollered down at our group, "We made it!"

We had. Together, we had explored another mystifying canyon trail. We had safely recrossed the fiery red desert in the footsteps of ancient peoples who stalked it for food and water thousands of years earlier. The camaraderie and discovery had bonded us. And we enjoyed sumptuous plates of molten-cheese-covered enchiladas. Thanks to Galen, who showed me how to "Go and look behind the Ranges," this rim-to-river journey on ancient trails had shined the light on new canyon adventures that I would embark on in the future. What a treasure we had found.

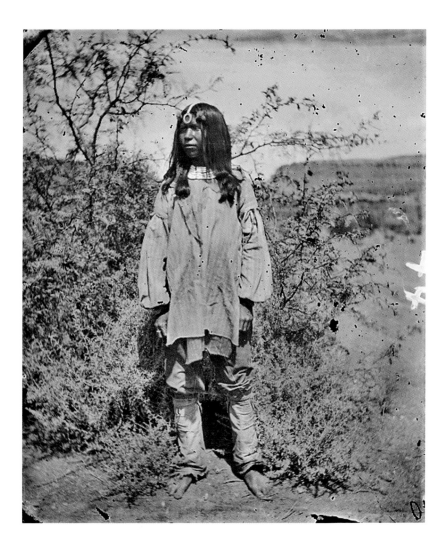

Ta-peats (Small Rocks) was a Shivwits Paiute who guided Major John Wesley Powell to the rim overlooking Tapeats Creek on September 6, 1872. Ta-peats told Powell he owned the creek, and Powell named it in his honor. *Stereograph by John K. Hillers, 1873, Powell Expedition photograph.*

* Caving is no longer open to the public, except for Cave of the Domes.

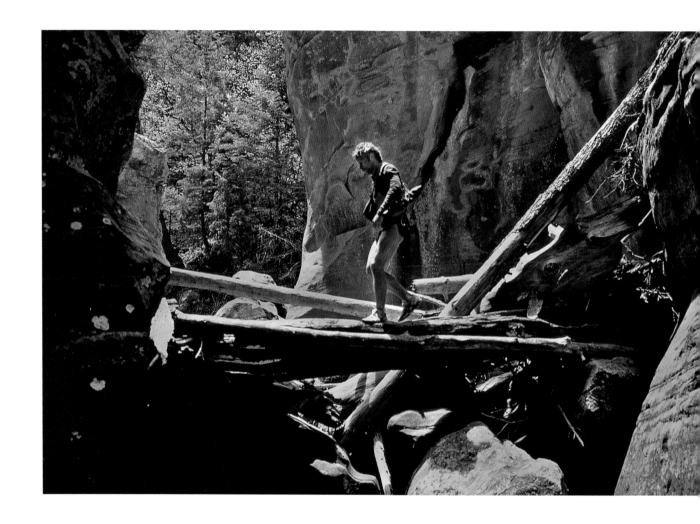

The author balances through a maze of fallen timbers
canyoneering end to end through the West Fork of Oak Creek
wilderness during a month long journey run across Arizona from
Mexico to Utah.

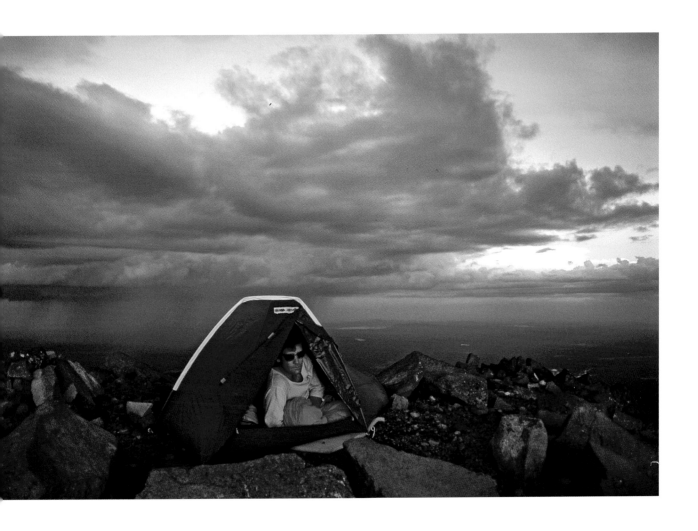

A hiker bivouacs atop the 12,360-foot summit of Agassiz Peak in the Kachina Peaks Wilderness, San Francisco Mountains, Arizona.

Following: The Esplanade sandstone formation is a wild, rugged, and beautiful terrace and ancient travel corridor that extends throughout the western Grand Canyon between Thunder River and Toroweap Point.

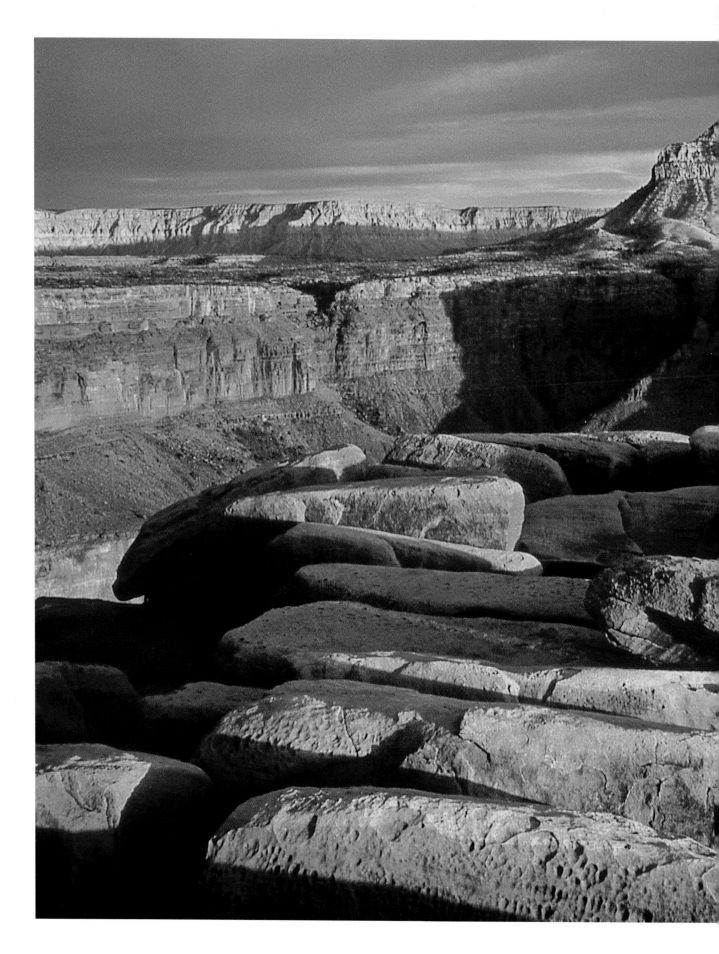

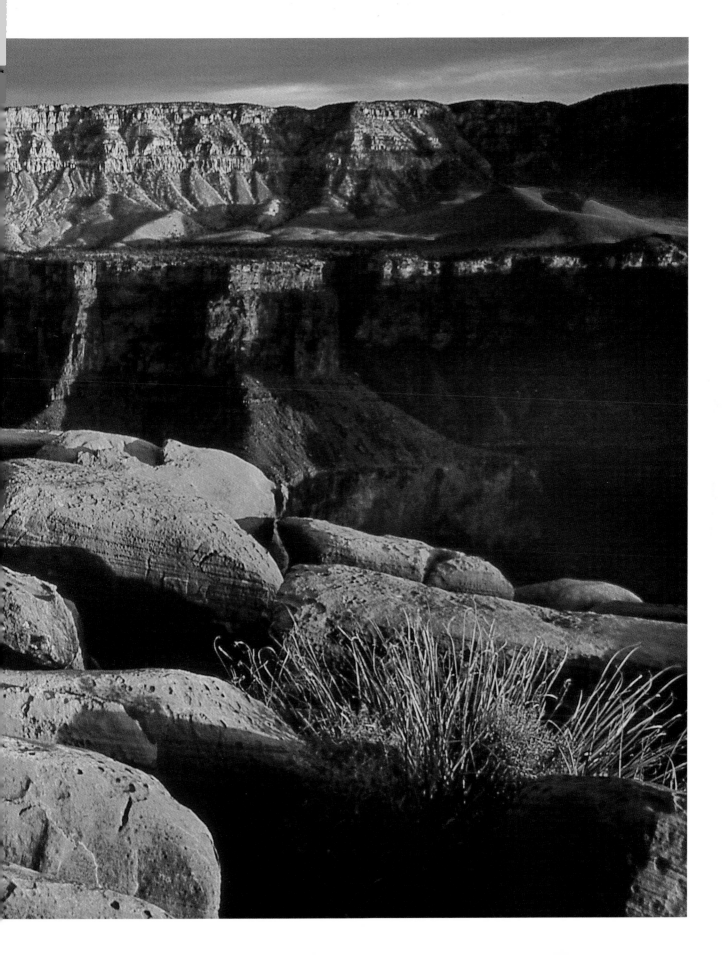

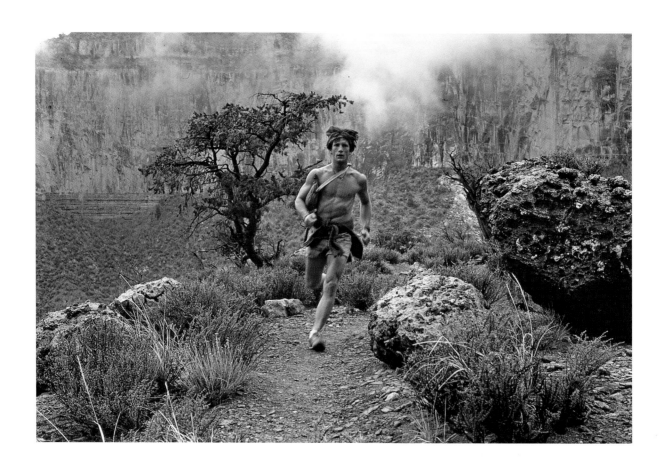

A trail runner breezes down the Boucher Trail, named for
prospector and trailblazer Louis de Bouchere, who forged the
trail circa 1892.

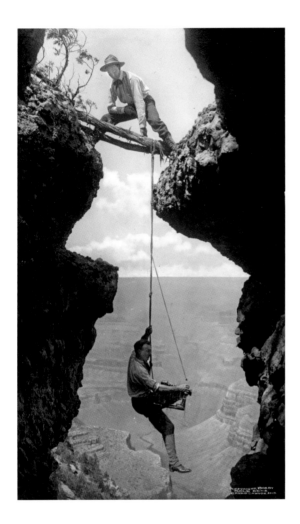

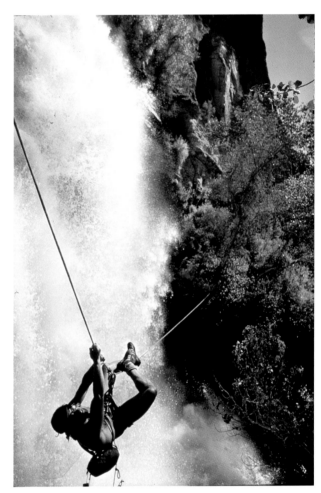

Emery Kolb belays his brother Ellsworth "dangling from rope in crevasse and photographing canyon wall" with a Seneca 8x10 view camera. *Gelatin silver print by the Kolb Brothers, 1908. Courtesy of the Library of Congress.*

The author hangs from a rope while crossing Thunder River during an early reconnaissance of Thunder River cave.

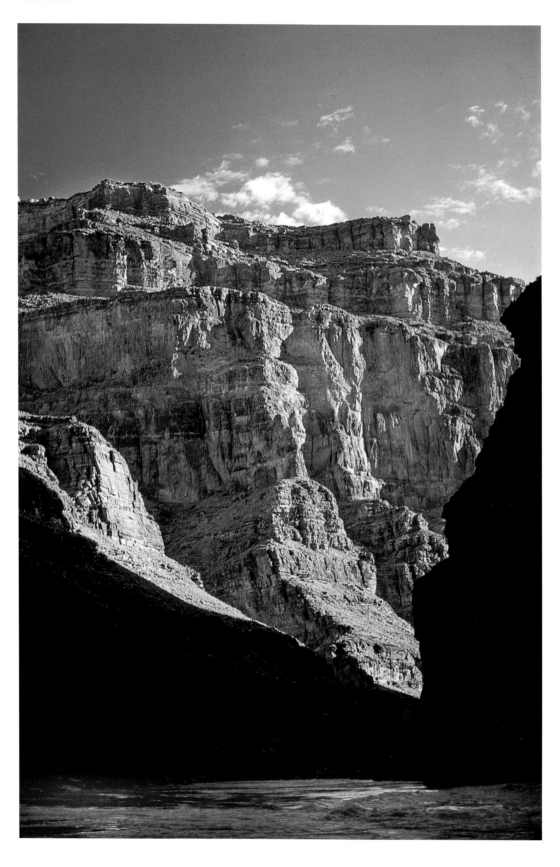

View of the Esplanade sandstone rim near Thunder River from
the Colorado River.

Spanish dagger agaves and house-sized boulders offered
ancient travelers food and shelter during their desert journeys
across the far reaches of the western Grand Canyon's
Esplanade sandstone terraces.

Following: Far below the ancient travel corridors of the
Esplanade sandstone, the Colorado River continues its journey
from the Rocky Mountains to the Gulf of California.

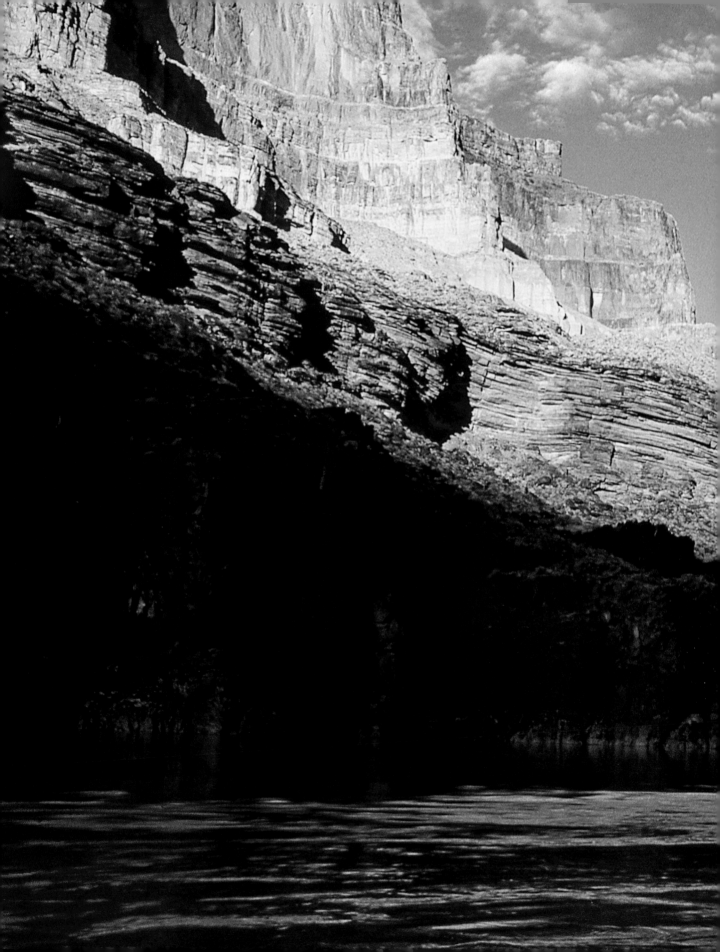

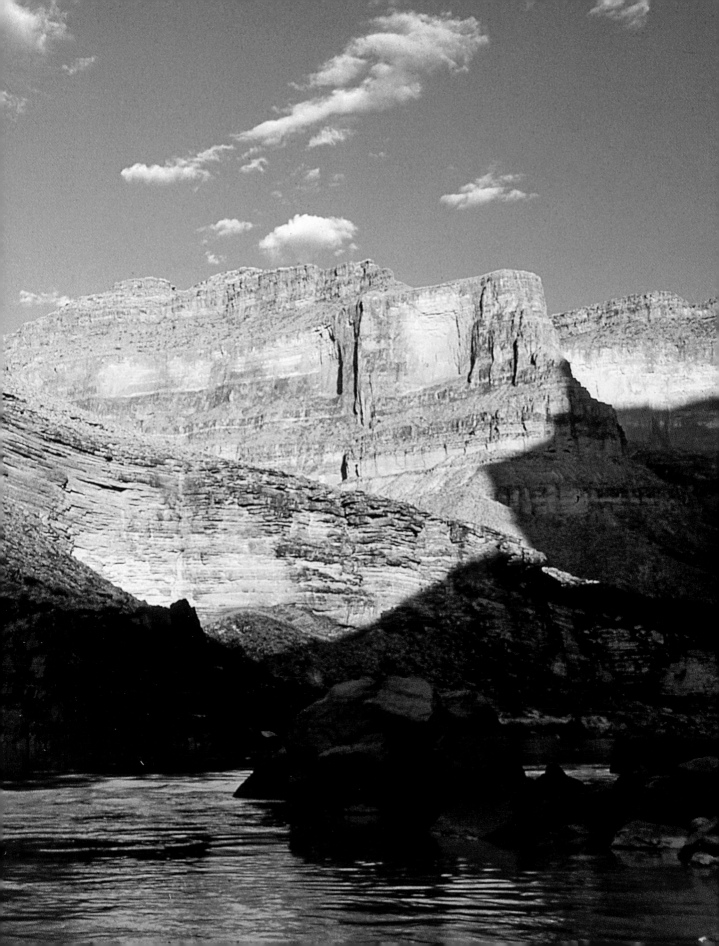

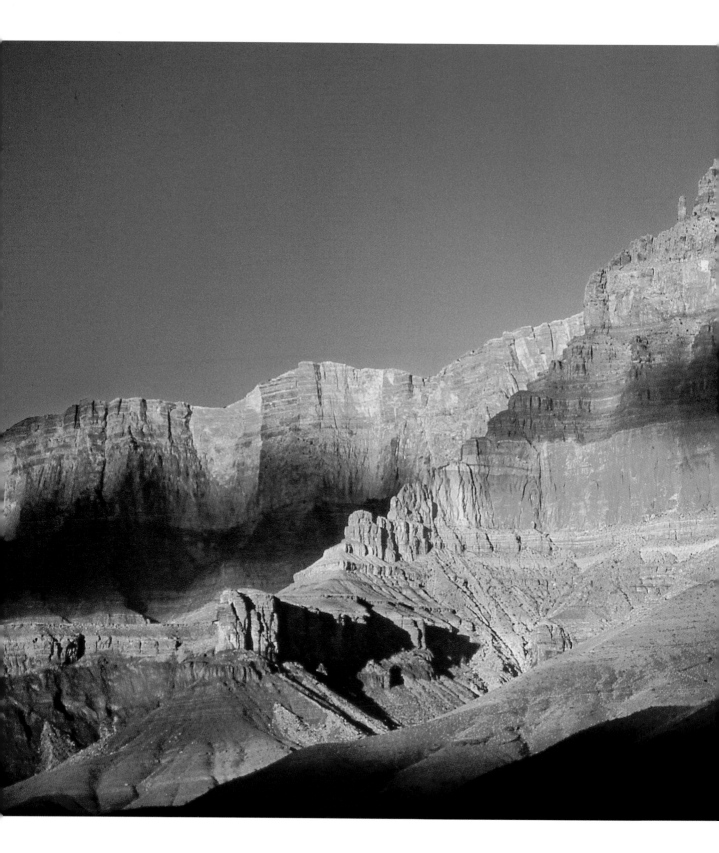

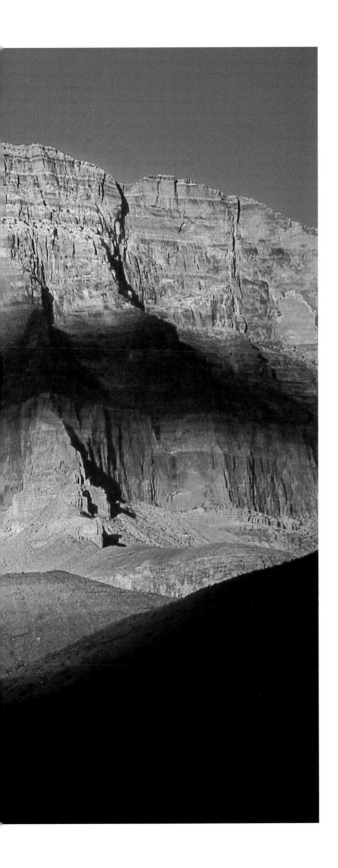

2

TRAVELING OVERLAND

Journeys to the Brink

*Whenever he went out by himself, he heard
the songs of spirits sung to him, or thought
he heard them sung . . . His three brothers
had no faith in him. They said: "When you
have returned from your solitary walks & tell
us you have seen strange things & heard
strange songs, you are mistaken, you only
imagine you hear these songs & you see
nothing unusual.*

—Washington Matthews, 1902, The Night
Chant, Bitáhatíni, *"The Visionary"*

The 6,800-foot Comanche Point Pinnacle and the cliffs of the
Palisades of the Desert (background left) tower more than 4,000
feet [4351 feet to be exact] above the Colorado River.

I walked along the edge of a cliff that soared more than four thousand feet above the Colorado River on the western brink of *El Desierto Pintado,* or the Painted Desert.

Spanish conquistador Francisco Vázquez de Coronado named the cimarron desert in 1540 during his search for the fabled Seven Cities of Gold. The ten-mile-long fractured wall of cliffs, hanging ledges, and boulders ready to tumble into space at the slightest provocation was later christened Palisades of the Desert by cartographer François Émile Matthes. Officially, it was the East Rim of the Grand Canyon. It formed the daunting boundary between the national park and the ancestral lands of the Navajo, revered as *Dinétah* (among the people) or Navajoland. From 7,073-foot Comanche Point, the rim rock precipice veered north across the sawteeth of Espejo Butte and Peshlakai Point and ended abruptly at the tip-off at 6,146-foot Cape Solitude. The cloud-scraping ceremonial perch was known to traditional Navajo, or *Diné* (the people), as *Tsin dah shijaa' bidáá* (sacred site), and it overlooked the hallowed confluence of the Colorado and the Little Colorado Rivers. There, where the Little Colorado River Gorge cleaved through stratified layers of earthly colors of the Desert Facade on the north and the Palisades of the Desert on the south, Navajo medicine men, *ha'athali* (singers), had chanted throughout the ages during the nine-day healing ritual, *Hózhóójí,* or Blessingway ceremony, to restore peace, harmony, and beauty. At one time, their voices echoed off the canyon walls far below, where the mesmerizing sounds of turquoise- and adobe-colored river waters of the confluence swirled together: "I have come upon it, *yo,*" the medicine men once sang, "I have come upon blessing, *wo.*"

Four of us had journeyed across the hardscrabble piñon- and juniper-covered scrublands along the limestone rim rock to climb a finger of rock called Comanche Point Pinnacle. It was midafternoon and a cold breeze was blowing across the high desert when I broke away from our group to stop and view the weathered gray timbers of a small sweat lodge. I wasn't sure what to make of the sacred dwelling so far off the grid in the middle of what many *bilagáana* (early American settlers) would have claimed was "Indian country." The sweat lodge looked like it hadn't been used in decades, but the sunrise-facing doorway brought to mind the memory of a fleeting chant I recalled: "We look to the east and the white light of dawn." Nearby, I viewed the remains of a roofless cabin painstakingly constructed with handlaid native stone. The rustic dwelling was undoubtedly built by a Navajo family who'd gathered nutritious piñon nuts, sacred herbs, and natural dyes nearby. They herded goats and sheep; carded, dyed, and spun colorful wool; and perhaps wove intricately designed saddle blankets they rode atop or sold at distant trading posts two days' horseback ride east. Whoever they were, they were gone, and I avoided entering their abandoned hearth that had once comforted their lives during the icy winds and snows of winter and the blistering heat of summer.

I walked away from the stone cabin on that blustery day and hurried to rejoin our small climbing party moving in the distance. But I'd imagined the aroma of hot mutton stew, chilies, beans, and Navajo fry bread cooking in the cabin and fragrant juniper woodsmoke wafting up from the small cobblestone chimney. By the time I caught up with my party, they had already arrived at a flat stretch of ground where we rolled out our sleeping bags and staked down our tents to brace for the coming darkness and evening frost. The next day we planned to rappel off the rim of the Palisades down to the foot of the pinnacle and climb a spire that pointed at the heavens thousands of feet above the Colorado River.

I left camp and scrambled up cherty limestone slabs to the edge of the rim rock to gaze at distant views of the inner canyon pyramid of Vishnu Temple and the forested mesa of Wotans Throne. They stretched south from the ponderosa pine forests of the Walhalla Plateau and loomed over the Colorado River, which the Navajo called *Bits'íís Ninéézi,* the River of Never-Ending Life. I put down my camera bag and tripod and peered over the edge, and a canyon updraft buffeted me backward. I braced the soles of my feet on the fossiliferous limestone, looked over the rim, and was thunderstruck by the sight of an American bald eagle soaring over the precipice at nearly eye level. It was close enough to see the six-foot wings flutter almost imperceptibly to ride the canyon thermal. For a moment I considered picking up my camera, but it was too close, and

any movement might frighten it away. Its noble crown of white feathers was adorned with a curved yellow beak. It pivoted its head back and forth, and its piercing black eyes surveyed the figure standing on the edge of the cliff. Never, in all my wanderings and adventures, had I witnessed such a wondrous sight. At the time, I did not know that bald eagles (*Haliaeetus leucocephalus*) periodically nested in the Grand Canyon and hunted the Colorado River for spawning brown and rainbow trout. So it was unimaginable for me as I stood there, breathless, silently watching the magnificent raptor gliding, almost hovering, fifty feet out from the edge of the rim until it suddenly banked, darted from view like a Clovis spearpoint, and disappeared below Comanche Point Pinnacle. *Whoosh!*

I looked at the pinnacle below the soles of my running shoes. It was a bold but shattered column of Kaibab limestone that protruded out from the wall like a scolding finger. My plans to climb it seemed inconsequential compared to what I'd just witnessed. America's majestic icon, adopted by Congress in 1782 as the Great Seal of the United States, had long been deified as a sacred spirit animal by Native peoples. Its feathers and plumes were traditionally collected from perilous cliff nests and used by the Navajo for *k'eet'áán* (talking prayer sticks), Hopi shrine *paahos* (prayer sticks), and Apache *Ga'an* (mountain spirits) headdresses.

Riveted on the edge, I'd been struck with an epiphany, of sorts. I had visited a Navajo sweat lodge, *Tá'cheeh Baahane'*—a place of cleansing, prayer, and spiritual renewal. And I had looked north along the colorful Palisades of the Desert toward Cape Solitude and seen where the Blessingway ceremony had been ritually performed. Touched by an eagle, I understood that this was the sacred ground of *Dinétah* and blessed by the Navajo's four sacred mountains. Then and there, out of deference to this hallowed place, I decided not to climb the pinnacle.

I scrambled back down to camp and thought about telling my companions what I had witnessed, but I considered the words from *The Night Chant: A Navajo Ceremony*. It was recorded by ethnographer and US Army surgeon Washington Matthews, who was an initiate of Navajo rituals: "When you have returned from your solitary walks & tell us you have seen strange things . . . You see nothing unusual."

At dawn the next day, I suggested to my companions that it'd be better if I stayed on the rim to photograph aerial views of the climb. They agreed. But inside, I sensed the eagle was a sign for me to step back. I gathered my gear, snacks, and notebook, then climbed back up to the breezy rim rock, determined to survey the landscape. When I arrived, my companions were setting up the long rappel to reach the foot of the pinnacle. I gazed in the distance and slowly turned to contemplate the four directions. To the Navajo, each direction was sacred: East is dawn, South is day, West is dusk, and North is night. From where I stood, each cardinal point, and those in between, pinpointed a trail on the horizon that had lured so many travelers over the ages who had journeyed against long odds from the far reaches of the Great Southwest—and beyond—to reach the edge of the brink in search of their dreams, conquests, and discoveries.

Over the years, I had ventured out to trace many of their journeys on foot, raft, and rope. Far to the east of Comanche Point, adobe pueblos floated atop the distant red mesas of the Hopi, *Hopituh Shi-nu-mu* (peaceful people). Inhabiting First, Second, and Third Mesas; cliff dwellings at *Bitát'ahkin* (house on a rock ledge); and elsewhere across the Painted Desert, the Hopi pueblos were sought out by Spanish conquistadors, explorers, and missionaries who came in search of gold, souls, and slaves to build their missions. But the Hopi had revolted at their presence ever since Coronado's first *entrada* during his unsuccessful search for the Seven Cities of Gold in 1540. Subsequent expeditions by Spanish colonizers included Don Antonio de Espejo in 1583 and Don Juan de Oñate in 1604, and they would not relent in their intrusions on the Hopi. Most tenacious, perhaps, was Franciscan missionary explorer Francisco Tomás Garcés. In 1776, Garcés traveled two thousand miles on foot and by horseback from Mission San Xavier del Bac in *Nueva España* (New Spain) in what later became Sonora, Mexico, then Arizona Territory. But Garcés's proselytizing fell on angry ears, and the missionary priest turned back the way he had first journeyed, along what was known as the Hopi-Havasupai trade route. The

long and winding path traversed the Coconino Plateau along the South Rim of the Grand Canyon from the Hopi mesas two hundred miles west to the paradisal canyon oasis of Havasupai. Using historian and army surgeon Elliott Coues's 1990-era work, *On the Trail of a Spanish Pioneer: The Diary and Itinerary of Francisco Garcés (Missionary Priest)*, as a historical field guide, I traced Garcés's footsteps from the ca. 1100 Hopi pueblo of Oraibi to the ancient multistory dwelling of *Wupatki* (tall house) toward Havasupai over the course of seven spirited and exhausting days and nearly died of thirst twice retracing Garcés's approximate route 210 miles to Havasu Springs.

The indefatigable Garcés was not the only missionary who traveled along the edge of the brink during the American Revolution in 1776. Seventy river miles north of Comanche Point, where the Colorado River meets the confluence of the Paria River, Spanish and Mexican missionary explorers Francisco Atanasio Domínguez and Silvestre Vélez de Escalante were faced with defeat after giving up their quest to pioneer a new route from Santa Fé, New Mexico, through the uncharted territory of Colorado and Utah to the Presidio Real de San Carlos de Monterrey, California. Threatened by the approach of winter, wracked by thirst and illness, and reduced to eating three of their horses, they were looking for a shortcut home. But Native peoples warned the Franciscans of the dangers of trying to cross the Grand Canyon to return to Santa Fé by way of Havasupai and the Hopi pueblos. Domínguez and Escalante took their sage counsel and forged across the Hurricane Cliffs and Kaibab Plateau along the foot of a formidable wall of Navajo sandstone that would later be called the Vermilion Cliffs for their resplendent colors. Unable to ford or swim across the icy Colorado River on a log raft after repeated attempts and near drownings, the padres were trapped in the cold sand along the Paria River, wedged between unscalable, 2,700-foot cliffs. Their prayers were answered when one of their guides found a route up what Escalante called the *Cuesta de las Animas* (climb of suffering souls). Writing in his journal with a quill pen, Escalante described the dangers: "it is very rugged and sandy and afterward has very difficult stretches and

extremely perilous ledges of rock, and finally it becomes impassable. Having finished the ascent toward the east, we descended the other side through rocky gorges with extreme difficulty." Still trapped on the wrong side of the frigid Colorado River in a maze of cliffs and canyons, a Ute guide came to their rescue and showed the padres the declivitous Ute Ford, where they used axes to chisel steps in the slick rock for their horses. The site later became known as *El Vado de Los Padres* (the crossing of the fathers). After covering 1,700 rugged and circuitous miles across the Colorado Plateau in 159 days, Domínguez and Escalante finally returned to the Mission San Miguel in the provincial capital of Santa Fé.

Searching in every direction from Comanche Point, I'd recalled other early travelers who'd also been struck by the monumental scale of Grand Canyon country, walking, bushwhacking, boating, climbing, and riding horseback through forests, deserts, canyons, and mesas. To the south, for one, came naturalist C. Hart Merriam. In 1889, the Adirondack Mountains schooled scientist covered five hundred miles in twenty-four days, studying the biogeography of plant distribution between the summit of Arizona's 12,670-foot San Francisco Mountains and the bottom of the Grand Canyon. While surveying the Painted Desert, Merriam crossed the "Desert where water is very scarce," he wrote, then described the marvels of an oasis: "On the evening of August 20 [1890] we camped for the night at a small spring about 5 miles west of Grand Falls. At dusk hundreds of Doves came to drink, and continued coming until it was so dark that they could not be seen." Inspired by the sight, Merriam marshaled on, concluding his formative study with a journey to the bottom of the Grand Canyon on a tender knee.

During a 750-mile journey run across Arizona from Mexico to Utah, I'd retraced Merriam's approximate route from the snowy summit of the San Francisco Peaks to the bottom of the canyon. In the process, I'd descended the biogeographical staircase of Merriam's "Life Zones of North America," which he'd recorded en route to the Sonoran Desert at the Colorado River. Merriam summed up his observances: "In descending from the [Coconino] plateau to the bottom of the [Grand] cañon, a succession of temperature zones

is encountered equivalent to those stretching from the coniferous forests of northern Canada to the cactus plains of Mexico."

One hundred and fifty-eight river miles west of Comanche Point, Diamond Creek flash floods often roared through the wild brink of Peach Springs Canyon to the banks of the Colorado River. The floodwaters carved a rim-to-river gash in the earth in the western Grand Canyon that drew missionaries, surveyors, artists, and pioneer photographers into the heart of Hualapai country. The Hualapai took their name from ponderosa pine trees in their canyon highlands that Merriam called the "Pine Zone," and called themselves *Hwalbáy*, People of the Tall Pines.

Perhaps no other overland journey to the brink of the Grand Canyon rivaled the adventure of Charles Fletcher Lummis when he climbed Peach Springs Canyon's beguiling limestone pyramid with a broken arm and his dog, Shadow. Years later, I took the opportunity to retrace Lummis's transcontinental adventure, in part, from Diamond Creek.

In 1883 the Harvard-educated Lummis set out on a transcontinental walk from Cincinnati, Ohio, to Los Angeles, California, to take a job as the editor of the fledgling *Los Angeles Times*—daily circulation 2,700. His route from Fort Smith, Arkansas, to Los Angeles followed the Atlantic and Pacific Railroad along the 35th parallel through Arizona Territory's Painted Desert. A delightful contrast to an Ohio winter, Lummis described the petrified forest in his book *A Tramp across the Continent* and wrote that he stopped for "a hasty look at the wonderful petrified forest, where the ground for miles is covered with giant trunks and brilliant chips of trees that are not only stone, but most splendid stones, agate of every hue, with crystals of amethyst and smoky topaz." Lummis wasn't satisfied with merely walking. He climbed up a cliff while chasing a deer. A ledge gave way and

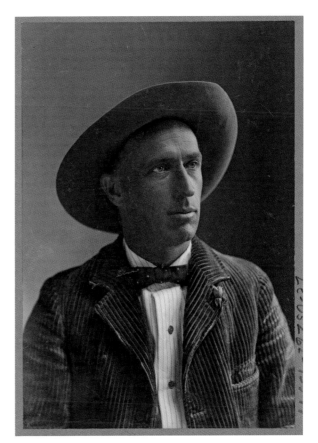

The author runs across the 12,633-foot summit of the San Francisco Mountains to the Grand Canyon during a month long journey run across Arizona from Mexico to Utah.

Charles Lummis portrait. *Print by Aemilian Scholl, 1897. Courtesy of Library of Congress.*

Lummis fell twenty feet, broke his arm, and lost consciousness. When he came to, he wrote: "That arm—always my largest and strongest— was broken two inches below the elbow, and the sharp, slanting, lower end of the large bone protruded from the lacerated flesh." Far from medical help, Lummis did the unthinkable. He double-wrapped one end of his long leather canteen strap around his tortured wrist, tied the other end around a cedar tree, and jumped backward to reduce the compound fracture. At that point you'd think Lummis would have thrown in the towel, but before setting out on his epic 3,507-mile transcontinental trek, he'd made a point: "Railroads and Pullmans were invented to hurry us through life and miss most of the pleasure of it."

One hundred and sixty-six walking miles west of Winslow, Lummis and Shadow detoured north from the Hualapai settlement and Atlantic and Pacific Railroad station of Peach Springs and walked twenty-three miles down Peach Springs Canyon. In *A Tramp across the Continent*, Lummis described the canyon trail he followed: "steeply downward more than three thousand feet to the bottom of the most stupendous abyss upon which the eye of man has looked . . . From the deep snows of three days before we had descended to the tropics and found verdure and full-leaved bushes and springing flowers. Birds sang and butterflies hovered past. The wild majestic cliffs loomed taller, nobler, more marvelous, at every step."

That's where I'd picked up Lummis's trail 135 years later. Was the "vast butte" Lummis described Peach Springs Canyon's 3,512-foot Diamond Peak? I wasn't sure, but I was determined to find out. After driving down the washed-out Peach Springs Canyon road, I planned to camp out in the "tropics" on a sandy beach along the banks of the Colorado River. Surprisingly, my climbing partner and I had the beach to ourselves. This spot was the remote "takeout" for more than twenty thousand river runners who end their Colorado River adventures at Diamond Creek after rafting through the Grand Canyon from Lees Ferry each year. We were camped at a historic spot above the rumbling waters of Diamond Creek Rapids. Of course, we weren't the first to do so. Missionary Francisco

Tomás Garcés camped at Diamond Creek and called it the *Arroyo de San Alexo* while traveling en route to the Hopi pueblos on July 17, 1776. Destiny lured many others along the padre's trail, including Lummis and Shadow and the stouthearted travelers who preceded them.

During the mid- to late 1880s, three explorers ventured into this territory with differing rates of success. Where Lieutenant Joseph Christmas Ives's Sisyphean 1858 expedition failed to navigate the Colorado River in small boats upstream from Black Canyon, George M. Wheeler succeeded in 1871 against the same odds that had tested Powell's 1869 Geographic Expedition. On October 5, 1871, Wheeler noted that:

the boat party entered the jaws of the Grand Cañon, not knowing what was before them . . . On the 19th of October . . . after many difficulties, in comparison with which any other of the hardships and privations of the expedition sink into insignificance, the exhausted boat party reached the mouth of Diamond Creek, and are next day gladdened by the sight of the [overland] relief party.

Traveling upstream from Black Canyon, Wheeler's eight-man crew spent fourteen days rowing, eddy hopping, portaging, and towing their two small boats, the *Picture* and the *Trilobite*, upstream against perilous currents and rapids that had driven three of Major John Wesley Powell's men to abandon his maiden 1869 voyage below Diamond Creek at Separation Rapids. Among Wheeler's crew of handpicked men were Frank Hecox, George Salmon, Jonathan W. Grinnel, and Arthur Keegan; three Mojave scouts turned boatmen, Halitauwa, Panambona, and Mitiwara; and photographer Timothy H. O'Sullivan. No stranger to hardships under the worst possible conditions, O'Sullivan had proved his mettle on the horrific Civil War battlefields and during the US Naval Expedition in the

steamy, nearly impenetrable jungles of the Darién Gap, Panama. O'Sullivan produced three hundred negatives during the Wheeler Surveys. Among the albumen prints was the stereoview of the haggard boat crew after towing their remaining wooden boat, the *Trilobite*, upstream from the head of navigation at Diamond Creek. It was 225 miles short of Lees Ferry. The Grand Canyon of the Colorado River stood in the way.

Now camped in the western Grand Canyon at the riverside vista experienced by Garcés, Ives, Powell, and Wheeler, I wondered what tomorrow would bring. I had no route descriptions or maps indicating where to climb the more than two thousand vertical feet up Diamond Peak. Nor did I want them. I wanted to climb the peak "on sight," as Lummis, early tourists, and the Hualapai had conceivably done. One Grand

Canyon boatman told me he'd heard an unsubstantiated account that a Hualapai climbed Diamond Peak barefoot ages ago. I had little doubt that the Hualapai, and perhaps the Mojave, had first climbed it, given the ancestral ascents of Wotans Throne and other canyon temples and cave shrines ancient peoples had scaled in the eastern Grand Canyon. But I doubted anyone climbed Diamond Peak barefoot, given that the steep, broken faces are composed of sharp, skin-shredding Redwall limestone. In my files, I'd collected a brief note that read: "Diamond Peak . . . Bottle with note in it dated 1894 found near summit. A man from Ireland and a woman had climbed it." From the literature I'd studied, I was convinced that transcontinental walker Lummis had made the first recorded ascent of Diamond Peak a decade earlier.

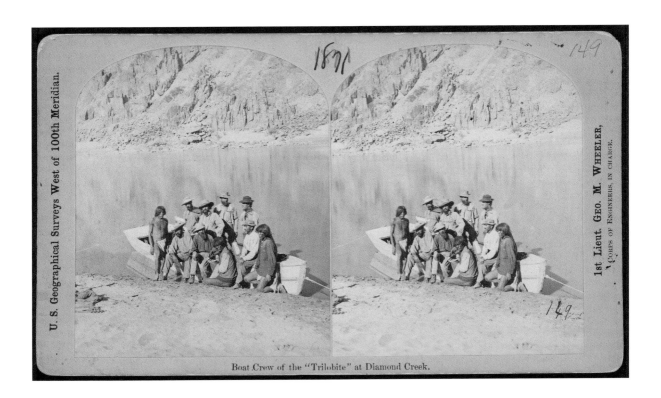

Boat crew of the "Trilobite" at Diamond Creek. *Stereograph card by Timothy H. O'Sullivan, 1871. Courtesy of Library of Congress.*

At first light the next morning, I brewed coffee, mesmerized by the river's song. Our plan was simple: Hike up to the base of Diamond Peak and piece together the safest route that, from my view, could be climbed by an injured man and his dog without ropes. Then we'd bivouac on top to photograph the summit views in the sweet light of sunset. The morning glow of sunrise was beaming off the river's canyon walls when we started hiking up Diamond Creek. We turned northeast and followed wild burro tracks up the rugged drainage through ocotillo and creosote bushes to what I called Diamond Peak Pass. Set loose by prospectors during the late 1800s after they discovered there was more silver to be gleaned wrangling dudes into the canyon than prospecting, feral burros flourished throughout the Grand Canyon to the point that they'd impacted the natural habitat of the more timid desert bighorn sheep. During the 1980s, the burros were hunted and successfully airlifted out of the canyon by cargo-net-dangling helicopters. But wild burros still found refuge in the back of beyond of Hualapai country. And it was curious to hear the echoes of their braying "hee-haw, hee-haw" in the distance of Two Hundred and Twentyfour Mile Canyon.

Using Lummis's descriptions as a rough guide, I studied the broken ramparts of Diamond Peak's southeast side: "Before daybreak next morning," Lummis wrote, "we were up, climbing one of the rugged terraced walls of a vast butte to get the view from its crest. It was a toilsome and painful climb for me, thanks to my arm, and at the easiest points it is no easy task for anyone." It came to mind that Lummis had described what many early rock climbers used to call "a dog route" (it was so easy, a dog could climb it). And that unlocked his nondescript route up the craggy peak we followed.

From Diamond Peak Pass, we trudged up a loose, rubble-strewn talus slope. For every two steps we took forward, we slid back one foot, climbing hundreds of vertical feet until we reached a hanging terrace. Spotted by my companion on the sharp stone, I traversed a ledge to the left until I reached a steep gully guarded by thorny ocotillo limbs and Spanish dagger century plants. I turned to make certain my partner was safely following and carefully surmounted the

exposed rock benches to reach the south summit ridge of Diamond Peak. I sauntered across the narrow crest as quickly as I could and stopped to photograph my companion summiting the limestone pyramid. We nodded. But I lingered to take in the 360-degree view. This had been my ritual since I'd worked as a wildlands firefighter and lookout tower fire finder in Washington years earlier. Lummis had also written of the view:

The reward of that groaning, sore, skyward mile lay at the top. From that dizzy lookout, I could see a hundred miles of the stupendous workshop of the Colorado . . . It is incomparably the greatest abyss on earth— greatest in length, greatest in depth, greatest in capacity, and infinitely the most sublime.

To the south, I'd viewed the length of Peach Springs Canyon. Over the millennia, it was traveled by the "Old People"—the ancient Cohonina, Cerbat, and Patayan. They were variously believed to be the ancestors of the Hualapai, who traveled up and down Peach Springs Canyon in their footsteps. It was a seasonal migration corridor where they lived, hunted, gathered, and built diversion dams to nurture fields of corn, beans, melons, and squash. From the ponderosa pine forests they inhabited during the summer, they traveled through the warm winter depths of the Grand Canyon they called *Hackataia*, along the Colorado River they revered as *Ha'ka'Ama* (water flowing by). The march of history followed in the Hualapai's footsteps. This included Garcés, Ives, Wheeler, Mojave scouts, O'Sullivan, the 1884-era mule-drawn Farley Stagecoach that transported tourists to the two-room Diamond Creek Hotel, the 1914 Metz 22 Speedster descent piloted by Los Angeles reporter O. K. Parker, who was reportedly the first to drive to the bottom of the Grand Canyon, and untold thousands of river runners returning from their journeys down what the Hualapai call *Haitat*, the backbone of the river.

To the west was the Hualapai's hallowed place of origin, *Matwidita*, or Mattaweditita Canyon. To the northeast was Shivwits Crossing, where the Hualapai forded the Colorado River on driftwood and log rafts between Lava Falls and Toroweap Point to trade with the Shivwits Paiute. And to the east was Comanche Point Pinnacle, also linked by the great river. Comanche Point Pinnacle was fraught with exposure greater than Yosemite National Park's glacier-polished granite finger of the 6,930-foot Lost Arrow Spire, and its difficulty was compounded by crumbly limestone. My three companions backed off the totem named for the Southern Plains Comanche. Desert rock, it turned out, was not every climber's cup of breakfast tea.

Even Lummis, who'd been resilient enough to climb the magnificent peak with a bandaged fracture, had voiced his concerns:

The descent was ten times worse than the ascent—more difficult, more dangerous, and more painful . . . There were but two courses—to try to jump so as to land on the side of the cleft, or to hang on till exhausted, and drop to sure death. . . . With a desperate breath I thrust my whole life into a frantic effort, and sprang backwards into the air. If the Colorado Cañon ran all its seven hundred miles through cliffs of solid gold, I would not make that jump again for the whole of it.

Together, Lummis and his faithful dog, Shadow, finished their "tramp" to Los Angeles. I wasn't sure where Lummis had made his gravity-defying jump, but we'd leapt a short crevice to gain the north summit where we bivouacked for the night. Far from worldly concerns, I considered the prospect of our ropeless descent the next morning through friable cliffs of the rough-cut diamond-shaped peak. I'd been convinced that buckskin-moccasin-clad Hualapais had climbed to the summit from Peach Spring Canyon long before any of us first regarded its regal form, which looked like it had been flint-knapped by nature.

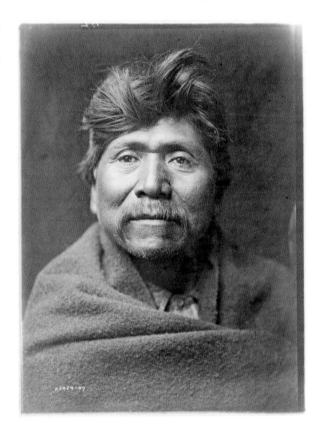

Pachilawa—Walapai chief. *Photographic print by Edward S. Curtis, 1907. Courtesy of Library of Congress, Prints & Photographs Division, Edward S. Curtis Collection.*

A climber braces for the morning chill on the rim of
Comanche Point.

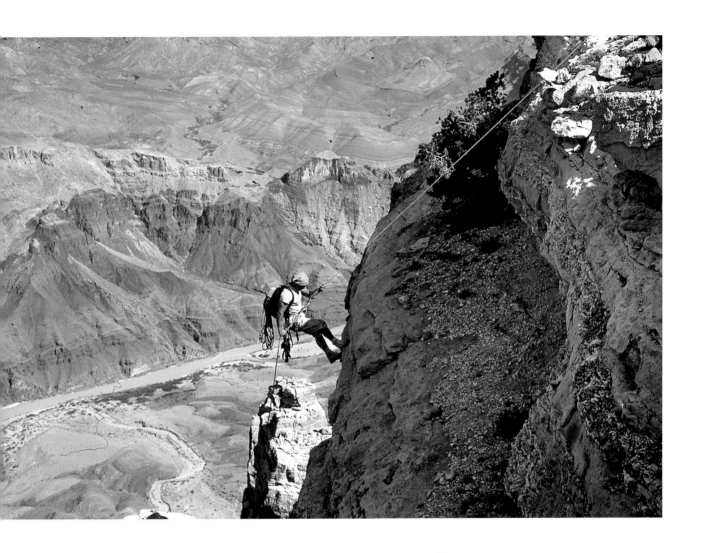

A climber rappels over the edge of 7,073-foot Comanche Point.
The Colorado River is seen far below.

The hint of first light blushes dark skies at our Colorado River camp in the western Grand Canyon.

Map, *Parts of Northern & North Western Arizona and Southern Utah*, Atlas Sheet on 67. George M. Wheeler. *Courtesy of Library of Congress.*

Surviving punishing upstream river currents where no map could guide them, the boat crew of the *Trilobite* stands for a portrait at Diamond Creek. *Albumen silver print by Timothy H. O'Sullivan, 1871. Courtesy of Library of Congress.*

On page 42: A climber reaches the remote 3,512-foot summit of Diamond Peak in the western Grand Canyon on Hualapai ancestral lands.

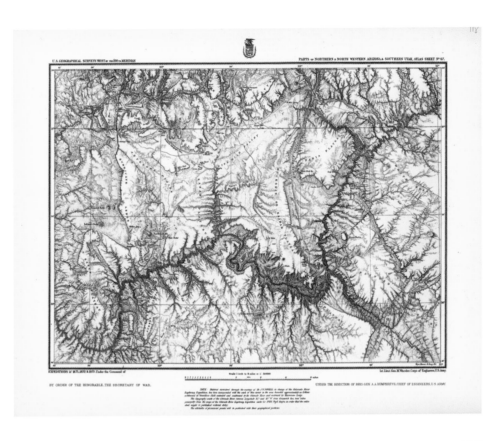

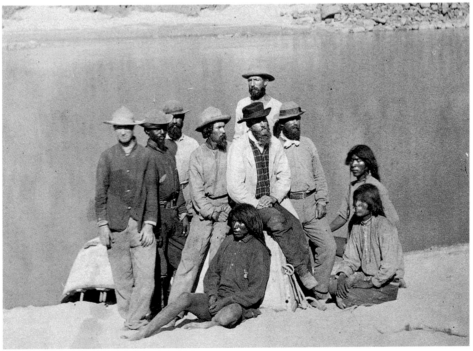

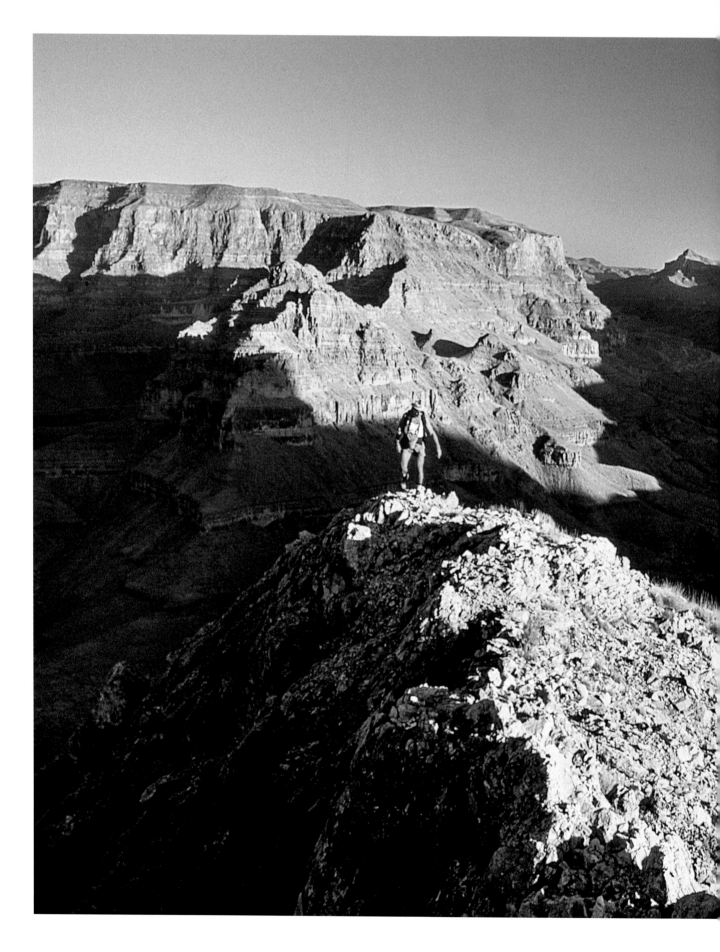

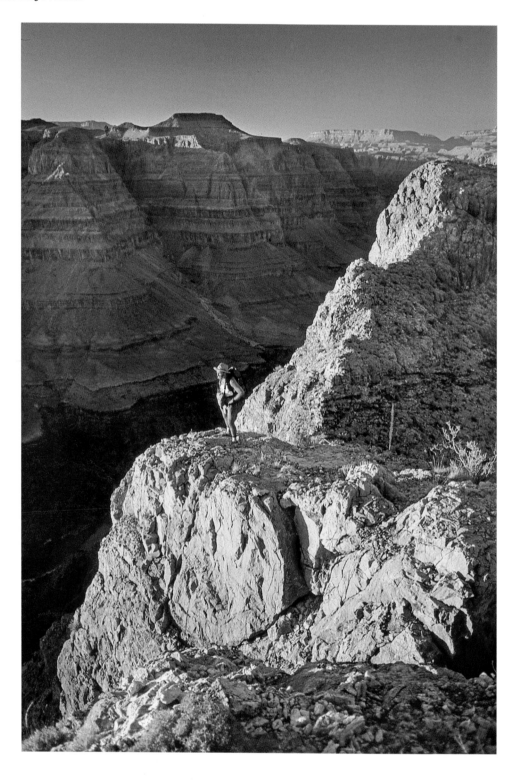

A climber takes in the view from the summit notch of Diamond Peak nearly 140 years after Charles F. Lummis and his dog, Shadow, climbed the peak in 1884.

Twilight reflections on the Colorado River near Hell's Hollow.

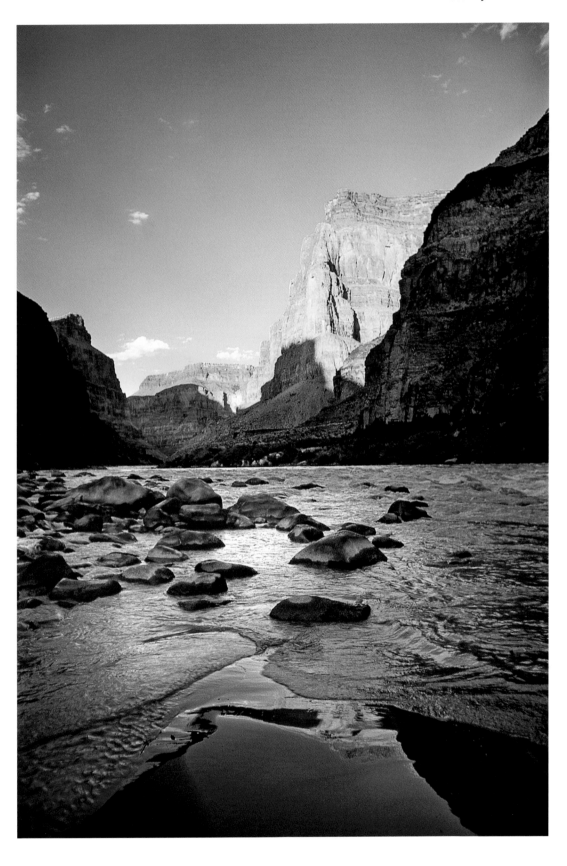

Soaring walls at Vermilion Cliffs National Monument, Colorado River.

3

RÍO COLORADO

Journeys down the Unknown River

The moon was glorious shining on the water between high walls, the white boats were reflected in the ripples, and the oars glistened as they rose and fell to rhythm. This, with the voices of comrades glad to be alive and singing of that river which had nearly annihilated them, will ever remain in my memories.

—Elzada Clover, 1939, "Danger Can Be Fun"

At times, the Colorado River had nearly annihilated them. But the moon was full, and they were beating their tom-toms: dun-dun-dun-dun, dun-dun-dun-dun, dun-dun-dun-dun. Singing of the river at the top of their lungs, they were happy to be wild and free. Firelight kissed the moon-dusted canyon walls, sending up flurries of crackling red embers. The river rolled peacefully by as the shadows of figures danced in

the sand and rocks, sending up puffs of dust with each random footfall. The dancers, some with faces finger-painted with charcoal, joined in the chorus, whooping and hollering, and circling around the fire to the primal drumbeats: dun-dun-dun-dun, dun-dun-dun-dun. In a word, they'd gone tribal.

The river drummers were not Ghost Dancers who once circled hand in hand around the firelight of Havasu Canyon many moons ago in 1890. That's when the Hualapai, Mojave, and Havasupai joined together for four nights running and beckoned gods to bring back their ancestors from the dead.

They were three women—women of the river, who hungered for more than what the Bay Area, Heart of Dixie, and Land of a Thousand Lakes had to offer them. Beautiful, independent minded, strong, resourceful, and kind, they were creating their own legacy in what once was thought to be the exclusive domain of bronze river gods. And they were beating stainless-steel spoons against thick aluminum stew pots, singing a chorus few would remember the next day. The shadows of river runners continued dancing and chanting long into the night around fire-pan-lit flames that glowed along the edge of the black water of the *Río Colorado*, Red River. I'd never seen anything like it, not at bonfire-lit desert soirées once called "boondockers" or at indigenous ceremonies where straw-figured men were burned at the stake as sacrifices in the southern reaches of the Great Southwest.

This river rendezvous had begun at the historic river crossing of Lees Ferry, Arizona. The US Geological Survey determined it was located at river mile 0. The tribal drums that echoed across the moonlit canyon walls were located at a river camp called Ledges, 150 miles downstream. Many scenarios had played out in the intervening miles along the Colorado River, not just for our flotilla of five boats, but for all those who had attempted to navigate the wild and mysterious river on log rafts, wooden boats, dories, and sweep scows. Guided by Utah boatman Norman Nevills, botany professor Elzada Urseba Clover and her young university assistant, Lois Jotter, were among the first one hundred river runners— and women—to run Utah's Cataract Canyon, the "Graveyard of the Colorado," before facing the daunting rapids of the Grand Canyon.

When the Nevills Expedition launched from Green River, Utah, on June 20, 1938, they were all but doomed by a *Salt Lake Telegram* newspaper editorial: "For fame, for glory, for thrill or for swell obituaries, they are going down the river. If there is a special providence that watches over the blind and the drunken, let all hope that it will extend its protective care over the foolish, reckless and heedless."

Against long odds, Nevills's four-man, two-woman expedition reached Boulder Dam on Lake Mead, Arizona, after forty-three days of navigating 666 miles of rapids-strewn river that had already killed thirty-five men and women. If a river rendezvous were ever held beneath the corral of cliffs at Lees Ferry, it would also be attended by legendary river runners, including the young Hopi Ti-yo, dressed in a breech cloth and buckskin moccasins, his shoulder-length black hair bound by a red sash. Wi-Ki, a Hopi rattlesnake chief, shared his story with ethnographer J. Walter Fewkes during the last days of the nineteenth century. Wi-Ki recounted that ages ago, Ti-yo (the youth) floated the Colorado River, which the Hopi called *Pisísvayu*, "water flowing through two high walls." Fewkes wrote that in a sealed box, Ti-yo "floated over smooth waters and swift-rushing torrents, plunged down cataracts, and for many days spun through wild whirlpools, where black rocks protruded their heads like angry Bears."

Also attending the fiddle-playing, foot-stomping rendezvous would be the mustached, fifty-three-year-old gold prospector James White, who nearly replicated Ti-yo's mythic river journey. New York born White and his two partners, Captain Charles Baker and George (Henry) Stroll, were prospecting on the San Juan River in 1867 when they were attacked by the Ute. *Denver Tribune* journalist Thomas Dawson, who investigated the incident, wrote: "Baker, the leader, was killed by Ute Indians near the head of the Colorado River, and the other two men were forced to take to the river to avoid a like fate."

White and Stroll fled toward the wild river to escape. Using two hundred feet of rope they'd carried on horseback, they built an eight-by-ten-foot cottonwood log raft and floated down the thundering rapids, clinging to their crude raft, when Stroll was swept away and drowned. In a

1917 Senate Resolution before Congress, Dawson described the perilous conditions White had endured: "Alternately baked in the semitropical sun and submerged beneath the turbulent waters, he scarcely knew whether he was fish, flesh, or salamander." Fourteen days after he first escaped down the river, army veteran White emerged from the tortuous canyon depths nothing but skin and bones, half naked, his eyes sunken in his head, and was dragged ashore at Callville, Nevada. When he finally recovered at the Mormon outpost four weeks later, he told a tale of survival that's still debated today.

Almost everyone else attending the Lees Ferry rendezvous would have been convinced that Major John Wesley Powell made the first river journeys down what Spanish missionary explorer Padre Eusebio Francisco Kino had named the *Río Colorado del Norte*, Red River of the North. During Powell's 1869 Geographic Expedition, and later during the Second Expedition in 1871–72, he forged the template that many river runners tried to follow in his tumultuous wake. University of Wooster educated mining engineer Robert Brewster Stanton was among them. He envisioned building a railroad along the river corridor through the Grand Canyon in 1889. Like Powell, who'd lost three men after they'd abandoned his first expedition, Stanton lost four of his own men during his two disaster-plagued expeditions that brought him no closer to building the Denver, Colorado Canyon, and Pacific Railroad. The river seemed to breed tragedy, and few stories are more poignant than the epic honeymoon tale of Glen and Bessie Hyde. After navigating an unwieldy, heavy wooden Idaho sweep scow from Green River, Utah, nearly all the way through the canyon in 1928, the newlyweds disappeared without a trace in the depths of the western Grand Canyon 232 miles below Lees Ferry.

A year earlier, the Clyde Eddy expedition navigated far beyond the Hydes' last camp. Eddy, a future member of the Explorer's Club, was a newcomer to river running. But he meticulously planned an expedition that included three custom-made mahogany boats provisioned with food, equipage, and life vests. His handpicked crew of thirteen men included daring, yet untested, Harvard and Notre Dame "college boys," two men, and a "hobo"—a former British Army sailor named McGregory who claimed to have mastered rapids navigating on the Euphrates River during WWI.

The crew's mascots included an orphaned New York Zoo bear cub named Cataract and a mongrel dog pound airedale. Together, they'd faced a wild river that had already peaked at its high-water flood stage of 30,000 cubic feet per second. It did not look promising to onlookers. Surveying the expedition from their launch site, a young well-wisher told them, "In two weeks you'll be dead." To the surprise of many other naysayers who were said to know the river far better than Eddy and his crew, theirs became the first and only known party to run the West's "Big Water." In forty-three days of upsets and near drownings, they had navigated and portaged 330 rapids during their 800-mile river adventure from Green River, Utah, to Needles, California.

Yet, until 1937, no expedition rivaled that of Oregon boatman Haldane "Buzz" Holmstrom. The pioneer river man surpassed all previous expeditions when he became the first person to row solo from Green River, Wyoming, through Cataract, Glen, Marble, and Grand Canyons to the Hoover Dam on the west end of Lake Mead. Not everyone cheered his remarkable success. In his diary, Holmstrom wrote: "Women have their place in the world, but they do not belong in the Canyons of the Colorado."

Enter leopard skin leotard–clad Georgie White Clark. She broke the Colorado River's glass ceiling in 1952 when she became the first woman to row all the way through the Grand Canyon. Cresting on her fame, the Oklahoma-born White launched the first commercial river outfitter run by a woman, the Royal River Rats. And she piloted her motorized "triple rigs"—three rafts lashed together—until her last trip at age eighty-one, a year before she died of cancer in 1992. Other women took notice.

In spite of their legendary river journeys, Georgie White, Major Powell, and James White had all been eclipsed by the extraordinary exploits of a Nez Perce girl named Catherine. She navigated across the Colorado River twice in 1841 during a trapping and trading expedition led by mountain man Thomas Long "Pegleg" Smith from Pierre's Hole, Idaho, to the Gulf of California, Mexico. Recalling her dangerous adventures, the young boatwoman gave the following account:

But there was the [Colorado] river and to cross it there was not a bit of standing or drift timber wherewith to raft. We killed two horses, made a canoe of their hides and landed safely over. By a long search we found willow enough to make an osier frame for our skin canoe sufficiently strong for our purpose.

I showed up at Lees Ferry sometime later to join a paddle-powered Colorado River expedition. In the tradition of Georgie White, the trip was led by a trio of boatwomen, assisted by two boatmen and an apprentice. I was among the crew. At the time, boatwomen were the exception, not the norm. That was fine by me. Schooled as a boatman on the Green and the Yampa Rivers in Utah's Dinosaur National Monument, I'd hired on with a Grand Canyon outfitter. And I was eager. I was about to learn how to paddle-captain a raft from those I was told were among the best, three women I'll call Mina, Lourie, and Samantha, or Sammy. One veteran river outfitter said Samantha was one of the truly great river guides he had ever known. I was about to learn what I thought I already knew from rowing the Green River's Hells Half Mile through the Gates of Lodore and the Yampa River's Warm Springs Rapid the season before.

Unloading the white truck in the broiling summer heat of Lees Ferry, we inflated our boats; strapped on the aluminum frames; slotted oars; gathered paddles; loaded coolers, food boxes, and personal river bags; and waited in the muggy shade of tamarisk trees. Hours later, the busload of passengers finally arrived. A safety pep talk was given, and questions like "How deep is the river?" (forty feet, on average) were asked and answered. We loaded their gear, helped strap on their life vests, and headed down the river with a colorful roster of eager beavers lathered in white sunscreen and costumed in floppy hats, bandanas, sunglasses, long cotton shirts, shorts, and flip-flops.

It was my first paddle trip. As Sammy demonstrated, I ruddered from the stern of the raft and ran paddling drills with our crew as we floated down the quiet river below the Paria River riffles and the soaring trusses of Navajo Bridge.

As I called out the drills, "Forward, back, right, hard right forward, hard forward, left, hard left," the crew clacked their paddles like hockey sticks on the icy river until they got the hang of it. Under my prompts, they alternately pivoted the raft to the right, to the left, back, and forward until everyone was in sync. I needed to be ready, they needed to be ready, we all needed to be ready for everything the Grand Canyon of the Colorado River would throw at us, come hellish heat or high water. That included Al, the near-invalid seventy-two-year-old retired truck driver we helped in and out of our raft at every stop.

The Colorado River and the Grand Canyon changed people. I'd witnessed these transformations on numerous occasions and realized that I was fortunate to be with the group as we paddled, drifted, and navigated exciting but benign rapids through Badger Creek, Jackass Creek, Soap Creek, and Sheer Wall Rapids. I wondered how these rudimentary rapids had tested Ti-yo and James White, who grappled on driftwood timbers and a wooden box, half submerged and gasping for every breath. We had it relatively easy in comparison, and we were coming together as a crew, riding above the surface of the cold river past Hot Na Na Wash until we pulled ashore above House Rock Rapid and tied off our boats.

Sammy took me by the hand and said in her sweet southern voice, "Let's go look at the river." We skirted a narrow ledge above the river. It offered a breathtaking view of a mirror-slick tongue of water pouring into stormy holes and waves below—what early surveyors called House Rock Canyon Rapids. Sammy bent over and picked up a thick gray limb of driftwood. Then she asked, "Where are you going to go?" Her voice was captivating.

"Right down that current," I said, pointing.

She smiled knowingly. "Watch this," she said, flinging the limb into the river. It slid down the slick tongue, as I expected it would, and then spun around in the river like a compass needle, flipped, and tumbled into the first hole. "You don't want to be there," she said. "What if you're not where you thought you'd be—what are you going to do then?" She wasn't talking about one moment, or what my exit strategy would be if I wound up in the wrong place at the wrong time. She was talking about the entire run: my setup at the top of the rapids, my

line of descent through the rapids, and going with the flow of the river's subtle currents.

From that moment forward, Sammy became my mentor and inspiration. We scrambled back to our boat and the group of us untied, shoved off, and paddled down the glassy tongue.

"Forward," I yelled. Paddles dug deep in the water, and I ruddered right, leveraging against the left side of the raft. "Hard forward," I yelled again. We angled clear of the first hole, then whooshed past the second hole that recycled a collapsing wave that doused us with cold water. We rode down the river, paddling and pirouetting through the Roaring Twenties rapids. Days melded into one another. We stopped to explore the slot canyon of Silver Grotto, drank sweet spring water at the lush hanging gardens and waterfalls of Vasey's Paradise, and lunched at the floodwater-sculpted cave of Redwall Cavern. Our journey had become a rhapsody of sights, sounds, and movement, floating on an artery of snowmelt pulsing through a gash in the earth, past arches, hidden alcoves, and ancient cliff dwellings down the hypnotic chasm of Marble Canyon to the confluence of the Little Colorado River. There, the silt-laden, rust-red Río Colorado merged with the turquoise waters of what the guides call the "Little C," an intoxicating swirl of watercolors stirred by the hands of nature.

We turned west beneath the soaring walls of the Palisades of the Desert into the sun-seared black schist of the Upper Granite Gorge. Prepped by days of paddling to reach this dogleg turn of the Colorado River, we faced, scouted, and paddled a gauntlet of rapids some called Big Drops for their size, fury, constriction, and gradient. We ran Hance, Sockdolager, Horn Creek, and Granite Rapids to Hermit Rapids without a hitch. Stroke for stroke, everyone was in lockstep. They pulled their weight paddling through the churning brown water—even Al. In a matter of days, he had undergone a metamorphosis from a man shrunken by age, stiff limbs, and self-doubt to his truck driver former self, getting behind the wheel of what he called "our rig" and paddling like he was driving down Route 66.

We stopped at Hermit Rapids, where a few of our group doubled-up their life preservers and escaped the sweltering heat by swimming the Hermit Wave Train. The rest of us ran down and waited in the eddy below, watching them scream

and bob over each exploding haystack. We hauled everyone back onboard the rafts. Their sunburned faces were beaming, and they still gushed with excitement and joy as we paddled down the mesmerizing river. We rollercoastered through gentle rapids called the Gems and finally reached the river's nemesis of Crystal Rapids. We paddled ashore, tied up the boats, and scouted the deadly hole from a rocky lookout.

"Where are you going to go?" Sammy asked me.

"With our crew," I said, "I'm going to play it safe and sneak down the right side."

That's what we did, together, and celebrated our triumph at camp that night dressed for a "formal wear" gala. The river couture included shorts, togas, flowered wahini skirts, wigs, straw cowboy hats, derbies, sombreros, neckties looped over T-shirts and bathing suit tops, sequined sunglasses, gaudy jewelry, and too-much rouge lipstick. It didn't matter much who wore what. Through my camera lens, it was an odd-looking masquerade as they grazed on fresh green salad, savored sizzling steaks, and sipped an array of aperitifs, vintages, and lagers to the sound of southern rock. For most, life couldn't get any better.

The next day we frolicked in the trickling waters of Elves Chasm; lunched on hummus, avocado, and bean sprout wheat-bread sandwiches—an acquired taste—in the cool chamber of Blacktail Canyon; and floated through the blissful afternoon light of Conquistador Aisle as bighorn sheep ran along the shore. We tied up at sunset to camp.

After running the Big Drops, the job of paddle captain started to look easy to one of our crew members the next day. Sammy gave him the green light and coached him through the setup of Dubendorf Rapid. But the broad-shouldered high school football player the crew had nicknamed Hunk was not listening. From the bow, I watched him fumble with his paddle and his commands, and the next thing he knew, he was "in it," too late for Sammy to correct his run. I pivoted back around in a heartbeat to face downstream and was stunned when our raft poured over a ledge hole. The next moment I was catapulted out of the boat, the raft cruised over me like the shadow of a shark, and I struggled in the strainer below.

I couldn't get up to breathe. I flailed in the wild water, tumbling and turning. The powerful

hydraulics had me in a crocodilian death roll. I needed air. Twisting and turning in the bubbles and froth, I tried to kick my way to the surface again and again. But I was hopelessly stuck, trying to grab the ledge to hang onto, when I saw a ray of sunshine gleaming down through the murky water. That was it! I was gagging, about to black out, and I did the one thing every fiber in my body told me not to do. I swam down toward the bottom of the river and stroked underwater downstream with the current until I popped up for air, coughing, spitting up water, sand, and phlegm, and stood on my wobbly legs and feet.

I lunged toward shore, disoriented and half conscious. Sammy met me in the river, draped a towel over me, and helped me lie down in the sand. Sitting over me like a caring friend, she whispered, "You'll be all right." I would be. We camped at Stone Creek below Dubendorf Rapid that evening, I thanked my lucky stars, and it was lights out. In the parlance of river guides, I had met the "green slime" at the bottom of the river and escaped.

Up at dawn the next morning, I ignited the "master blaster," a propane burner that sounds like a small jet engine, and started brewing two gallons of coffee before joining the other guides cooking breakfast. We feasted on a John Wesley Powell breakfast of bacon, eggs, biscuits, and hot coffee, then formed a conga line to load our kitchen and duffle back on the boats and headed downstream. Our flotilla paddled and rowed into Granite Narrows. It was the narrowest portal on the Colorado River, and we paddled through eddies that spun like whirlpools against the canyon walls and over boils that bubbled up to the surface of the river. "Stop paddling," I whispered to my crew. We rested our paddles and started laughing when our boat spun through the narrows like a Coney Island Tea Cup ride. "Forward," I said to the half-dizzy crew, ruddering the boat as we paddled beneath the sandstone walls downstream to the foot of Deer Creek Falls.

The 190-foot-high cataract was the most spectacular waterfall on the Colorado River. We tied up our boats near the foot of the falls and hiked up to the "patio" of overhanging walls. Skirting a narrow catwalk of slick stone above the roaring falls, we were surprised to see delicate pictographs in the form of faint handprints adorning the walls. Unbeknown to us, we had entered the heart of the Kaibab Paiute's ancestral *Puaxant Tuvip,* or holy lands. Powell photographer E. O. Beaman was the first to record his observation of one handprint in 1872, when he named the waterfall Buckskin Cascade: "This hand was like a dark blood-stain in color, and was neither carved nor laid on with any material that chemicals would act on. Could it be that this was the mausoleum of some long-extinct race, and this hand so symmetrical and womanly reached out from the external rocks to tell the tale of its ossification?"

Below Deer Creek Falls, we "bathed" in thick adobe mud at the confluence of Kanab Creek Canyon, climbed up a dangling rope ladder from the river into the hanging canyon of Olo, listened to meditative flute music and creek water in Matkatamiba Canyon, stayed right side up in Upset Rapids, and finally arrived at our Ledges campsite late that afternoon.

I'm not sure what started it, but when the sun set and darkness seeped over the canyon, the moonlight hinted of mystery and mischief, and the revelry started like spontaneous combustion. The metal spoons and stew pots came out, and the drumming started, *dun*-dun-dun-dun, *dun*-dun-dun-dun. Flip-flops came off and the singing and dancing continued until the moon began to wane. We were in the dream world of a river journey. The farther down the river we traveled, the deeper we were romanced and entranced, and there was no turning back.

When Norman Nevills guided botanists Elzada Clover and Lois Jotter to Havasu Canyon in 1938, he wrote the following in his river diary on July 26:

The water is an unbelievable shade of turquoise blue. Its color was the inspiration for the noted song "Land of the Sky Blue Waters." We swim, then walk up the canyon a ways. The scenery is breathtaking, and the water is an incredible contrast to that which we've been boating on. . . . To cap it all, a double rainbow formed, from wall to wall. One of the most spectacular and beautiful sights I've ever seen.

Our crew, and most of the others, rose up from the river like centipedes, wriggling across steep gray-limestone ledges. We traipsed along Havasu Creek and waded and walked for miles through thigh-deep water, sharp boulders, and forests of wild grapevines until we reached the brink of a forty-foot-high bluff overlooking Beaver Falls. One passenger was puzzled. "I thought we were going to cool off and go for a swim," a spry, safari-hatted older woman asked one of the guides.

"We are," he said. The next minute, the boatwomen jumped headlong, one after the other, screaming as they plummeted into the pool of turquoise water below.

"That answers that," the woman said. After the Dubendorf Rapid incident, I was still nervous about dunking my head underwater. But Sammy climbed back up to the top of the cliff. She was soaking wet, grinning freckle to freckle, and her sun-streaked auburn air dangled like corn silk from her homemaker-turned-pirate bandanna. All that was missing were gold loop earrings.

She took my hand and said in her good ol' country girl voice, "Let's go together." The next thing I knew, I was hurtling toward splash down forty feet below. We hit the water and plunged below, and I almost panicked when I saw how deep we'd sunk. I kicked through the bubbles to the surface and remembered what another boatwoman had said about Sammy: "She can charm a rattlesnake back into its hole."

"Follow me," Sammy coaxed. We swam toward another cliff, she took my hand, and we dove underwater. I followed her bubble line and the soles of her white feet flashing in the dark water as she led me into a subterranean pocket. It was called the Green Room. We popped up for air in what amounted to a small air chamber. "That wasn't so hard," she laughed, poking me in the ribs! In the refracted aquamarine light, she looked like she could swim into the movie role of a vixen pirate. "Watch your head; don't come up too early," she said, then disappeared underwater. I took a couple of deep breaths and followed her back out into the sunshine, happy I'd fully recovered from my Dubendorf swim.

From Havasu Creek, everyone seemed to be counting down to our day of reckoning at Lava Falls, the one rapid against which all others are measured in North America. My crew wasn't sure what to expect. Like Clyde Eddy's "pink-wristed" college boys, not one of my crew members had been to the Grand Canyon before, much less taken a river trip. Yet, within the span of ten days, they had adapted to the extreme heat, freezing water spilling from the depths of Glen Canyon Dam, collapsing waves, and sand in their food and clothing. Together they'd navigated what Clyde Eddy called "the most dangerous river in the world."

We climbed up to the Lava Falls overlook and scouted the booming falls. The river poured over the Ledge Hole, through the giant V-wave, and pummeled the Black Rock that earned its own reputation for flipping boats and spitting out passengers into the wave train, where some were swept all the way to Son of Lava rapids downstream. "Where are you going to go?" Sammy asked.

I wasn't skilled enough yet to run what was called the "bubble line," a near-phantom current that appears and disappears seemingly at random, like a water snake slithering around the right side of the Ledge Hole. So I said, "I'm going right." I stood there alone for a few minutes and realized that Lava Falls was the choke point for nearly every river runner who had come down from Green River, or Lees Ferry, and survived this far. What had Ti-Yo and James White done, I wondered. Had they even known what was coming, floating facedown at eye level, struck with fear and anxiously scanning the surface of the river until it fell off the edge of the world and disappeared into what sounded like a cataclysm? How did they hang on through the whitewater storm, or did they get relentlessly Dubendorfed until they woke up onshore below Son of Lava, spitting up water, silt, and mud?

We scampered down to our rafts, cinched on our life preservers, and pushed into the current. I stood on the stern tube; peered into the confusion of breaking waves, lateral curlers, and haystacks of water; and saw the V-wave and what looked like the Black Rock far below. I heard that voice in my head again—"Where are you going to go?" I keyed off a mushroom of water that flowed over a submerged boulder called Meteor Rock on the left and the V-wave on the right. I sat down, hooked and locked my right foot under the rear cross tube, and whispered on the still, quiet pool of water,

"Forward, easy." Sliding down the tongue of Lava Falls in charge of keeping five other people

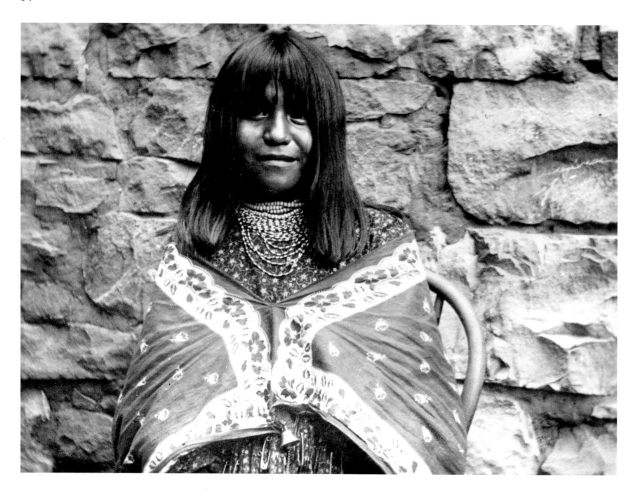

alive felt a bit like jumping Butch Cassidy–style off a cliff onto a runaway train, yelling at your partners, "It's all good!" It was slow motion at first, slow enough to play back the boats I'd seen flip in the Ledge Hole and the bobbing heads of passengers, and the next thing I knew we were accelerating without any brakes or a train whistle to blow.

"Forward," I yelled. "Hard forward," I yelled louder. I braced against the side of the boat with my paddle and ruddered right. "Hard right!" We slid toward the V-wave and ran the current between the Black Rock and the curler that broke off it. It could pulverize us even before it flipped our boat. "Haaard left!" We turned and caught the current running up the face of what's called the Big Wave. It should have been named Sunset Beach for Oahu's North Shore giant. From the stern of our boat, I watched two paddlers on the bow get nearly wiped out as the wave collapsed over them; we caught air as we slammed down the wave's back side. We counted heads in the whitewater lather, "Six?" I yelled. "Six!" someone shouted back. We cheered and bounced up and down in the boat as we headed toward Son of

Portrait of Havasupai woman, Fannie Baanahmida (Glad Man), wearing shawl. *Silver gelatin print by Henry G. Peabody, 1902. Courtesy of Grand Canyon National Park Museum Collection.*

Lava and pulled over to enjoy the traditional post-Lava revelry at our camp.

The journey was almost over. We were about to reenter what most of us considered the "real world" of home, family, work, and bills that, at times, seemed like abstract concepts on a distant planet. Immersed in the Grand Canyon of the Colorado River, many discovered, there was little chance of escaping the irresistible force that it held over us nearly every waking hour.

Later, we bid our farewells in Flagstaff at a roundtable of food and memories. It was a happy affair, if a bit melancholy. As one of the first one hundred river runners to brave the dangers of the Colorado River, Elzada Clover had reminisced: "There was a feeling of regret as the last rapid came into view." We had lived, breathed, and experienced so much together, and we were about to part ways forever. On the other hand, it was revealing to study the faces of my crew. They weren't the anxious, sometimes nervous faces of city dwellers and flatlanders who had put on the river at Lees Ferry two weeks earlier. They were confident, hardy, tanned river veterans who shared intimate moments, indelible sights, solace, raucous laughter, and the adventure of overcoming adversity. I, too, was touched. I'd found a mentor who, over the course of a month of back-to-back river journeys, opened a new door for me, and she was about vanish like a monarch butterfly. My crew, including Al, had rediscovered the very essence of who they were—and who they had become once again.

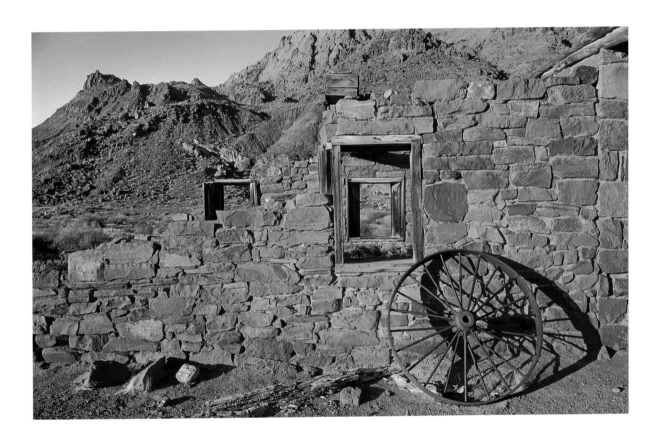

Lees Ferry Fort, built in 1874, Colorado River, Glen Canyon National Recreation Area.

Following: Reflection, Colorado River at Fourmile Wash, Marble Canyon.

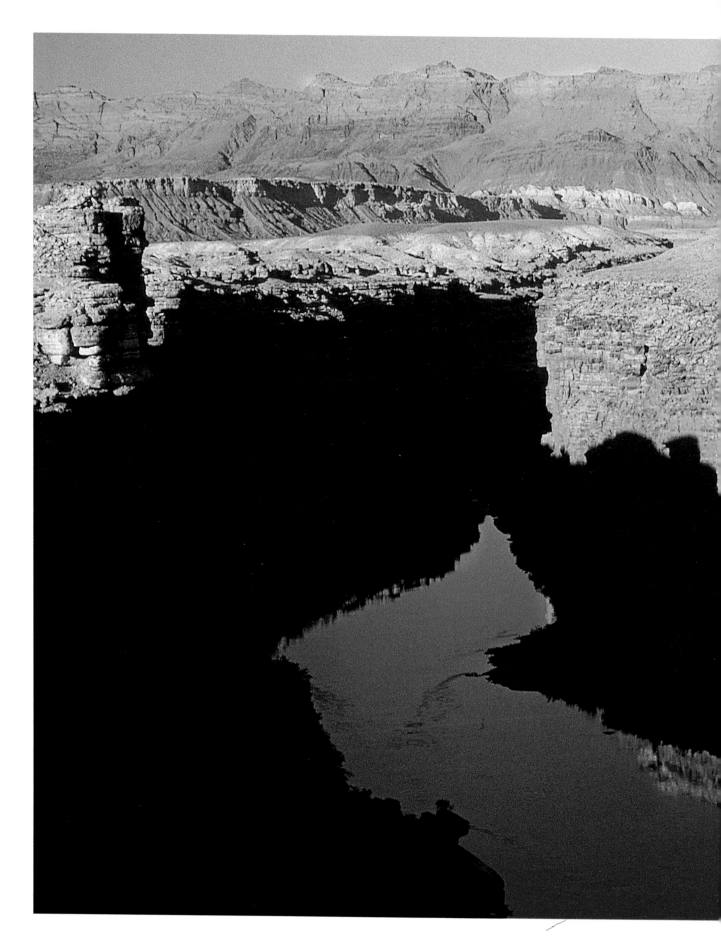

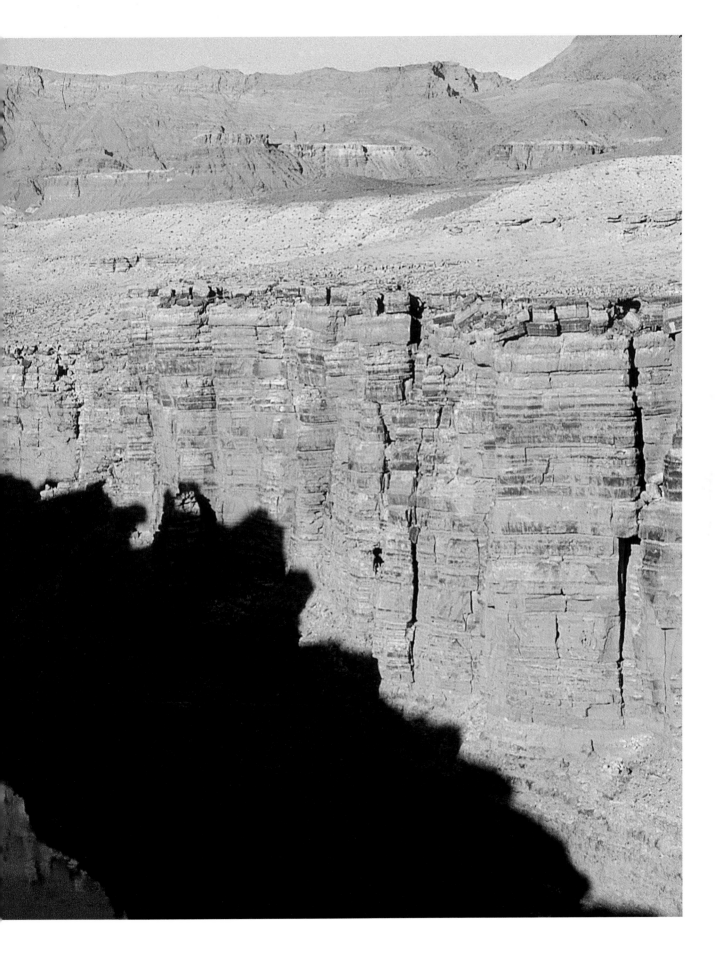

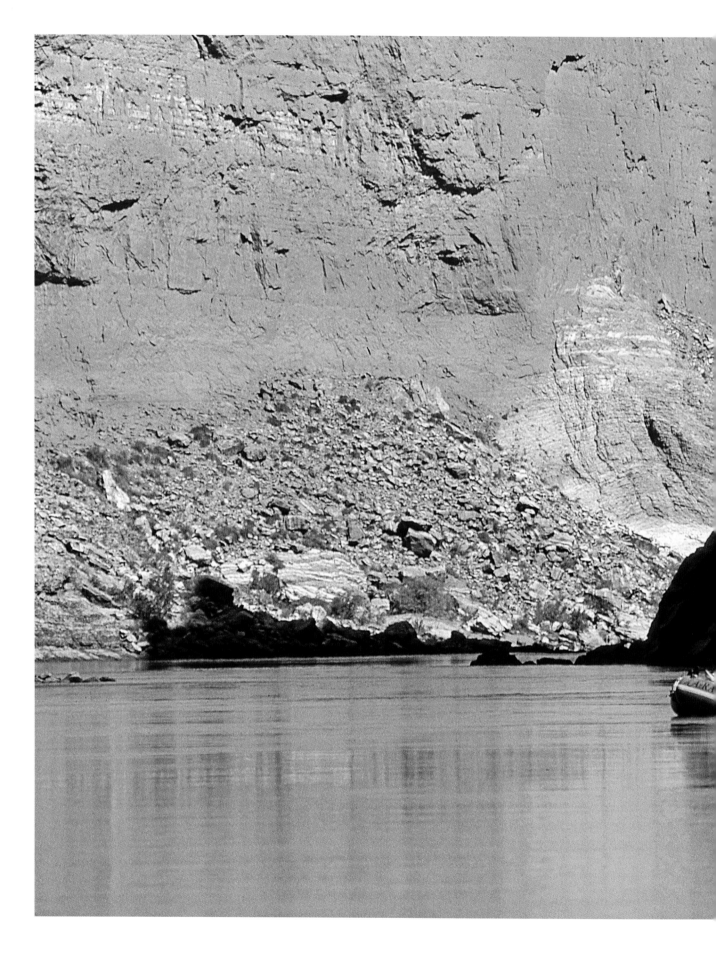

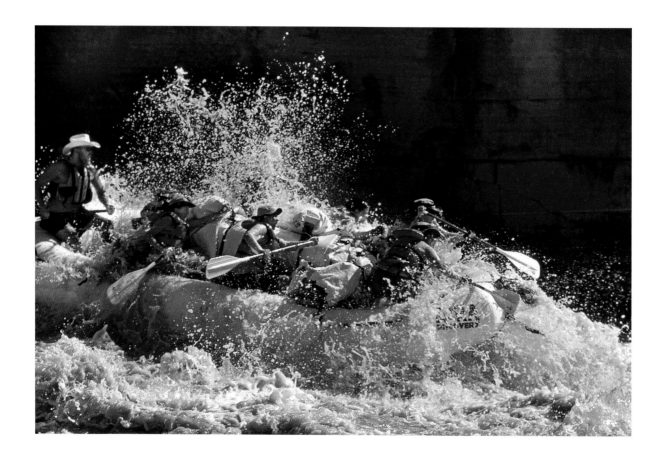

Previous: A boatwoman traces the shadow line of the Colorado
River through the depths of Marble Canyon Gorge.

A river boatman captains his paddlers through Upset Rapid,
Colorado River.

River guides portrait, Colorado River at Cardenas Creek camp. Following: Paddling Marble Canyon near Fifty Mile Creek, Colorado River.

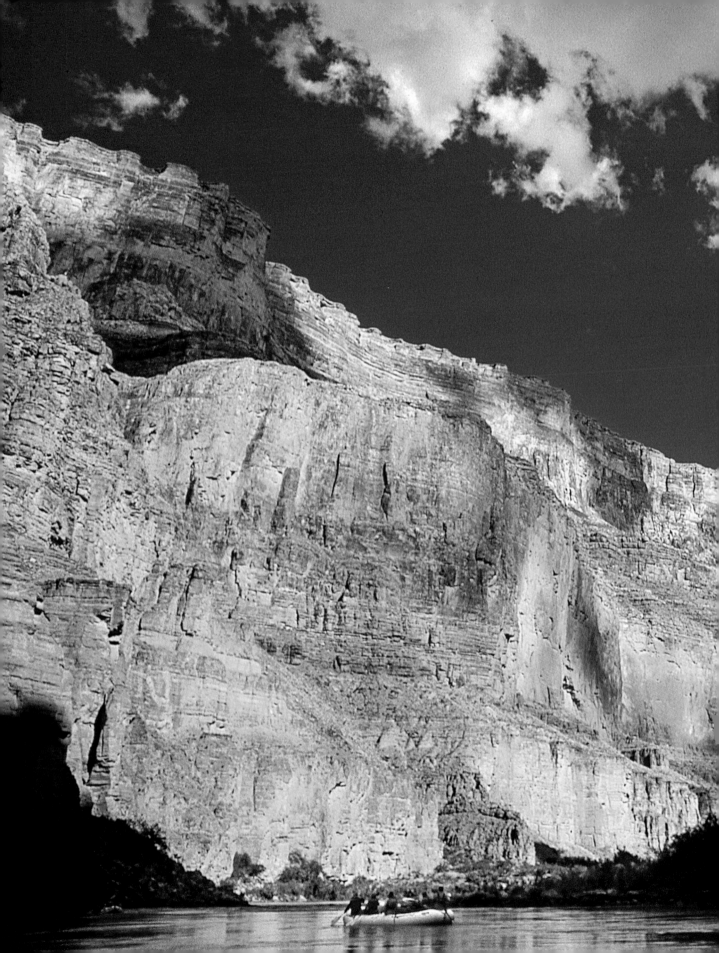

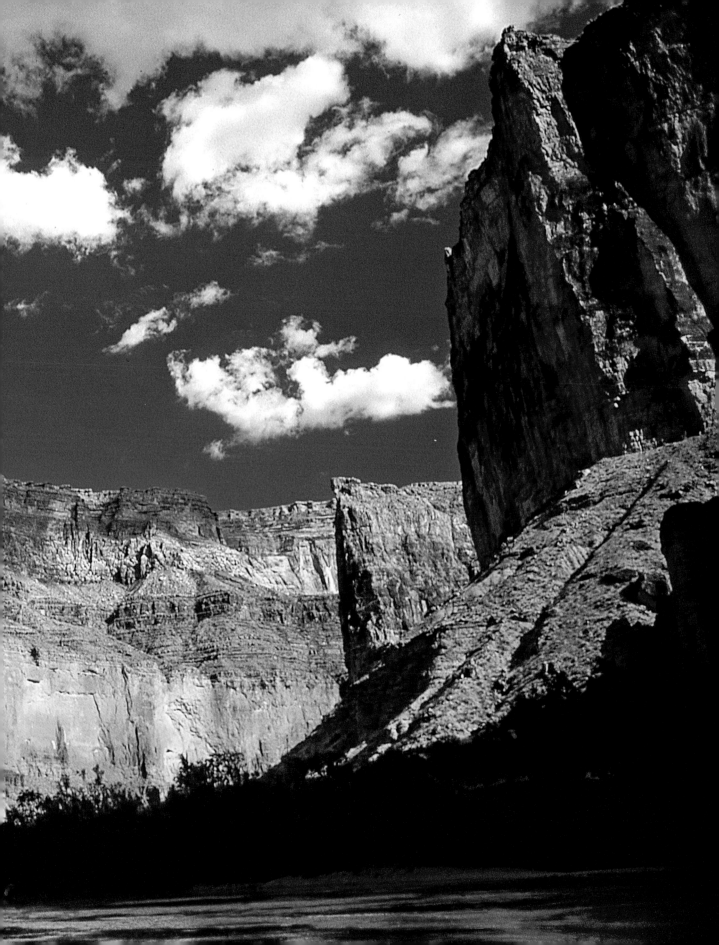

River-worn feet, Fern Glen Canyon, Colorado River tributary.

Pedicures, Matkatamiba Canyon, Colorado River tributary.

Following: A boatwoman faces the gauntlet of Hermit Rapids' wave train of powerful hydraulics that form the biggest waves in the Grand Canyon.

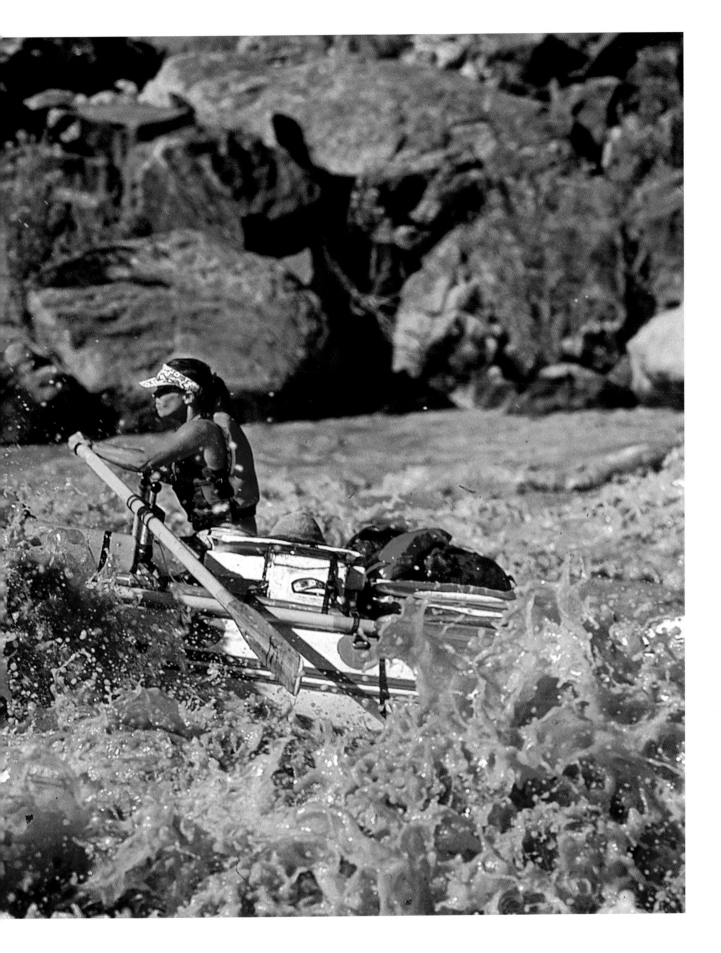

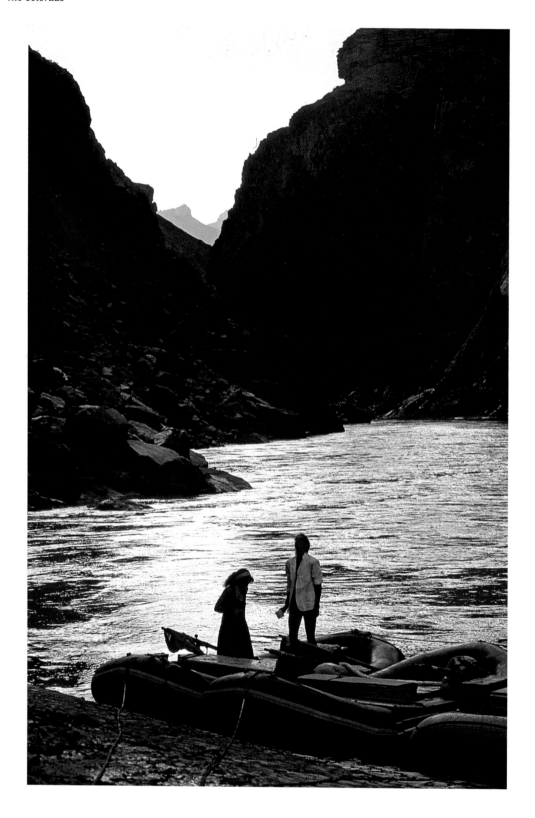

Boatwomen's cocktail hour on the Colorado River at
Grapevine Creek.

A boatwoman paints in her river journal, Matkatamiba Canyon,
Colorado River tributary.

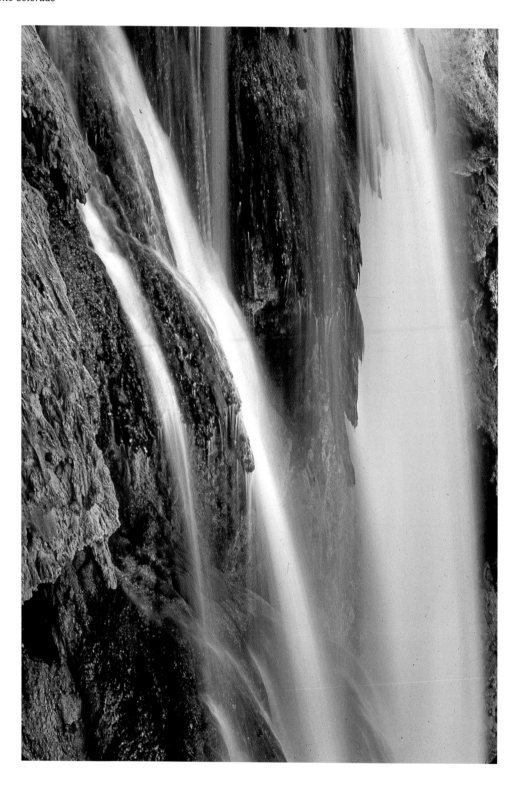

Cascades, the other side of Havasu Falls. The falls are the
heartbeat of the *Havasuw `Baaja* (People of the Blue-Green
Waters), who still live in the depths of the Colorado River tributary.

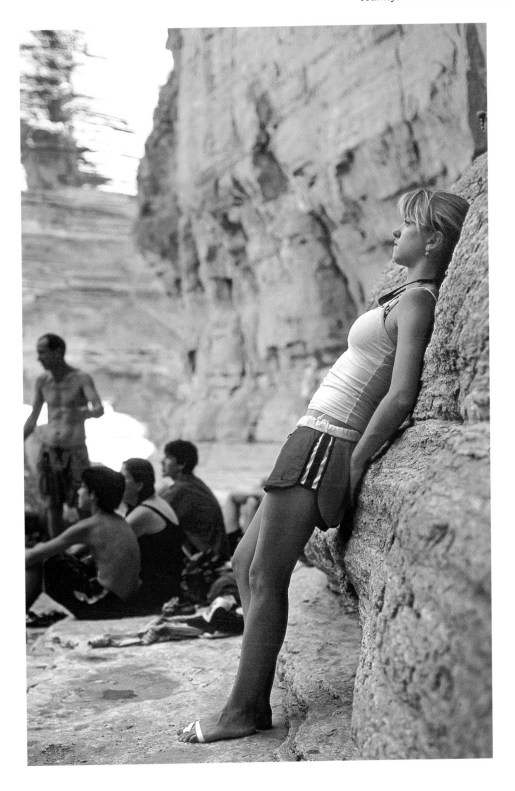

Canyon dreamer, Fern Glen Canyon, Colorado River tributary.

Following: The upstream canyon view of the Colorado River in Conquistador Aisle.

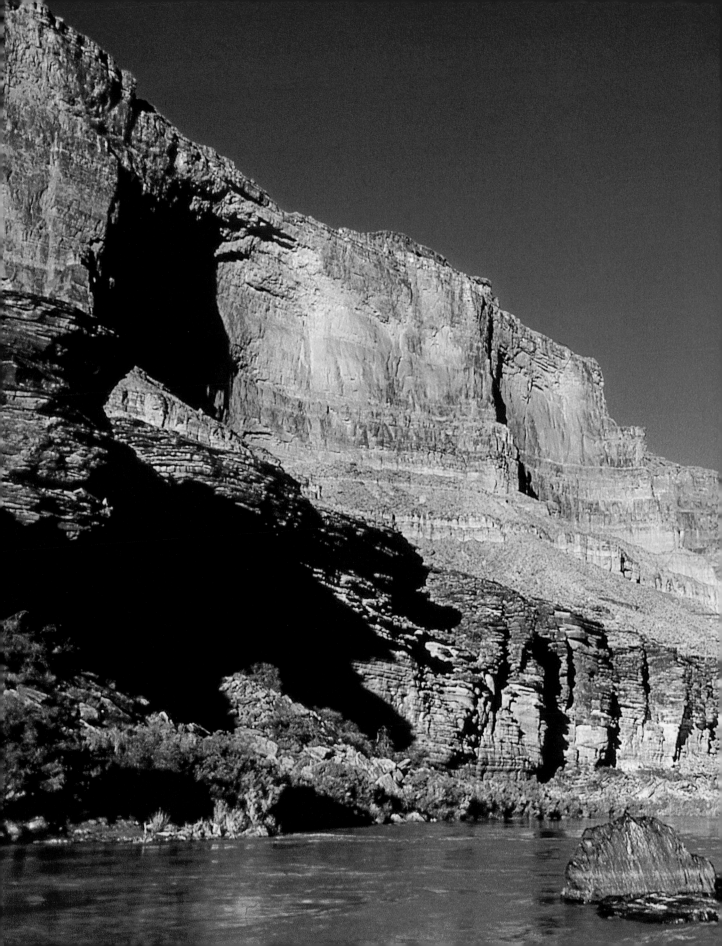

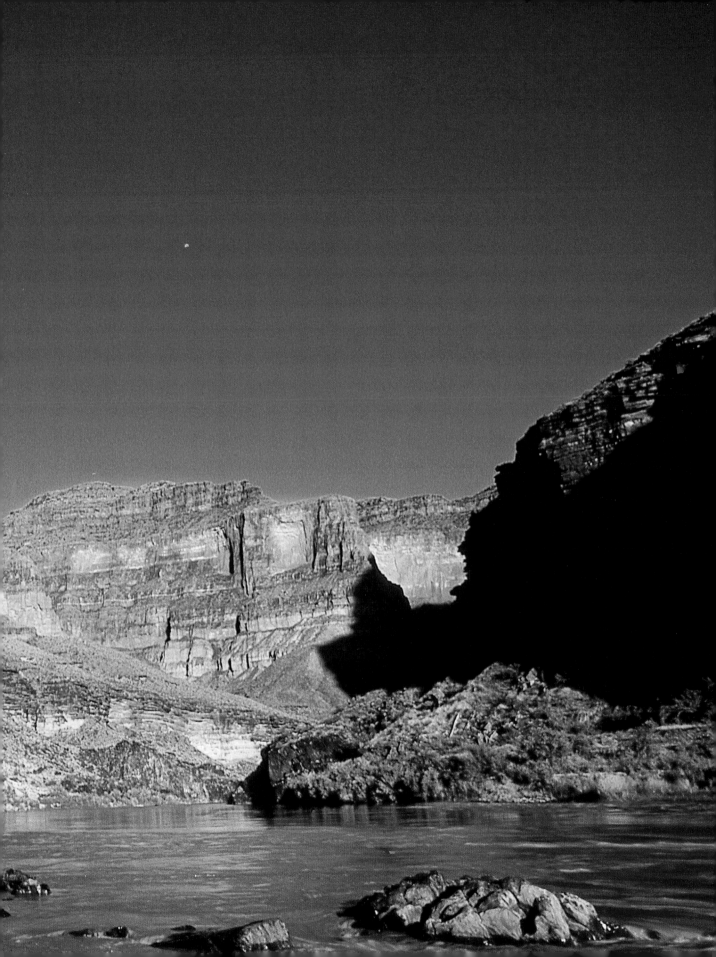

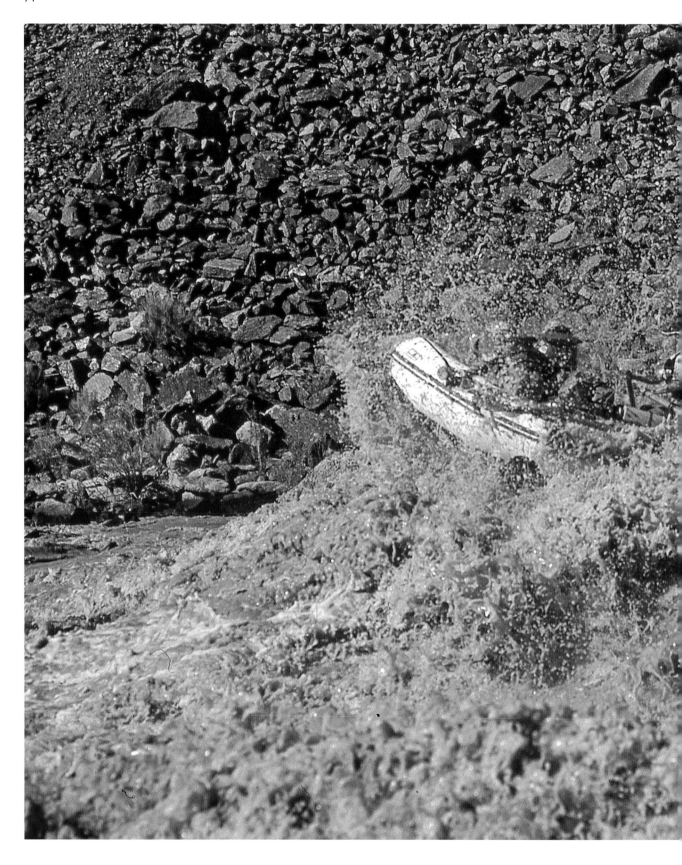

A boatwoman navigates an exploding
haystack in Hermit Rapids.

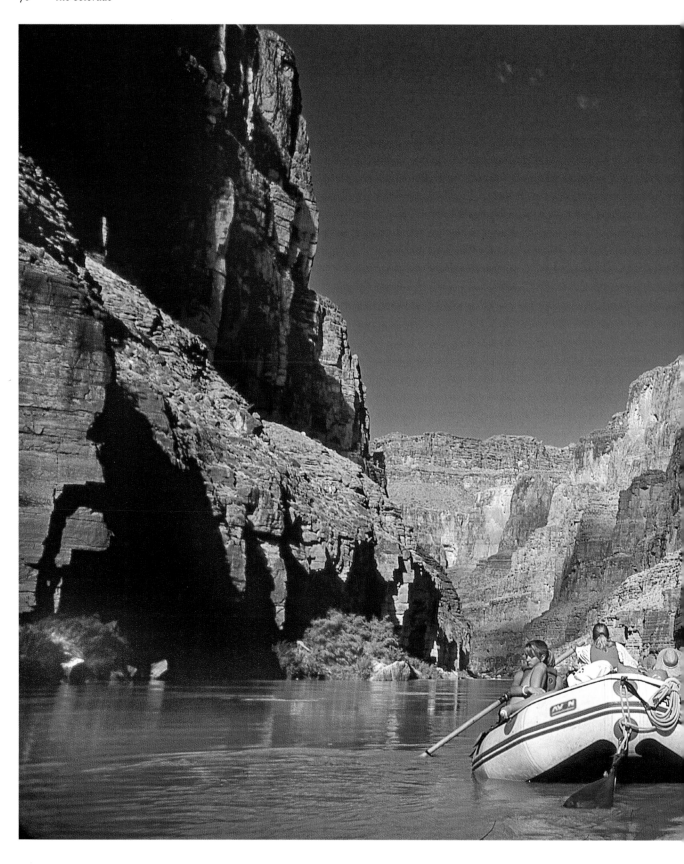

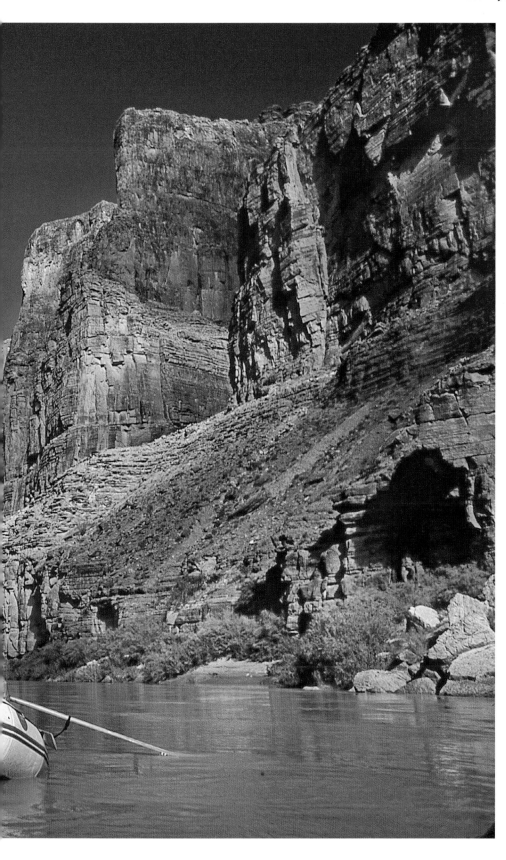

Rowing home. A boatwoman rows through the mesmerizing depths of Muav Gorge, named for the Muav limestone that characterizes the Colorado River canyon.

Daybreak winks over the sandstone megaliths at 6,761-foot
Angels Gate below the North Rim.

4

SACRED TEMPLES

Journeys to the Thrones of the Gods

Within the abyss the darkness gathers. Gradually the shades deepen and ascend, hiding the opposite wall and enveloping the great temples. For a few moments the summits of these majestic piles seem to float upon a sea of blackness, then vanish in the darkness, and, wrapped in the impenetrable mantle of the night, they await the glory of the coming dawn.

—Clarence E. Dutton, 1882, Tertiary History of the Grand Cañon District

We stood atop a dizzying eagle's perch on the edge of the rim rock and watched the sun wink over the golden pillars of Angels Gate. In the dreamy distance, Angels Gate was nearly lost in the receding shadows of a panorama that arced over the silver currents of the Colorado River swirling in the dark chasm far below. Looming above all else were the evergreen forests of the Kaibab Plateau. They crowned the cliffs around the sacred temples, spires, and altars of stone that inspired Grand Canyon geologist Clarence E. Dutton, author George Wharton James, and cartographer François Émile Matthes to name them after ancient gods, deities, and spirits revered on the far side of the globe.

In the crisp winter air I could see Shiva Temple, a flat-topped, 7,646-foot-high island in the sky. Named by Dutton after the Hindu supreme deity Śiva during the Powell Survey of the Kaibab Plateau in the summer of 1880, Shiva Temple reigned over a trinity of mile-deep tributary canyons carved by tempestuous winds, violent floodwaters, and rock-splitting freeze-thaw erosion.

Viewing the seldom-explored escarpments east of Shiva Temple, I saw the sheer-walled stone monolith of 7,212-foot Buddha Temple. James named it after Gautama Buddha, who taught "the middle way" to his disciples in 500 BCE. One historical account, cribbing from the works of James and Dutton, professed that a Chinese Buddhist monk named Hui Shen discovered the Grand Canyon during the fifth century while searching for the mythical land of Fú Sāng. Across the canyon directly in front of us stood the ivory-colored sandstone horn of 7,123-foot Zoroaster Temple. Arguably the Grand Canyon's most sublime, James named it after the Persian prophet Zarathustra, who founded Zoroastrianism 3,500 years ago. And to the northeast, towering over Angels Gate, was 7,668-foot Wotans Throne. It was tenuously linked to the North Rim by a serrated isthmus of stone and named by Matthes after the Norse deity Wōden, who reigned during the Viking age. These striking landmarks stood out among their peers that bore the names of the Egyptian goddess Isis, the Buddhist deity Deva, the Hindu sage Manu, and the creator god Brahma. They were surpassed in stature only by the 7,633-foot pyramid of Vishnu Temple. It was the largest mountain in the Rocky Mountains–scaled inverted mountain range of the Grand Canyon. Named after the Hindu deity Visnu, Dutton also marveled at its appearance: "It is more than 5,000 feet high, and has a surprising resemblance to an Oriental pagoda. We named it Vishnu's Temple."

These temples played hide-and-seek among a hundred other islands in the sky that took the form of pillars, spires, buttes, crests, points, and pinnacles. Over thousands of years they'd lured Archaic-aged indigenous pilgrims, Ancestral Puebloan hunters and gatherers, Native peoples, prospectors, surveyors, early tourists, artists, and adventurers to climb their remote summits. Dwarfed among the weather-sculpted stone marvels was the lowly yet elegant portal of 6,761-foot Angels Gate. The three of us had come to climb its 275-million-year-old sandstone fissures that still bore the fossilized footprints of salamanders, lizards, and tetrapods. On another level, I had come to make a pilgrimage to what the Paiute were said to believe was the hallowed gateway of their gods.

I was inspired by the lives of late British mountaineer Peter Boardman and his climbing companion Joe Tasker. Boardman touched on the sanctity of such spires and mountains in his book *Sacred Summits*: "In the east a distant spire rose from a crown of rock. The Matterhorn. Little more than a century ago, the natives of the surrounding valley felt an invisible cardon drawn around it. . . . The mountains, the trees, rocks, and the springs of Europe were respected then as sacred places."

Angels Gate would be lost in the rubble of the cloud-piercing, 14,692-foot-high Matterhorn, or the Himalayan peaks Boardman and Tasker risked their lives triumphing over and ultimately perished in. The comparatively minuscule Angels Gate was also said to be sacred to the Paiute. George Wharton James wrote in his seminal 1900 book, *In and around the Grand Canyon*, "Some day the gods, Those Above will return to the earth, and 'Angel Gate' is to be their place of descent."

It would take us two days to reach the foot of that mysterious passageway on the other side of the canyon near the foot of Wotans Throne. We stepped off our perch as sunlight kissed the

summits of Angels Gate and resumed our descent from the forested rim rock down the canyon's steepest rough-cut trail. Shouldering heavy packs with food, water, gear, and climbing ropes, the grade was knee buckling and descended nearly a vertical mile in the span of a what would amount to a weekend 10K race. The man-made trail switchbacked through a kaleidoscopic palette of geology leading to bold new worlds for many travelers. We were on our own quest.

Hidden from the view of the thousands of hikers, mule riders, and wranglers who've tromped up and down the beaten path, at times through ankle-deep moon dust, the historic trail paralleled an elusive prehistoric route that left the brink of the South Rim at a 7,300-foot mantle of stone called Cremation Point and led to a sacred cave.

Near the edge of the rim rock, Ancestral Puebloans had conceivably ignited pyres of piñon and juniper wood to cremate their kin, set their spirits free, and hurl their ashes into the abyss. Their primeval graveyard was not far from a long-forgotten cave shrine where ancient peoples paid homage to the sacred spirits with handwoven, 4,000-year-old split-twig effigies of desert bighorn sheep and Pleistocene-aged Harrington mountain goats. To their astonishment, archaeologists using climbing gear and ropes also discovered that the indigenous pilgrims used considerable climbing skills to enter the precipitous cave that scientists had named *Tsé'áán Ketán*, or Prayer Stick Cave. Elsewhere in their daunting canyon home, Native peoples had scaled cliffs, crevices, and ramparts, including Shiva Temple and Wotans Throne, in buckskin moccasins and yucca fiber sandals, sometimes aided with log ladders and bridges fashioned from ponderosa pine timbers, stacked rock steps, and hand-carved hand-and-foot holds. Prospectors and explorers called them "Moqui steps" after the Hopi. The *Hisat'sinom* (people who lived long ago), as the Hopi referred to their ancestors, and later the Hopi ventured deep into the canyon to collect sacred salt at *Öönga*, gather *saqwa* (copper ore) for ceremonial face paint, and trade with the Havasupai. Perhaps the Hopi and Hisat'sinom had also visited Prayer Stick Cave. I had been speculating that Native peoples— namely, the Kaibab Paiute—or their ancestors, the *Mukwic* (people we never saw) had used a distant cave shrine across the Colorado River before climbing up toward Wotans Throne to seek *puha* (power) and pay homage at Angels Gate.

By midmorning, we had switchbacked down through the top layers of the canyon's multihued stratigraphy known as the Kaibab limestone, Toroweap Formation, and Coconino sandstone. We'd gazed in wonder at the trailside 6,071-foot O'Neill Butte monument and the vertical crack that inspired its first climbers to call it "Book of Genesis." George Wharton James named the butte for Spanish-American War Rough Rider William Owen "Buckey" O'Neill. We'd traced what hikers called the "Razors Edge" across cinnamon-colored Cedar Ridge, zigzagged through the steep, crumbly Redwall limestone, and reached the inner canyon aerie of Panorama Point. Overlooking the Colorado River, it was captivating to watch the clear, olive-green river run through the pink quartz-streaked black corridor of Vishnu schist of the Upper Granite Gorge. It was not difficult to imagine the Havasupai on this cliff-hugging trail, wriggling in unison like a giant centipede carrying heavy steel cables needed to build the Kaibab Suspension Bridge in 1928.

To reach the foot of the inner canyon bridge across the Colorado River, we entered a dark tunnel quarried by hand and dynamite out of the nearly impenetrable 1.4-billion-year-old basement rocks of Vishnu schist at the bottom of the Grand Canyon. Emerging from the tunnel, we welcomed the blue skies and the 440-foot-long steel gangplank spanning the river. We stepped off the bridge and followed in the footsteps of John Wesley Powell's maiden 1869 Geographic Expedition along Bright Angel Creek. Powell named the stream on August 15 while he traveled along what he described as "a clear, beautiful creek, coming down through a gorgeous red canyon." Inspired by the scene, Powell and his men searched for suitable timbers to hand-hew new wooden oars to replace the battered oars that were lost or broken during their river voyage. Like Powell, the three of us stayed for the night, resting beneath a canopy of cottonwood trees. I was soothed by the melodies of Bright Angel Creek and the sight of the cosmos wheeling in the crystal-clear night sky pinched between the canyon walls.

About where the Powell expedition found "a large pine log, which has been floated down from the [Kaibab] plateau, probably from an altitude of more than six thousand feet," we climbed out of the gorge called the Box the next morning and followed a trail hand-forged by the Civilian Conservation Corps (CCC) during the 1930s. It climbed to the rim and traced the primordial trackways of Ancestral Puebloans and the Kaibab Paiute, known among themselves as the *Kaipa'pici* (mountain lying-down people).

Winded from the thigh-burning ascent, we topped out at a rocky vista nearly a thousand feet above. It overlooked the rustic tourist lodge of Phantom Ranch nestled along the Bright Angel Creek. We turned east and hiked across the undulating desert tablelands of the Tonto Platform, following the CCC's Clear Creek Trail. It contoured along the edge of the rim rock high above the river, weaving in and out of side canyons, talus slopes of cherty limestone boulders, and a desertscape of black brush,

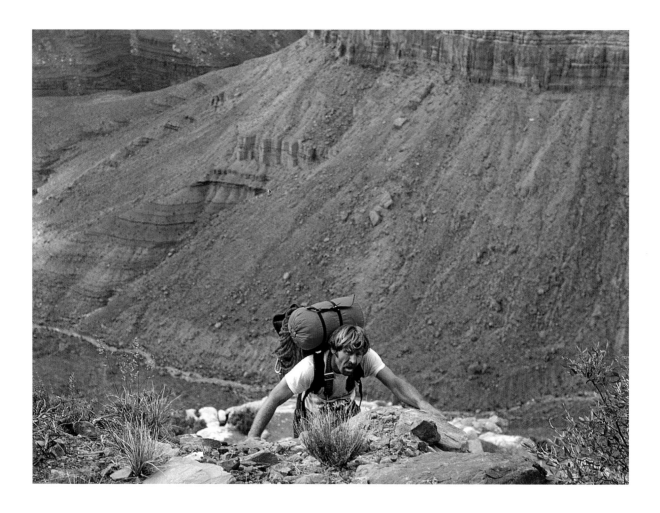

A climber rests during the rugged two-day trek to reach Zoroaster Temple from the South Rim.

thorny-limbed ocotillo, Anasazi agave, Mormon tea, and sweet-smelling creosote bushes, one of the oldest living organisms on the planet. We stopped at Sumner Wash, unshouldered our heavy packs, and took a short break. Named for Jack C. Sumner, a boatman on Powell's 1869 Geographic Expedition, Sumner Wash was a wide, stairstep series of ledges in the slick rock of Tapeats sandstone that offered potholes of snowmelt to top off our water bottles and a comfortable spot to view Zoroaster Temple. The temple poked out of the distant red walls like a lone incisor. Years earlier, three climbing companions and I had tackled the first ascent of its southwest face, which culminated in climbing the final pitch, or rope length, in complete darkness. It was frightening to lead what I called the Midnight Crack. "I don't want to be alone, but I feel as if I'm on the edge of the earth and about to tumble off into an endless free fall," I wrote in my journal.

We'd endured a cold summit bivouac, shivering around a small campfire of twigs until sunrise warmed our bones. After three long, groggy rappels, we touched down on terra firma and renegotiated the tricky descent through an unnerving limestone notch to Sumner Wash. Weary but triumphant, we had prevailed where others were said to have turned back.

We stood up, shouldered our packs, and continued east across the Tonto Platform until we reached the head of Zoroaster Canyon, where we got glimpses of Brahma Temple towering over unscalable cliffs of Redwall limestone. When George Wharton James first viewed the monolith a century earlier, he wrote: "the most dignified and majestic, is Brahma Temple, named after the first of the Hindoo [sic] triad, the Supreme Creator."

A day before our ascent of the southwest face, our party had spent an enjoyable afternoon replenishing our drinking water from potholes in the lofty rim rock north of Deva and Brahma Temples. Scrambling across the boulder-strewn talus slopes back to our Zoroaster spike camp, we realized we were close to Brahma Temple. We cached our load of water and climbed unroped up a series of chimneys that split its west face, delighting in the panoramic view from 7,651 feet, a mile above the Colorado River. The air was fresh,

the day was balmy, and the canyon world was at our feet. From the summit of Brahma Temple, we could also see Angels Gate in the distance, and two of us made a pact to return and climb it.

Today was that day. Ancient paths I'd traced on foot elsewhere were proof to me that the Mukwic, or Ancestral Puebloans, would have had little difficulty reaching Clear Creek from their cliff dwellings beneath the North Rim in Bright Angel Canyon or from their riverside pueblo at the confluence of the Colorado River and Bright Angel Creek. There was dependable seasonal water en route at Sumner Wash, and there was ample agave, a mainstay for Native peoples to harvest and roast in stone hearths.

Moreover, three curious CCC workers had made a discovery in Clear Creek Canyon during the winter of 1933. Exploring the remote canyon, they'd chanced upon a cave shrine that held 11,000-year-old condor bones and were struck by the sight of three straw-colored figures. It was the first such discovery of the canyon's ancient peoples making what archaeologists concluded were split-twig figurines, effigies "taken to certain sacred inaccessible caves and ritually killed . . . [for] ceremonial hunting magic." Two of the fragile specimens were horned, suggesting cliff-climbing desert bighorn sheep and extinct Harrington mountain goats. A third effigy had what appeared to be a spear plunged through its body, indicating the mysterious hunters were using *atlatls*, wooden-shaft-thrown spears, to hunt. When archaeologists later surveyed the cave shrine and others throughout the canyon, including Prayer Stick Cave, they learned that the Clear Creek Cave was the only shrine built in proximity to a pueblo settlement. This ancient knowledge might have remained lost had the CCC workers succeeded in mailing the effigies home as souvenirs of their trail work.

Unknown to most canyon explorers, river runners, and scientists at the time, the young men had wandered into a lost paradise of cliff dwellers that may have dated back 4,390 to 3,700 years—about the same time during the fourth millennium BCE that the alpine-climbing "iceman," Ötzi, perished traversing the snowy Tyrol Alps with his copper ice axe. The cliff dwellers lived in a rugged yet lush canyon oasis

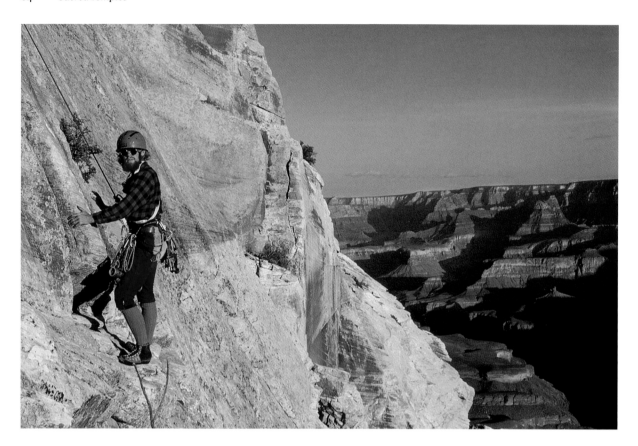

along a perennial creek beneath a spectacular 150-foot-tall cascade that created fertile loam where they tilled and harvested their triumvirate of corn, beans, and squash. They'd also ground maize and mesquite beans with *mano* and *metate* milling stones; hand-coiled, stone-smoothed, and painted ollas fired in stone kilns; and flint-knapped arrowheads to hunt deer, bighorn sheep, rabbits, and squirrels. They paid spiritual homage at their cave shrine and, like people the world over, they lived, laughed, loved, cried, and died. It was not difficult to believe the hardy canyon dwellers could have easily scrambled up to the foot of Angels Gate that was so tantalizingly close and within view of their daily rituals in Clear

Creek Canyon. Had Clarence Dutton known this at the time, he might have used the Paiute phrase *Puaxant Tuvip* (power land) to describe the mouth of Clear Creek Canyon, as he had assigned Paiute names to other landmarks during the Powell Survey of the Kaibab Plateau in 1880. Instead, Dutton called the geographical feature the Ottoman Amphitheater after the twelfth-century Turkish Empire and wrote: "It is one of the first order of magnitude . . . and about as grand as any. It is notable for its magnificent display of buttes." Two of those buttes included Angels Gate and Wotans Throne.

That's where we headed, up the steep drainage slopes, trudging through fallen slabs and

A climber composes himself after taking a forty-foot fall during the first ascent of the southwest face of Zoroaster Temple.

boulders scattered like rock salt across the burnt chestnut-colored talus in the footsteps of the Mukwic (people we never saw).

By late afternoon, we pitched a small camp in the breathtaking saddle of Angels Gate and Wotans Throne. Looming nearly a half mile above us to the east was the imposing form of Wotan, crowned by a forested mesa of ponderosa pine, piñon and juniper, wooden snags, Utah agave, and ephemeral water pockets. Piercing the sky above us to the west were the backlit pillars of Angels Gate.

As the sun began to set over our isolated tent camp hissing with tiny stoves brewing homemade stew and hot tea, I watched the summits of Angels Gate cast their shadows like solstice sun daggers against the formidable red, ivory, and beige walls of Wotans Throne. They took the forms of ethereal figures reminiscent of anthropomorphic shaman pictographs that slowly crept up to the summit into the softening amber, fuchsia, and purple hues of twilight until they melted into stone and sky, vanishing as mysteriously as they appeared. The unimaginably clear night skies were lit with brilliant white stars, constellations, streaking comets, and galaxies that soothed me like the caress of a delicate canyon breeze.

Daybreak came late the next morning where I lay cocooned in the chilly shadows of Wotans Throne. Far to the west, hidden from view, was its twin "sky island" of Shiva Temple. Their imposing landforms were strikingly similar. Detached from the Kaibab Plateau, they thrust out into the heart of the Grand Canyon. Both enticed ancient hunters and gatherers to their forested mesas that seemed to float in the sky. The supernal temples also attracted early climbers and scientists who claimed "first ascents" during the American Museum of Natural History and Patterson Grand Canyon Expeditions of 1937. Surveying the summits of the soaring mesas, expedition members discovered lithic scatters of hand-flaked stones from projectile points and hide scrapers, agave roasting pits some called yant ovens after the Southern Paiute word *na'anta* for agave, a precarious cliff dwelling mortared to a hanging stone catwalk, and masonry summit dwellings built by Ancestral Puebloans, or Mukwic. They had scaled both temples without ropes ages

earlier to hunt deer and gather succulent agave hearts. Like many Native peoples, they undoubtedly observed the summer and winter solstices and spring and summer equinoxes and celebrated their gifts of life in ceremony and song atop their islands in the sky.

Rested from our two-day trek, I scrambled with my partners up the terra-cotta talus slopes to the foot of Angels Gate. When George Wharton James first described these altars of stone, he wrote: "Some day the gods Those Above will return to the earth, and 'Angel Gate' is to be their place of descent." I had watched the shadows ascend Wotans Throne the evening before, and I had watched the shadows descend Angels Gate this morning. I hoped those observances would bode well for our climbs.

While my partners rested, I slowly circled around the towering, 275-year-old Coconino sandstone monoliths. They brought to mind the ancestral coral-eyed basalt faces of the Moai of Easter Island, the carved limestone columns of the Temple of the Warriors at Chichén Itzá, and the upended ceremonial dolerite boulders of Stonehenge. Up close, Angels Gate's textures and radiant light and warmth were palpable. Was that what the Mukwic felt in their presence? Three decades earlier, Paiute elders had explained their spiritual beliefs of the "Elements of the Universe" to those who knew how to listen: "Paiutes believed that power (*puha*) could reside in any natural object, including animals, plants, stones, water, and geographic features, and that it habitually resided in natural phenomena such as the sun and moon, thunder, clouds, and wind."

Had Paiute shamans, called *Puha'gants* (one who has sacred power), made pilgrimages to Angels Gate to acquire *utu'xuxuan* (supernatural spirit), or *puha* (power), as they had elsewhere in the Grand Canyon, aided on their journeys by *tututuguuvi* (spirit helpers)? According to James, they had: "It has been the duty of certain Shamans, or medicine men, on given days of the year to watch for the spirit helpers' coming." What words did the Puha'gants whisper in their prayers, repeat in their ceremonial chants, and sing in the songs that echoed across *Piapaxa 'Uipi* (Big River Canyon)? And what were the offerings they made? Did they carry a deerskin medicine pouch similar to the Navajo's *jish* or *dzileezh*

bijish, which contained herbs, turquoise stones, and wild tobacco, and fan the smoke over Angels Gate with an eagle-feathered prayer stick, as the neighboring Navajo and Hopi did at their sacred shrines, canyon vistas, and mountains? I could only imagine.

That ancient knowledge has been lost to the modern world, just as the secret totems of Clear Creek Canyon were nearly lost. I was reminded of what a mentor told me before I visited the *Guarijío*, "the Lost Tribe of the Sierra Madre," in northern Mexico several years earlier: "Think about the knowledge that is lost every time an elder dies." In the hidden sierras of the Río Guajaray, I was held spellbound by an aging Guarijío shaman, or *cantadora*, singing at the *Tuburada*, a corn-planting ceremonial gathering of his people, the *Macurawe* (those who roam the earth). But the crude wooden bench beside him was vacant. There was no "sorcerer's apprentice" to carry on his sacred knowledge that had been passed down since Spanish missionary padres first made contact during the eighteenth century. Who was the last shaman that traveled up the Puha trail from Clear Creek Canyon to Angels Gate before his ancient knowledge was lost?

I stretched out my arms, placed my hands on the flat walls over my head, closed my eyes, took a deep breath, and listened to the silence. I felt peace and contentment. Under warm, blue skies, I sauntered across the ridge that formed the narrow skywalk between the megaliths of Angels Gate, marveling at the Paiute's elements of the universe. In their spirit world, the red hermit shale I walked on, the evergreen piñon and juniper trees, the crisp air I breathed in, the sunlight that bathed me with warmth, the stone walls and ravens that floated above me—everything in the natural world had power that they sought to acquire.

I joined my friends and roped up to climb the first pitch, or rope length. I caressed the sandpapery stone with my fingertips and lifted one foot, then another, as the toes of my shoes stuck to the coarse stone like a fly to flypaper. It was exhilarating to climb, almost romp, up the fossilized sand dunes to the summit aerie that undoubtedly served as perches for golden eagles, red-tailed hawks, black ravens, and others who had journeyed to touch the mythic stones. We

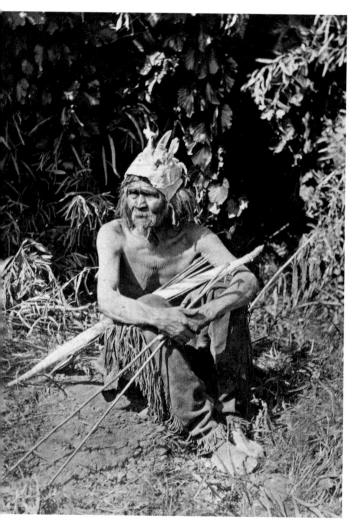

Paiute shaman Enuintsigaip. Stereograph by John K. Hiller, 1871. Courtesy of Robert N. Dennis Collection of Stereoscopic Views, New York Public Library Digital Collections.

took our turns lead climbing and belaying each other until we crossed the last traverse over the Colorado River gorge.

From the summit, I saw the western rim of Wotans Throne towering above friable terraces, storm-polished cliffs, and flying buttresses of stone. I could only imagine how ancient climbers, wearing flimsy hand-braided yucca fiber sandals nimbly threaded, hung by their fingertips and cat-walked and climbed along the narrow colonnade linking the great mesa to the rim of the Kaibab Plateau. What were their fears, thoughts, prayers, and dreams during their quest for *puha* and sustenance?

I looked north, beyond the scorpion-shaped terraces of Thor Temple, toward the forested 8,044-foot Émile Matthes Point. It was named for the Dutch-born geologist who used the perch as a triangulation point for a cartographic work of art called "Bright Angel Quadrangle" in 1903. He was the first to pioneer a treacherous descent along the Paiute's ancient trail through Bright Angel Canyon and later wrote: "We found ourselves face to face with a barrier more formidable than the Rocky Mountains . . . we cast longing glances up Bright Angel Canyon . . . we were told, afforded no practical route for pack animals, and might be impassible even to the foot of man."

And I looked west at the gleaming Brahma Temple between Deva and Zoroaster Temples, where I traced the route of early canyon climbers Donald G. Davis and Clarence Ellis. Davis and "Doc" Ellis had reportedly made the first ascent of the magnificent temple on May 15, 1968, in a fourteen-hour round-trip "dash" from Phantom Ranch. During their ascent, Ellis wrote: "We noticed a large block of fallen Coconino [sandstone] on which was preserved, tilted on its side, a several foot length of perhaps the best fossil track way I have seen—the footprints of some lumbering. . . beast . . . the claw marks clearly visible on many prints. The feet were about three inches wide; the tail some ten inches."

That evening in camp, we were overtaken by fatigue from our journey from the South Rim to Angels Gate. One member of our group, who had tried to assure us that he came from an "era of wooden ships and iron men" and needed no advance training, suddenly came to grips with the scale of our return trip through the inverted desert mountain range. By the next day at sunset it would have entailed thirty-seven miles of trekking and scrambling, and climbing and descending 19,820 vertical feet. That was the price of admission, he conceded, to climb in one of the Seven Natural Wonders of the World.

I enjoyed our tiny stove "campfire" camaraderie, took comfort in my pilgrimage, and relished the thoughts of young climber George B. Andrews, who had climbed Wotans Throne with the Patterson Expedition in 1937. It towered in the starlit skies above us: "Far into the night I lay awake watching the earthly beauty of the moon-flooded gorge. Each individual rock spire and mesa stood out in startling relief against the background of drifting shadows, transformed into objects of beauty and mystery under the passionless white light."

I sat up suddenly in my sleeping bag and wondered if "moon-flooded gorge" was a missing clue. Did Paiute gods descend through Angels Gate not only by day, but during moonlit nights when "drifting shadow" blessed the Paiute in their sacred canyon home? I could only imagine.

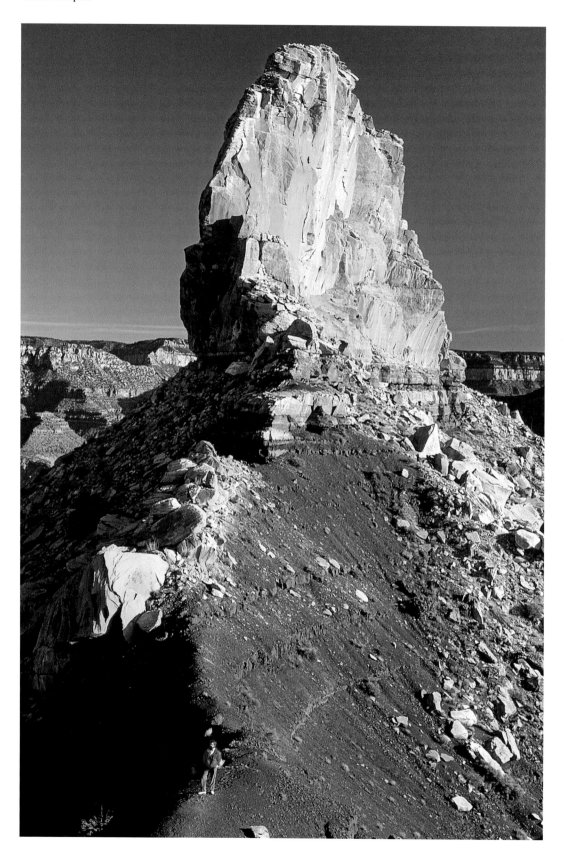

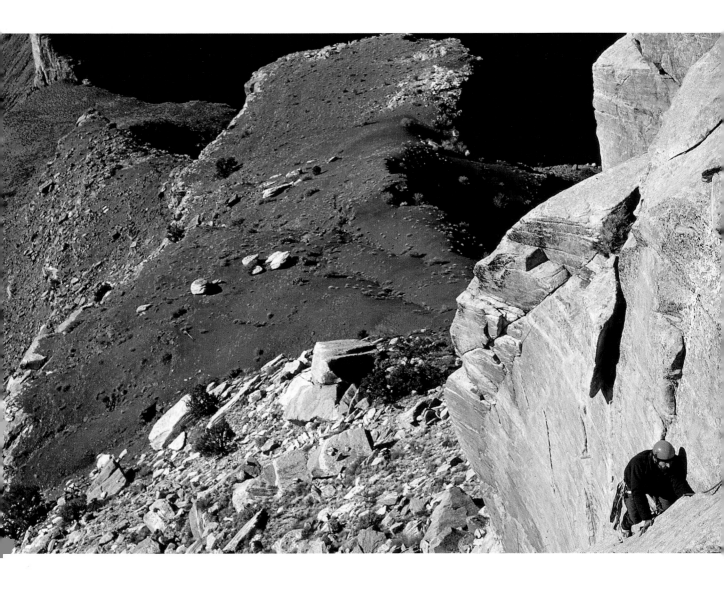

A climber is dwarfed by the Coconino sandstone megalith of Angels Gate.

A climber faces the unnerving exposure of climbing in the mile-deep chasm.

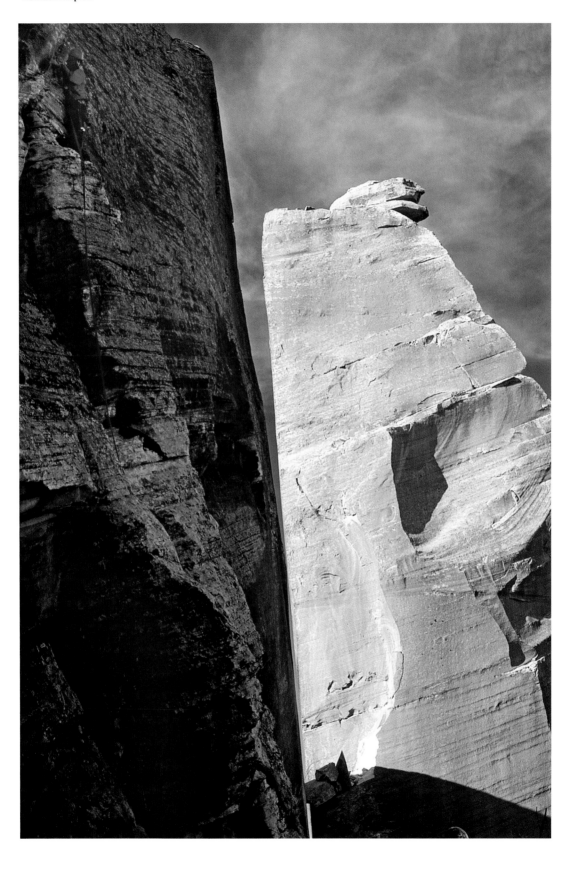

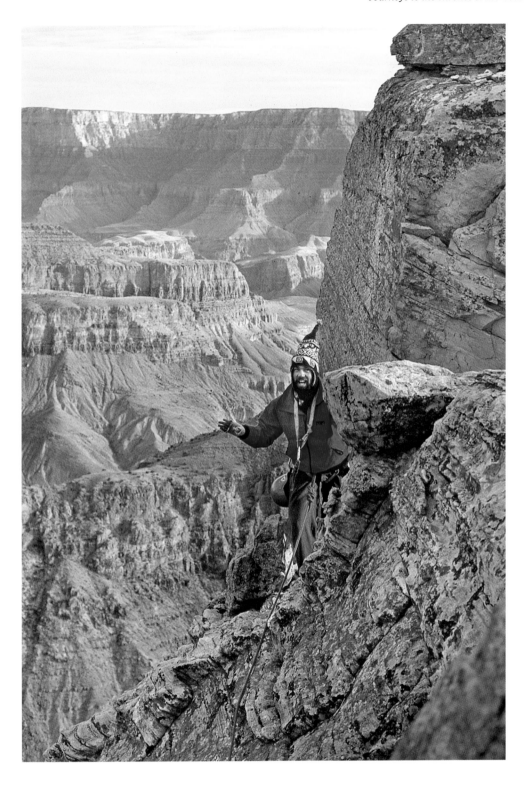

A climber scales one of the twin monoliths of Angels Gate.

A climber approaches the sacred heights of Angels Gate, passageway of Paiute deities.

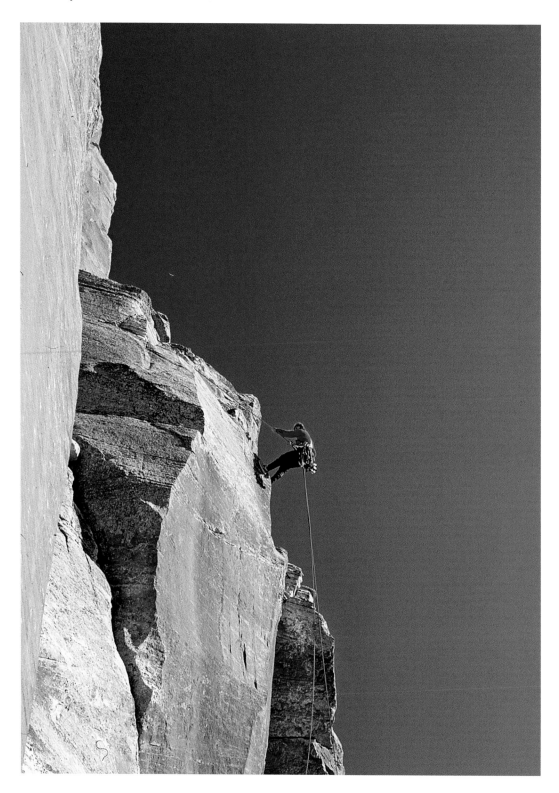

A climber rappels down the sheer walls of Angels Gate into the great abyss.

Far below the sacred summits of the canyon's supernal temples, river runners paddle down the Colorado River through Marble Canyon.

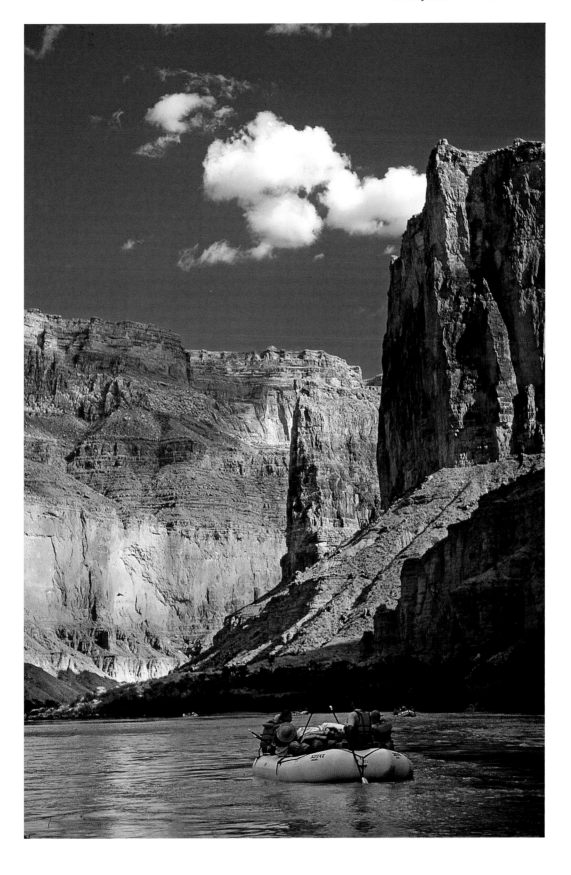

5
EARTH CRACKS

Journeys through the Heart of Stone

The landscape had become one of incredible wildness, of tremendous and desolate majesty. . . . The sullen rock walls towered hundreds of feet aloft, with something about their grim savagery that suggested the terrible and the grotesque.

—Theodore Roosevelt, 1916, A Book-Lover's Holidays in the Open

A canyoneer peers into the Navajo sandstone "earth crack" during his end-to-end adventure through Buckskin Gulch / Paria Canyon to Lees Ferry, Arizona.

I peered into a deep chasm that wound through cliffs thousands of feet above the Paria and the Colorado Rivers. It sluiced through the high plateaus in a primeval land that settlers sometimes thought God had forsaken. Few people knew this territory better than John Doyle Lee. The pioneer cattleman carved out a foothold at Lees Ferry, Arizona Territory, where Spanish and Mexican missionary explorers Francisco Atanasio Domínguez and Silvestre Vélez de Escalante had been imprisoned by imposing cliffs a century earlier. The forlorn outpost later offered refuge to Powell's 1869 Geographic Expedition on August 4, after they'd navigated the wild Colorado River all the way from Green River, Wyoming. "Here, encompassed by distance, silence, and solitude," wrote Lee's chronicler Juanita Brooks, in "one of the loneliest spots on earth," Lee and two of his wives "built a small house, obtained water for irrigation from the Paria River, and began to farm the rich alluvial soil." Here, Lee established the only reliable ford across the Colorado River for hundreds of miles in either direction. And, here, too, I picked up the Mormon fugitive's trail nearly a century and a half later.

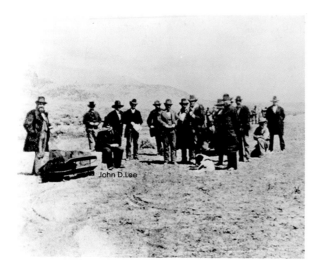

Lee's improbable route through the slick rock canyon started forty miles north of Lees Ferry at a benign-looking sandstone gateway. Tumbling from its headwaters atop the Pink Cliffs in the sylvan forests of southern Utah's 9,300-foot Paunsaugunt Plateau, the Paria River flowed through the landscape "like a badly twisted snake crawling along," territorial journalist Sharlot Hall wrote, adding: "It was as beautiful as it was wild and strange and I doubt if there is a wilder and stranger spot in the Southwest." First trod by moccasin-clad Ancestral Puebloans, Paria Canyon was later known among the Kaibab Paiute as *paria-pah* (deer water) for the abundant game they hunted. I wanted to retrace the route of John D. Lee along the ancient migration corridor through a heart of stone to his lonely way station and ferry at the confluence of the Paria and the Colorado Rivers. In the history of the American West, Lee's journey down Paria Canyon was unprecedented; he drove fifty-seven head of cattle through a narrow, boulder-choked chasm more suited to nimble-footed bighorn sheep. Traveling alone, and at times with others, I planned to put one foot in front of the other to experience firsthand the obstacles Lee endured.

Grand Canyon country's most sublime tributary chasm, Paria Canyon, was said to be the longest, deepest, and narrowest canyon in the world, and it was no place for horses or livestock. The forty-two-mile-long twin gorges of Buckskin Gulch and Paria Canyon stood among the Grand Canyon's four longest and most rugged tributary chasms. The seldom-visited gorges included the Little Colorado River Gorge, Kanab Creek Canyon, and Cataract and Havasupai Canyons. I was keen to journey through each of them, following in the footsteps of Spanish missionaries, Hopi salt pilgrims, gold rush prospectors, river explorers, pioneer photographers, and Paiute shamans. Taken alone, Paria Canyon would not be easy to traverse, but John D. Lee had it worse. The US Indian agent

John D. Lee sitting next to his coffin just before his execution at Mountain Meadows, Utah. *Photograph by Powell Expedition photographer James Fennemore, March 23, 1877. Courtesy of Josiah F. Gibbs,* The Mountain Meadows Massacre, *Salt Lake City:* Salt Lake Tribune, *1910 / Wiki.*

was ordered by the Mormon church to establish Lees Ferry as penitence for his alleged role in the Mountain Meadows Massacre. Between September 7 and 11, 1857, the Utah Territorial Militia, along with Paiute allies, had reportedly killed 122 Arkansas immigrants traveling in a California-bound wagon train on the Old Spanish Trail. Before Lee was tried, convicted, and executed by a firing squad while he sat atop his coffin, he decided to drive a herd of bawling cattle straight down Paria Canyon to Lees Ferry.

It was a pleasant morning in late spring when I entered Paria Canyon. From the phantom settlements of Ancestral Puebloans who built three-room limestone pueblos in the weathered rocks, I ran down the creek bed, splashing through trickling water. I glided past a gallery of stone windows that stretched along the foot of the wall. Nature had been at work over the millennia sculpting these beguiling alcoves in pink sandstone, hollowed out by water and howling winds. I stopped and climbed into one of the sandstone cocoons. It enshrouded my body like a solar pod, one in a dozen or more that pocked the canyon walls beyond. I huddled inside for a moment, relishing the sensation of sitting in the little chamber, then sprung out like a canyon tree frog and resumed my journey. In the distance, a dislocated sandstone buttress called Slide Rock Arch beckoned me. I ran though the iris of stone and stopped at a shimmering pool of water at the confluence of Buckskin Gulch.

During an early exploration of the Colorado Plateau's slick rock canyons that geologists described as "incised meanders," a companion and I had journeyed down the length of Buckskin Gulch to the confluence of the Paria River, where I now stood gazing up at a cathedral of water, stone, and light. The entrance to the slot canyon began a dozen miles upstream with a sand slog that narrowed to a body-width, skin-sanding squeeze between perpendicular walls that blocked out the sun. Carrying our packs overhead safari-style, we had tiptoed through the narrows, shrouded in dust kicked up by our footfalls in the powdery sand. We threaded the dark, mysterious earth crack—more like spelunking than hiking—until we emerged into the open with a turquoise-blue sky overhead. The passage had given way to petroglyphs depicting bighorn sheep. During

ancient floodwaters, the bighorn sheep symbols marked the only lifesaving route up the canyon wall to the safety of the rim rock above. When archaeologist Neil M. Judd explored Buckskin Gulch during the 1920s, he described the petroglyphs that conceivably dated back to Archaic peoples in 1,500 BCE.

Buckskin Gulch proved an effective barrier in ancient times and forced primitive man to make his way around it. As he passed its less formidable head he pecked a series of pictographs on a red cliff; below [Buckskin Gulch's] mouth he pounded out holes for toes and fingers as he marked several pathways across Paria Canyon.

On our trek, the view from above the precipitous route had revealed the piñon- and juniper-studded West Clark Bench that rimmed Buckskin Gulch and exposed what at first glance looked like a tomb-dark stone crevasse. Boatman and historian P. T. Reilly described what had earlier been called Kaibab Gulch: "The deeply incised Buckskin Gulch joins Paria Canyon close to the Utah-Arizona state line to form an intaglio in sandstone impossible to cross for man or beast."

Climbing down the ancient "bighorn sheep trail" the next morning, we were halted by boulders wedged between canyon walls that loomed higher and higher the farther we descended and the closer we approached the Paria River confluence. During violent flash floods, these stones served as natural strainers for timbers, broken tree limbs, and brush. We slithered like earthworms through the cold mud beneath a crawl space, dragging our packs behind us, then climbed up and down a hastily hacked set of "Moqui steps" to surmount the last sandstone barricade. Prying and scraping the sticky mud off our shoes with wooden sticks, we strolled into the confluence's cathedral of light, held rapt by the warm, ambient glow refracting off terra-cotta walls.

Now I resumed my wild run down Paria Canyon and faced an altogether different journey. I was alone, carrying my camera and meager rations in a small pack. And I had miles to go before I slept. Traversing the narrows below the confluence, I could only imagine how John D. Lee ramrodded a herd of cattle through the quicksand-flooded riverbed in the middle of winter. From his diary, *A Mormon Chronicle: The Diaries of John D. Lee*, I learned that Lee had the help of his son and two brethren:

Sund., Dec. 3rd, 1871. " Bro. Jno. Mangram & Thos. Adair who proferred to help Me with My Stock to the Mouth of the Pahreah. This was certainly an act of kindness on the Part of these Brethren. We concluded to drive down the creek, which took us Some 8 days of toil, fatuige, & labour, through brush, water, ice, & quicksand & some time passing through narrow chasms with perpendicular Bluffs on both sides, some 3000 feet high, & without seeing the sun for 48 hours, & every day Some of our animals Mired down & had to shoot one cow & leve her there, that we could not get out, & I My Self was under water. Mud & Ice every day. We finally reachd within 3 ms. of the mouth [of Paria Canyon] with 12 head, leveing the remander to feed some 10 ms. above. 4 days had Elapsed since our provisions had exasted, Save Some beef that we cut off the cow that was Mired.

About where Lee's party nearly perished, I stopped to strain, purify, and refill my water jugs. Early settlers drank straight from silt-laden Paria River and frequently suffered from dysentery and typhoid as a result. I stood up and headed downstream toward Judd Hollow, running free as a bird, until I heard the telltale buzzing of a rattlesnake. I leapt aside to avoid it. My pace quickened, and I pushed on, bounding from one side of the little creek to the other as it streamed beneath canyon walls marked with a bathtub ring from a historic flash flood that, in 1958, peaked at Colorado River water levels of 19,000 cubic feet per second.

As the cinammon-colored ramparts peeled farther back, I gazed at the rim of the Paria Plateau. The soaring island of stone stood more than three thousand feet above the Paria River, encompassed nearly 450 square miles, and bore the names of Sand Hills, Sand Valley, and Sand Cove. It was desolate country no matter what you called it. Through the ages, the sand-dune-covered rock desert offered a seasonal, but marginal, haven for Archaic peoples, Ancestral Puebloans, Paiute, and Navajo. They subsisted on hidden rim rock springs like Sand Hill Crack and rainwater and snowmelt that collected in wide stone catchments called water pockets. They gathered agave hearts, piñon nuts, juniper berries, and all manner of plants and seeds. And they hunted game that included desert bighorn sheep, mule deer, porcupine, rabbits, lizards, and occasionally mountain lions at the top of the food chain. Their native sandstone dwellings and *kivas*, and later *hogans* and sweat lodges, generally faced east toward the rising sun, the Colorado River, Glen Canyon, Echo Peaks, and the Paria River. These storied landmarks were also the roosts of golden eagles and falcons that hunted and soared on canyon thermals that spiraled thousands of feet up the sheer faces of the Vermilion Cliffs. The kivas and hogans led explorers to believe that the seventeen families who once inhabited the Paria Plateau sought powers from their sacred spirits, holy people, and the cosmos to survive where strangers perished.

Along with their ancient route out of Buckskin Gulch, Native peoples had used precarious rim-to-river routes marked by petroglyph panels of shamans, bighorn sheep, water trails, and anthropomorphs when they utilized the Paria River for farming corn, beans, and squash—or when they traveled end to end through the depths of Paria Canyon. Taking a cue from their dangerous staircases, cattleman Johnny Adams had a "pipe dream" in 1937 to pump water from the Paria River up the Vermilion Cliffs to the Paria Plateau

to sustain his thirsty herd. Too often, they withered and died in the arid reaches of Poverty Flats, which was littered with their sun-bleached bones and leather carcasses. Adams's packhorses toiled for months lowering a heavy pump and sections of two-inch pipe over the edge of the rim rock and down nearly insurmountable cliffs and fissures ancient peoples had scaled on foot. Compounded by sudden torrential rains, the plateau's water pockets overflowed and finally doused Adams's pipe dream for good.

By evening, fatigue and thirst caught up with me miles downstream from Judd Hollow. I stopped for the night, built a small campfire from twigs and driftwood, and rolled out my thin Indian blanket in the sand. I lay down at the foot of a cliff that radiated the afternoon heat throughout the cool night, too tired to study the starry skies. I was up and gone at first light the next morning, jogging downstream half asleep past a side canyon that led to the flying sandstone truss of Wrather Arch. It was a natural cave arch that measured 165 feet high and 250 feet wide and was named for US Geological Survey director William Embry Wrather. I whisked past the steep sand and rock spit (Cuesta de las Ánimas) that weary Domínguez and Escalante first trudged up in 1776 and kept running until I reached the cottonwood-tree-shaded oasis of Lee's rustic Lonely Dell Ranch.

The pioneer cattleman, his son, and brethren had endured eight days of canyoneering cattle down the icy depths of the Paria, demonstrating grit, a pioneer's faith, and an iron will to prevail.

Weeks after I emerged from Paria Canyon, I started considering the possibility of retracing the Hopi Salt Trail down the Little Colorado River Gorge to its confluence with the Colorado River. But the weather wouldn't be optimum for another year. That's when a friend, a Grand Canyon National Park kayak ranger, dropped me off in the Painted Desert at the Cameron Bridge. It spanned the Little Colorado River. During a "sheep jam" in

The author stops for a rest at Lees Ferry, weary from his first day and night run down the length of Paria Canyon in the footsteps of cattleman John D. Lee.

1937, the hybrid truss bridge nearly collapsed when flocks of sheep overloaded the vital link the Navajo called *Na'ní'á Hayázhí* (little span across). The Cameron Bridge was located at a historic crossroads. The Cameron Trading Post once bartered with the Navajo and Hopi for sheep, handwoven blankets, kachina dolls, and turquoise-and-silver jewelry they brought by wagon and horseback from all points beyond. Nearby was Tanner Crossing, which proffered the good word and provisions for Mormon immigrants traveling the "Honeymoon Trail" from St. George, Utah, on the far side of Lees Ferry to distant Mesa, Arizona, to the south.

Shouldering my pack, I listened to my friend's warnings about "hair boating" kayakers (those who specialize in extreme whitewater) she knew who nearly drowned paddling the length of the Little Colorado River Gorge. I said goodbye and walked down the streambed toward Blue Springs, wondering if the hourglasses of drinking water I carried would run dry before I reached it. I followed the course of a tempestuous seasonal river borne from the sacred heights of 11,403-foot Mt. Baldy in eastern Arizona's White Mountains, 350 river miles upstream. Traditional Western Apache revered them as *Dzil Ligai*, white mountains. Summer monsoon rain and spring snowmelt ran down the mountains and across the Painted Desert and roared through the gorge the Navajo knew as *Tólchí'-íkooh*, Red Water Canyon, through a chasm that Hopi pilgrims called *Öngtupqa*, Salt Canyon.

I had some concerns as I walked toward the point where I could no longer backtrack or climb out of the canyon. Swept by deadly flash floods that killed livestock, wildlife, and canyoneers, the gorge was fifty-seven miles long and ended at the confluence of the Colorado River. I'd waited for a blue-sky forecast all the way up to Mt. Baldy and started my journey during the glaring heat of May as insurance that I wouldn't be unexpectedly swept away. Furthermore, there was no reliable drinking water en route. The only perennial water source was the unpalatable, heavily mineralized Blue Springs more than forty miles downstream. So I packed three gallons of water, nearly convinced I'd find ephemeral pools en route that would get me safely through the gorge.

The farther I descended, escape became an increasingly questionable option. There were no established trails in or out of the deep gorge and only one known route. There were few places to escape to in the sprawling high desert of Bodaway Gap, except for a Navajo home or hogan—if I could locate one. And if I did manage to traverse the gorge all the way to the confluence of the Colorado River in the Grand Canyon, I was still faced with a grueling journey out of the inner canyon to reach the South Rim at Desert View. The odds were stacked against me, but I was lured by my quest to photograph the gorge's stark beauty and experience some of Hopi cultural history. They'd made long journeys from their Second Mesa pueblos on foot to their salt mine, *Öönga*, in the Grand Canyon. The Little Colorado River Gorge was a place of pilgrimage, and I wanted to travel in their footsteps.

I marched on, beyond the din of summer vacation travelers who were speeding north on Highway 89A to Lees Ferry and the cool alpine forests of the Kaibab Plateau. I stopped at the mouth of Tappan Spring Canyon. It was choked with tamarisk trees, the scourge of western waterways. Pictographs painted with natural dyes at Tappan Springs indicated the basalt rock tank was an important water stop for Ancestral Puebloans traveling in and out of the gorge via the cross-canyon Moenkopi Wash. Later, during the 1880s, Arizona Cattle Company cowboys used Tappan Springs to graze their hungry herd on the A-One-Bar's winter range under the eyes of prowling cattle rustlers.

The early-afternoon heat was oppressive and the scenery tedious as I walked through a corridor of tamarisk trees that sucked the groundwater out from beneath the streambed. In contrast to Paria Canyon, which began in spectacular narrows, the Little Colorado River Gorge was broad, flat, and unassuming at the outset. That would change soon enough, I told myself. I stopped to rest in the shade at the mouth of Hopi Trail Canyon. It was a quiet place to contemplate the scale of the Hopi's sacred lands called *Hopitutskwa*, "Hopi land, ground, earth." They traveled on foot across the desert and mesas for many generations and left what they described as *itaakuku*, "our footprints," that marked their spiritual territory. The traditional Hopi route into the deep end of the Little Colorado River Gorge was via Salt Trail Canyon forty-five miles downstream. Other Hopi clans were known to have

crossed the gorge here to connect with the Hopi-Havasupai trade route they used to travel west across the Coconino Plateau to Havasupai. The *Tutuveni* (writing) shrine, where the Hopi prayed and etched their clan symbols on the sacred rocks, was less than twenty miles north of here. Conceivably, the Hopi, or their ancestors, may very well have also traveled the length of the gorge to pay homage at their great underground kiva of Sipapu before collecting sacred salt from the perilous cliffs overlooking the Colorado River at Öönga.

Rested and rehydrated, I got up and walked down the adobe mud–caked riverbed. I followed the path of least resistance, slogging through sun-scorched sand and mud spiderwebbed with deep cracks. I bent over, poked my fingers into a wide crack, and pried off a platter of hardened two-inch-thick mud. I winged it, watched it sail through the air faster than I could carry my load, and kept hiking downstream.

The corridor wound slowly into the earth, and the walls rose above me as the gorge began to earn its name. I'd entered the Coconino Narrows. My map showed me it was a thousand feet deep. It looked about thirty feet wide, and it offered a breezy respite from the Painted Desert's furnace heat. The deep crevice brought to mind Buckskin Gulch and Paria Narrows. Overhead, the Coconino sandstone walls were perforated with test holes reportedly drilled by Bureau of Reclamation engineers for a possible dam site. A rickety footbridge high above the boreholes no doubt taunted a party of early canyoneers who got bogged down in hip-deep mud. It took them nearly an hour to extricate themselves, and they nicknamed the captivating stretch Quicksand Alley.

But the narrows were bone dry, and I enjoyed the canyon passage through the Marble Platform as it made a dogleg turn southwest. Craning my neck, I could see the scenic vista overlook on the Southern Rim high above, exposing soaring cliffs of the Grand Canyon's signature layers of Kaibab limestone, Toroweap formation, and Coconino sandstone. The canyon cooled when I reached a US Bureau of Reclamation gauge station bolted to the side of a cliff. As I'd half anticipated, I discovered ephemeral pools of brackish water on the downstream side of streambed boulders to strain, treat, and replenish my precious drinking water. I hiked another two hours until I reached Dead Indian

Canyon. The sun began to set, shadows climbed the walls, and I rolled out the cotton sheet I was using for a hot-weather sleeping bag and mosquito screen. I built a small fire, heated a can of chili, and listened to the coyotes howl and bark in the distance. Life was good—so far. If a fickle microburst of thundering rain struck the Little Colorado River anywhere between my camp and Mt. Baldy, it'd be too late for me to scurry back upstream to climb the rusty gauge station ladder, stand high in the metal stirrups, and ride out the midnight flood. I'd almost reached the point of no return.

The Little Colorado River Gorge had enticed many to tempt fate and folly over the years. A tightrope walker crossed the gorge, billed as the "Grand Canyon," during a high-wire act. A BASE jumper backflipped off a pedestal of rock and wing-suited into the gorge unscathed. A German hiker disappeared near a rim-top petroglyph panel and vanished without a trace. An experienced canyoneer/photographer drowned with his companion in a flash flood that ambushed them from above. And years earlier, on April 21, 1934, a Flagstaff, Arizona, man fell ninety feet off a cliff into Dead Indian Canyon. He lay half dead at the base of a "1200 foot cliff" for days, until rescuers, led "by an Indian scout from Cameron . . . [who] had considerable experience in the deep ravines of the Grand Canyon," could hoist him out of the gorge. The victim and his companion "were trying to follow an old Indian trail in belief it might be the legendary salt trail used by [Hopi] Indians."

That's where I was headed: thirty-two miles down the Little Colorado River Gorge the Hopi called *Paayu* (little water) to reach Salt Trail Canyon. It was, as a horseback Hopi elder told me outside Oraibi when I started my journey along the Hopi-Havasupai trade route, "a looong way."

At first light the next morning, hoping to beat the canyon heat, I hurried down the streambed like a man being hunted. Take your pick: too-much water, too-little water, or "little water." I was passing the point of no return, and no one could get me out of here—if they could find me—if I made a mistake. I kept cranking out the miles in the cool morning hours in order to reach the shaded gateway of Hellhole Bend. During the 1800s, prospectors, pioneers, and government surveyors ascribed many geographical features with their own names and

mumbled curses, many of them earthy and colorful. Hellhole Bend was one of many such names officially recognized by the US Board on Geographic Names that appeared on US Geological Survey Maps. It was a fitting description of the house-sized boulders that choked the serpentine narrows, hairpin turns, and entrenched meanders. The obstacle course demanded moment-to-moment concentration until I got beyond Hellhole Bend and dropped from fatigue in a shaded niche. I napped in the dirt, got up, guzzled a quart of water, and pushed on into what felt like a mirage. I trekked past primitive, rarely heard-of canyons and long-forgotten trails. The records that I could find indicated they were used by ancient peoples, San Juan Paiute, cowboys, Navajo pack horses, sheep, and goats, and canyoneers who were hell-bent on wandering off the grid to see what they could see from Lee Canyon, Moody Trail, Indian Maiden Trail, Cedar Canyon, and the Paiute Trail.

I stopped at sunset, about a mile short of Waterhole Canyon, and bedded down beneath a lone cottonwood tree. It was flush with broad green leaves, and it surprised me at first glance. It was growing out of a dry streambed of sand, gravel, and river cobbles. Its long roots reached deep beneath the drip line into a groundwater aquifer. The cottonwood tree was sacred to the Hopi. Its malleable roots were used to carve prayer sticks called *paahos,* as well as *katsinas*, spirit beings, that are brought to life in the form of kachina figures. I hoped the tree that sheltered me was an auspicious sign for my journey ahead. I tucked a piece of cheese into a sourdough biscuit, took a few bites, and fell asleep on the bare earth. I woke from a dream, gazed at the dark skies pierced with flickering pinpricks of light, and nodded off again.

My research told me that a young man had walked across the drought-stricken red desert from his ancient home of Old Oraibi (*Orayvi*). He was led by his father and another traditional elder known as the War Chief. They had embarked on a long and dangerous journey of *Öngmokto* (to go on a salt expedition). Placing a prayer feather in the sand sprinkled with corn meal (a "breath line" extending in the direction they were to take), they followed the salt trail from Moenkopi to the sacred clan rocks across the Painted Desert to Salt Trail Canyon. The young man was an initiate. As his leather moccasins padded through the sand and

cactus across Hopitutskwa, he could see the distant snow-covered heights of the San Francisco Peaks, *Nuvatukya'ovi* (place of snow on the very top). For many generations, the Hopi had also followed ancient trails from their traditional villages of Oraibi and Shungopovi to the summit of the peaks to offer eagle-feathered *paahos* to the *katsinas* (spirit beings) for rain.

The salt pilgrims and their burros stopped at *Tutuventiwngwu* (place of the clan rocks) near Willow Springs. There, the War Chief carved a coyote head that represented his Coyote Clan and his eleventh salt journey. The father etched a sand dune, and his son was instructed to carve his Sun shield symbol. His name was Don C. Talayesva, and he was twenty-two years old. Raised as a traditionalist, and later boarding-schooled by "whites," he was being brought back into the fold to eventually become a Hopi sun chief. In his autobiography, *Sun Chief,* Talayesva described his pilgrimage and the life-changing moments he'd experienced:

"I selected a smooth surface nearby and carved my Sun symbol." It was one of 5,000 recorded symbols that generations of Hopi salt pilgrims had stopped to carve at Tutuventiwngwu during their ritual ninety-mile journeys to collect salt in the Grand Canyon. Talayesva continued: "When I had finished, I placed the breath line of a prayer feather at the mouth of my Sun symbol, pounded it with a stone until it stuck, sprinkled corn meal upon the face of the symbol, and prayed."

The young pilgrim would need protection. When the weary party reached the head of Salt Trail Canyon, they offered prayer feathers and cornmeal to the War Twins that embodied two Coconino sandstone spires. From this gateway, they could see the rugged route zigzag down through crags, boulders, and ledges into the Little Colorado River Gorge.

Talayesva described the scene he viewed that day during their late-summer journey in 1912: "I looked into the canyon, which seemed miles deep, and saw the Little Colorado River shining from the bottom. I was frightened and wondered if I would ever return safely."

As they scrambled down *Homvi'kya*, or Salt Pilgrimage Trail, into the hallowed depths of the gorge, they stopped to pray and offer cornmeal at the shrines of their ancestors. Talayesva saw the symbols of other Hopi clans who had also made the long pilgrimage. On boulders and slabs of stone were symbols of the Butterfly Clan (*Poovolngyam*), Red Ant Clan (*Anu*), Lizard Clan (*Kuukutsngyam*), and Eagle Clan (*Kwaangyam*). This was hallowed ground. Traditional Navajo called the same canyon Bekihatso, after its namesake lake, *Be'ek'id Di'ní* ("groaning lake"), which was within hearing distance of the Navajo water monster *Tééhoołtsódii*, who was said to periodically make the rumbling sounds.

I felt like a baying hound when I'd bolted from my camp at Waterhole Canyon the morning of my third day out. By the time I reached the foot of Salt Trail Canyon on the fourth day, I was haggard. Starting with Hellhole Bend, I'd faced a series of obstacles that often slowed my brisk pace to a near crawl through sand, gravel, and house-sized boulders until I reached Blue Springs. Bubbling and trickling from a spring line in the Redwall limestone, it flowed into aquamarine travertine pools and was a sight to behold. Down to my last quart of drinking water, I strained water from the pools and topped off my three gallons of water. The water was reportedly safe to drink, but it was highly mineralized with bicarbonate, calcium, chloride, and sodium. Once sought out by the Navajo for ceremonial use, the sacred waters of *Tó dootł'izh*, named for the color turquoise, were an acquired taste—if you could hold them down. I had to. The silt-laden waters of the Colorado River that would finally quench my thirst were still a day away. In his travels across the Colorado Plateau, Major John Wesley Powell used to boil bad drinking water with coffee grounds. But there was no time to brew coffee in the stifling midday heat, and the electrolyte powder I tried would not turn the beautiful turquoise waters into anything approaching an elixir.

With practice, I managed to hold it down, sometimes gagging, as I negotiated a series of beautiful travertine ledges, dams, and pour-overs. In the growing heat, they became debilitating hurdles that I was forced to cross or wade around in hip-deep blue water. At the mouth of Salt Trail Canyon, I finally picked up the trail of the Hopi salt pilgrims.

"We followed down the stream and reached the place of blue salt," Talayesva wrote, and added, "There we deposited prayer feathers." I followed the salt pilgrims trail down toward *Sípàapuni*, "hatchway where the Hopi emerged to the Fourth world." Out of deference to their spiritual beliefs, I didn't go near it, photograph it, or even look in the kiva's direction. I knew where it was going to be, and saw the faint shape only peripherally. I remembered Talayesva's admonition: "Some . . . profane fellows had desecrated the sacred spot where our ancestors—and theirs—emerged from the underworld."

Here the Sun Chief initiate wrote "Each of us placed prayer feathers by the entrance to the underworld and prayed silently to the Cloud People to accept our offerings and send rain."

Their journey was not over, nor was mine. At the confluence of the Colorado and the Little Colorado Rivers they drank "from the sacred river," then climbed up to the salt mine. It was dangerous using a frayed old rope to climb over crumbly sandstone ledges to reach the salt at Öönga, and Talayesva wrote:

Trembling, he [the War Chief] fastened the prayer feather to the chest of the image with a piece of [cornmeal] dough, and prayed: "Great War god, please hold me securely as I descend." Once they'd each filled their bags with precious salt, they turned toward home.

From the confluence they retraced their footsteps along the Homvi'kya trail through the Öngtupqa gorge, and across the sunburned Painted Desert all the way back to Moenkopi and Old Oraibi. When they finally

approached home ninety miles distant from
the hallowed salt mine, one of the elders
spoke: "Now we happily enter the houses of
our fathers and mothers. Let us go!"

Stopping at the confluence, I strained, filled, and waited for the muddy Colorado River water to settle in one of my water jugs before I poured the clear water into another jug. I repeated the process until I had two full jugs. I hoisted one to my cracked lips and slowly sipped the cool water that soothed my parched throat. After days of subsisting on warm, brackish, salt-laden water, the first kiss of sweet water was an epiphany. Then I took a deep drink of the sacred river water. It rejuvenated my body and spirit like a sunbeam. Shouldering my load, I marveled at the turquoise waters of the Little Colorado River merging with the brown waters of the Colorado River, which the Hopi called *Pisisvayu*, river of echoing sounds. This pulsing heartbeat of the Grand Canyon was also sacred to the Navajo, who prayed to Salt Woman here at the confluence of *Tooh Ahidiilíníand.*

Thus set, I followed a trail out of the gorge that was named for 1890s-era prospector Ben Beamer. He hacked out a narrow, precipitous trail to reach his diggings at the confluence where he lived, farmed, and fished alone without seeing another soul for an entire year. One misstep on Beamer's trail would send me plummeting hundreds of feet onto the cliffs and rocks along the river. But the journey had acclimatized me to the extremes, and I savored the hot headwinds that seared my face and buffeted me back and forth as I scurried across the trail, elated that I was free from the endless chasms of the Little Colorado River Gorge.

Decades earlier, a Navajo *ha'athali* (singer) had a vision to make a pilgrimage to pay homage to *Áshijh Asdáá*, Salt Woman, at the confluence of the Colorado and the Little Colorado Rivers. Upon his return across the precipice of the Beamer Trail that

Navajo pilgrims called *Tsétát'ah ha'atiin*, Trap Trail, the seventy-two-year-old medicine man succumbed to the merciless June heat before he could climb back up *Áshiih ha'atiin* (salt trail out of canyon). I followed the same path, now called the Tanner Trail, climbing the vertical mile he'd descended alone and far from home through a band of daunting cliffs to Desert View, where I ended my unforgettable quest. My journey had enlightened me. I was grateful for any forces that had guided me and kept me safe. And I counted myself as lucky to have explored a canyon long revered by ancient peoples but now largely forgotten by the modern world.

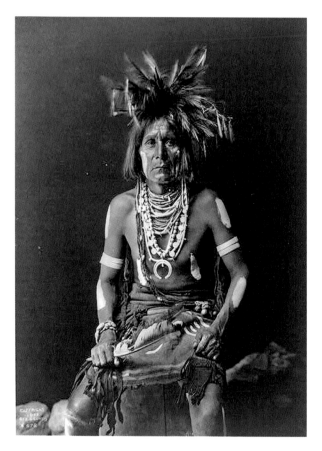

"Snake Priest." *Photographic print by Edward S. Curtis, 1900. Courtesy of Library of Congress.*

Peering at blue skies pinched between narrow rims, a canyoneer remains wary of flash flood dangers that fickle weather can generate from a hundred miles away.

Seen from the rim overhead, a canyoneer heads downstream
through Buckskin Gulch to reach the confluence of Paria Canyon
and eventually Lees Ferry forty-two miles from where he started.

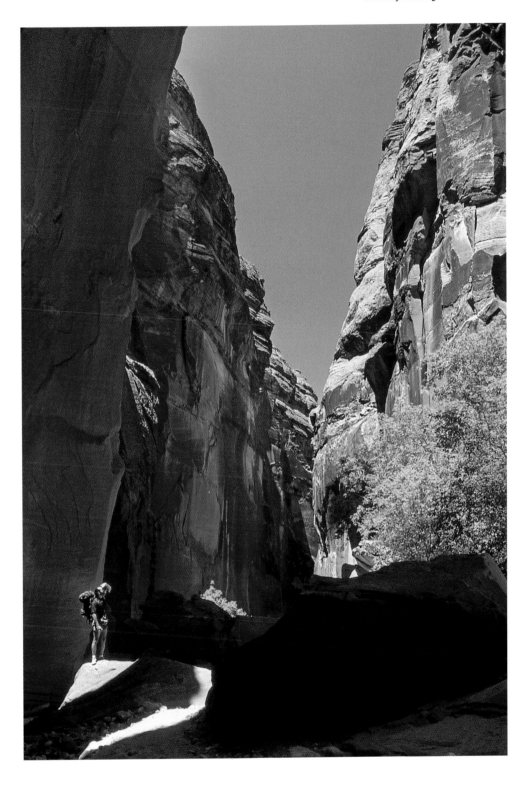

As early as 1500 BCE, Archaic peoples used the route
overhead to climb out of the flash flood–swept narrows.

Entering a fissure of water, stone, and light, a canyoneer threads the passage of Buckskin Gulch that geologists first described as an "incised meander."

Confident the weather will hold, a canyoneer jumps down Buckskin Gulch's cathedral of stone and light.

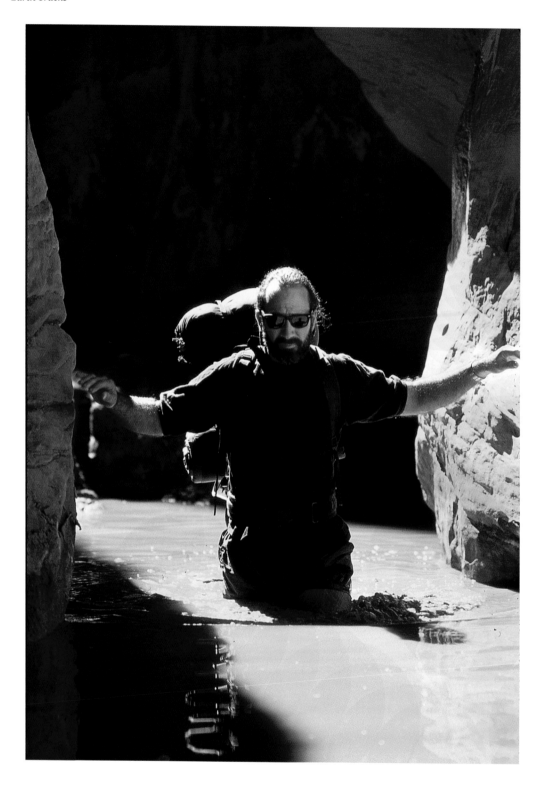

A canyoneer wades through a *charco* (muddy water) called the
"cesspool," described as quicksand in old western movies.

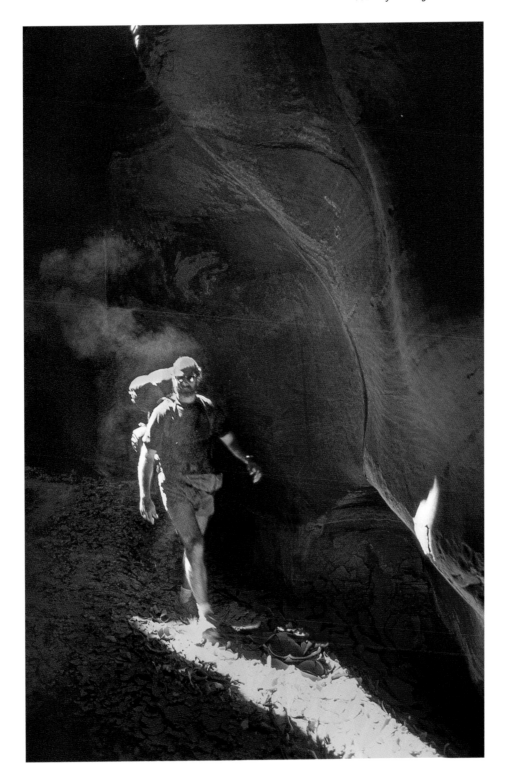

Covered with a dervish of dust, a canyoneer explores the
mysteries beyond the incised meander that territorial journalist
Sharlot Hall wrote winds through the earth "like a badly twisted
snake crawling along."

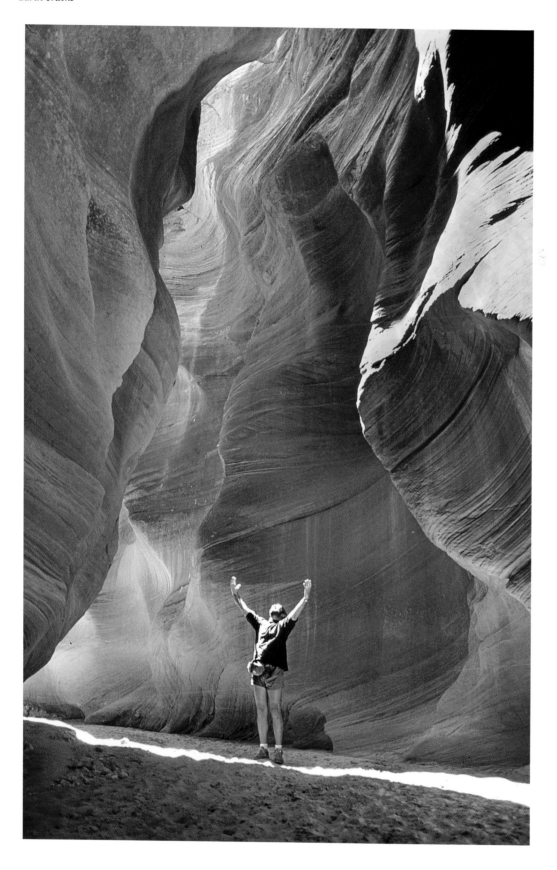

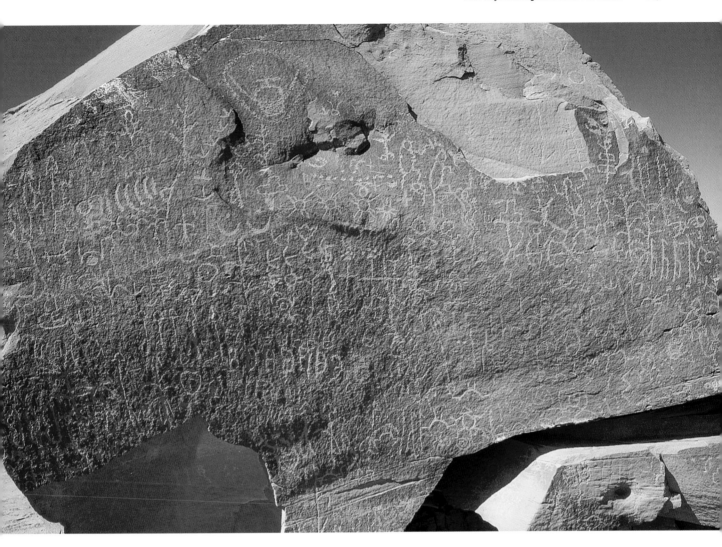

A canyoneer heralds the warm glow of refracted light near the confluence of Buckskin Gulch and Paria Canyon.

During his sacred pilgrimage to collect salt in the Grand Canyon, Hopi Sun Chief initiate Don C. Talayesva stopped here at *Tutuventiwngwu* (Place of the Clan Rocks) to pray and inscribe his Sun Clan symbol before heading down the fearful chasm of the Little Colorado River Gorge.

Following: Floating stone, Salt Trail Canyon, Little Colorado River Gorge. The Hopi followed the *Homvi'kya* (Salt Pilgrimage Trail) down the rugged tributary canyon to reach their sacred salt mine, *Öönga,* in the Grand Canyon.

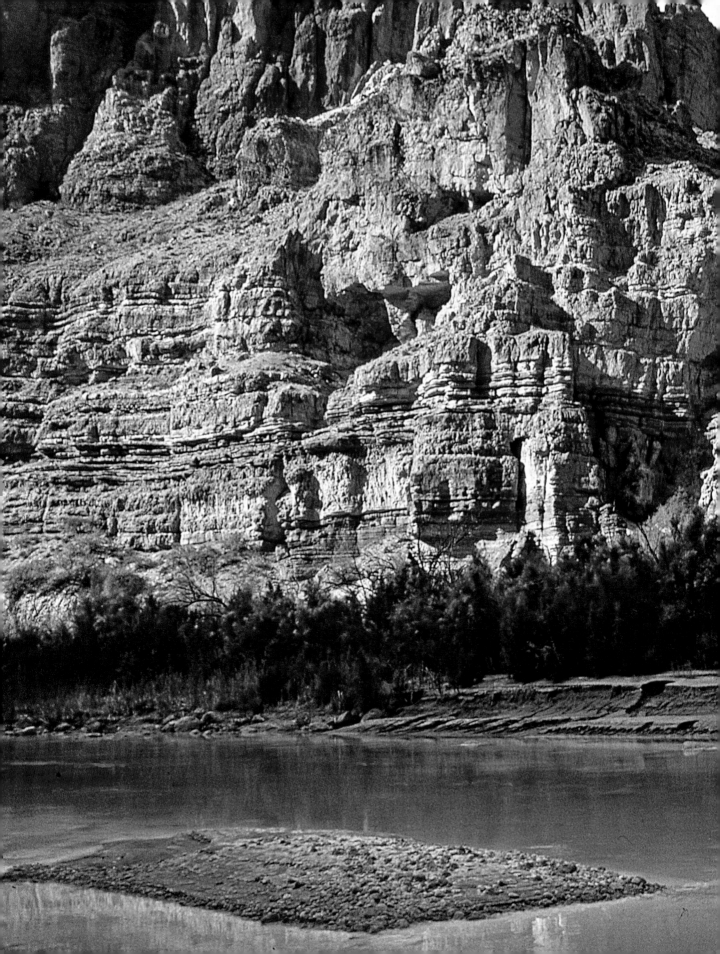

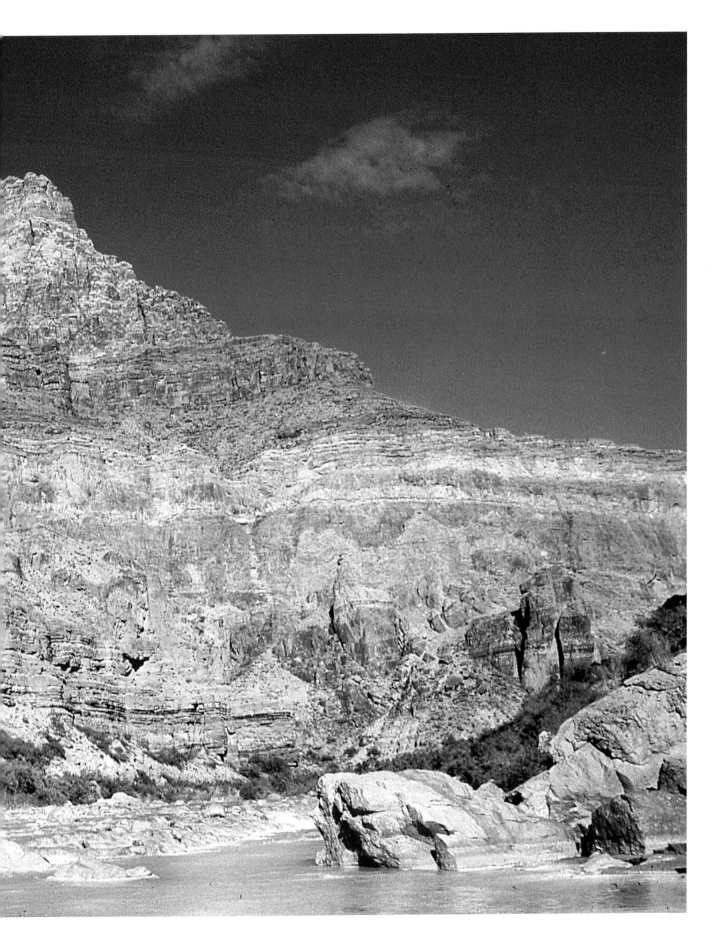

6

VISIONS, DREAMS, AND TALL TALES

Journeys to the Lost Worlds and Those That Never Were

I am sitting in the doorway of a house of the Stone Age . . . with a roofless city of the dead lying in the valley below and the eagles circling with lonely cries along the yawning caverns of the cliff face above.

—Agnes C. Laut, 1913, *Through Our Unknown Southwest*

The rugged rim rocks of the Kaibab Plateau's North Rim burn yellow in the morning sun.

Four Corners is a largely unknown region of crimson deserts, soaring mesas, and sinuous canyons. The bumpy dirt ruts I was driving led me deeper into an ancient landscape roamed by Puebloan peoples who had shunned the tide of conquistadors, traders, explorers, and surveyors rolling west in the quest of Manifest Destiny. The Puebloan's moccasin-trod paths led to hidden springs and seeps that supported their triumvirate of maize, beans, and squash and sustained them along with piñon nuts, deer meat, rabbits, squirrels, and bighorn sheep. Hidden beyond the reach of pioneer and immigrant trails stood their mysterious homes made of stone; they were lost in the frenetic pace of a civilization that was staking homesteads and mining claims, scratching out tillable lands, building wooden hovels, and fencing off wild grasslands for livestock. What early writers sometimes viewed as "eagle nests" clinging to the sheer faces of canyon walls were actually cliff dwellings, kivas, storage granaries, and lookouts built from hand-cut sandstone. Often they were plastered with adobe mud, and latilla ceilings were woven with wattle and daub.

What drew me deeper into the back of beyond north of Utah's San Juan River were exotic masonry towers built on canyon rims, nestled in alcoves, perched on fallen boulders, and camouflaged in the walls of deep ravines. To some early observers, these prehistoric towers resembled the fortified medieval turrets of Europe.

At road's end, I walked along the rim rock of Little Ruin Canyon, a remote *cañoncito* hidden in the high desert of the Great Sage Plain. The Ute called it *Hovenweep*—deserted valley. I traced the trail of pioneer photographer William Henry Jackson, following his forgotten footsteps in the golden afternoon light that graced the reclining vestal form of Sleeping Ute Mountain. I searched for vistas among sandstone potholes, piñon, and juniper that he photographed during Hayden's US Geological and Geographical Surveys of the American West in 1874.

More than a hundred towers overlooked the sea of Painted Desert that stretched taut across the four corners of Utah, Colorado, New Mexico, and Arizona. The crenellated masonry monument I examined once drew the attention of Jackson's large-format camera. He noted the photo he took

of it for his collection of glass plate negatives as "169 Ruined Fortress on the Hovenweep." I set up my tripod on the lip of the canyon rim above Jackson's creek bed perch, framed the image, and waited for sunset to paint the crumbling tower with roseate hues.

These prehistoric towers were inexplicably built during the same epoch as the European Crusades, between 1200 and 1300 CE, and were studied by American archaeologist Jesse Walter Fewkes in 1917–18. Some archaeologists speculated that the peep-holed towers were used as astronomical observatories for the Puebloan dagger-shadowed solar calendars that marked the equinoxes and solstices in order to time the planting and harvesting of corn. Others determined that they were ceremonial centers that reenacted the Puebloan spiritual journey from the underworld of *sipapu*, Place of Emergence (kiva), to *Túwaqachi*, World Complete (current Fourth World) of the earth and sky. Still others concluded that the towers were used as storage silos for maize and beans as a hedge against famine, as defense strongholds during the upheaval and resettlement of the San Juan River area by indigenous refugees who fled the collapse of the Chaco civilization, or as elevated lookouts for signaling between distant towers with fire, smoke, and blue skystone mirrors.

One person stood out among those who visited Hovenweep Castle after the lonely tract was proclaimed a national monument in 1923: Mary Elizabeth Jane Colter, an architect and visionary influenced by the Pueblo people. When she visited Little Ruin Canyon in 1931, she took copious notes and sketched detailed drawings of the "great houses" of Hovenweep Castle and its nearby Twin Towers, which had been plastered with human footprints. Clad in her dashing wide-brimmed hat, wire-rim glasses, beige safari jacket, and poplin bush pants tucked into knee-length jodhpur boots, Colter wrote:

Hovenweep is above everywhere else—"the

playground of the Towers." So literally are

they the "whole show" that one cannot but

believe that here the TOWER form of building originated and was only adopted by the builders of other localities. There are towers of every description here . . . There are small towers and large towers; square towers and round towers; oval towers and D-shaped towers. They play "hide and seek" among boulders in the arroyos; chase each other up the rugged sides of cliffs; hang to the very brink of the canyon walls; and scramble to the slanting crowns of monolithic rock pinnacles. We cannot but question what it is all about!

Colter's quest for knowledge, inspiration, and clues that would unlock the mysteries of the ancient Pueblo world did not stop at Hovenweep. She spent six months studying the glorious canyons and mile-high cimarron desert of the Four Corners region, which I roamed across one fall, when the aspen and streambed cottonwood trees turned brilliant yellow, orange, and red, and the moist, fragrant air hinted of the coming frost. Journeying in the footsteps of pioneer photographers, I continued tracing the wanderings of William Henry Jackson.

Pausing to reflect on the rim of Mesa Verde National Park one cool evening, I realized Colter had been on to something revelatory. From Four Corners "Indian Country," her epiphany had blossomed two hundred miles southwest on the remote Grand Canyon vista of Desert View in 1932. On the basis of her field notes and drawings, as well as her passion for Pueblo culture, materials, building patterns, and construction traditions, she resurrected a magnificent masonry tower on the edge of a mile-deep abyss that was more than three times the height of Hovenweep Castle when it was originally built a millennium earlier.

Colter designed and interior decorated other signature native stone dwellings at the Grand Canyon that have been designated National Historic Landmarks. Among them is the Hopi House, where legendary Hopi-Tewa artist Nampeyo was the potter in residence, and Hermit's Rest, Lookout Studio, Phantom Ranch, and Bright Angel Lodge. But many considered Desert View Watchtower her finest, a *pièce de résistance* created at the height of a brilliant career in an exclusive fraternity of men.

In addition to the building's breathtaking view of the Colorado River, Colter got something else right too. Viewed from the third-floor Eagle Nest lookout, you can see that her ode to Ancestral Puebloan towers was built at an ancient crossroads. To the east, Paleo-Indians used nearby

Legendary Hopi-Tewa artist Nunipayo decorating pottery. *Photographic print by Edward S. Curtis, 1900. Courtesy of Library of Congress.*

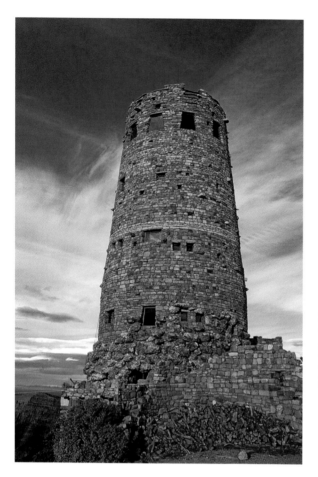

Carson's troops. Here, too, Spanish conquistador García López de Cárdenas and twelve men had been led to the Grand Canyon by Hopi guides and were later credited with "discovering" the marvel in 1540. Beyond—east, south, and west of Desert View—the Hopi, Navajo, and Havasupai traveled hundreds of miles on foot, burro, and horseback across the Coconino Plateau to trade at each other's villages of Oraibi, Wupatki, and Havasupai. Colter never mentioned this cultural crossroads, but someone must have known that the ancestral compass point was like no other in the Great Southwest.

In anticipation of the watchtower's grand opening, the Santa Fe Railway and the Fred Harvey Company printed a brochure that announced the momentous occasion. It read: "Prehistoric Towers, The Indian Watchtower, A Re-Creation from the remote past of the American Southwest, built in the heart of the prehistoric Indian country on the promontory that overlooks the wanderings of these ancient people." Whether it was serendipity or insight, Colter had created just that.

THE LOST WORLD OF
SHIVA TEMPLE

Tanner Canyon to hunt mega fauna (large mammals) in 9500 BCE with Clovis spearheads; the lanceolate projectile points had been recently discovered near Desert View. The Navajo had fled down the same rugged gorge into the depths of the Grand Canyon to seek refuge from Colonel Christopher "Kit" Carson's merciless campaign in 1863–64. Nearby, Navajo medicine men, *ha'athali* (singers), used the spectacular promontory to chant the *Diné yázhí ba'íítá* (enemy way) healing ceremony to restore harmony to their people and lands that had been ravaged and scorched by

From the South Rim of the Grand Canyon on clear winter days, one can see Shiva Temple, a white-rimmed blue mesa on the distant horizon of the North Rim. On a warm day in January, two partners and I had come to explore this mysterious "lost-world plateau" that was reportedly "cut off from the rest of the world" by 200,000 years of erosion. So read the feature story by naturalist Edwin Teale, "Explorers Hunt

Architect Mary Elizabeth Jane Colter designed the Desert View Watchtower after she visited and sketched ancient towers throughout the Four Corners.

Popular Science Monthly story by Edwin Teale, November 1937.

Prehistoric Animals in Lost Worlds," in a 1937 edition of *Popular Science Monthly.* Scientists dreamed of discovering new species or near-mythic beasts rivaling those of Nepal's Himalayan snow leopard, Mexico's saber-toothed *onza*, and the Galápagos' giant tortoise. They hoped to penetrate what had also been described as a "lost forest," separated from the mainland since the last glacial age, when mastodons, bison, ground sloths, and dire wolves still prowled the primeval landscape. "One of the reoccurring dreams of science," Teale wrote, "had been the discovery of some remote land that has remained the same for hundreds of thousands of years and will give glimpses of the world as the cave man saw it."

From the North Rim, our trail led us through a storybook forest of blue spruce, Douglas fir, and ponderosa pine to a panoramic vista named after the Hopi hero Tiyo. In the distance, beyond the craggy rim of the Kaibab Plateau, the blue mesa of Shiva Temple floated in cobalt-blue skies above the serpentine river corridor named after the Hindu deity Vishnu. The timeless river had worn its way through a collision of tectonic plates, molten volcanic upheavals, and black quartz nearly as hard as diamonds. The promise of climbing a temple that reigned over this cataclysmic landscape beckoned us closer to the edge of the overlook that stood more than a thousand feet above Shiva Saddle. The forest was empty, the Kaibab Plateau devoid of people, and an unseasonably warm breeze hummed through the treetops as we studied the precipices of the mile-long ridgeline. Through broken walls, terraced slabs, and fallen boulders, I spotted a route that led down to the steep talus held together by the tenuous roots of ponderosa, piñon, juniper, and Spanish dagger Utah agave. The 7,646-foot-high Shiva Temple stood at the end of this obstacle course, which rarely bore the footprints of modern travelers.

Our perch had formed the base camp for the American Museum of Natural History expedition that arrived here during the summer of 1937. It was led by American Museum curator of mammals Harold E. Anthony and American Geographic Society climber Walter A. Wood. After rendezvousing at the South Rim's rustic El Tovar Hotel, expedition members photographed and reconned Shiva Temple from the air in a Beechcraft Staggerwing, only to discover the North Rim

airstrip was too short to accommodate the Grand Canyon Scenic Airways Ford Trimotor they had chartered to transport the entire expedition across the canyon. As a result, they caravanned by car around the Grand Canyon and across the Painted Desert to reach the North Rim's alpine forests, parks, and meadows, which looked like they came straight out of Rodgers and Hammerstein's *Sound of Music.* Under the supervision of National Park Service superintendent Minor R. Tillotson, park service trucks shuttled the expedition's loads out to Tiyo Point.

Reading their expedition accounts, I gathered they'd imagined they were looking at a daunting Himalayan giant, like Nanga Parbat, from their rim-top base camp. As spectacular as Tiyo Point was, some expedition members had hoped to base their expedition out of the North Rim's majestic Grand Canyon Lodge, until logistics quashed their plans. So they hired six stout-hearted Mormon lads from Kanab, Utah, to serve as porters. Under the guidance of local rancher Preston Swapp, they stocked Tiyo Point with beds, tents, canned food,

two-way park radios, traps, guns, ammunition, and a cache of water that amounted to thirty gallons per person. As the expedition geared up, the local packers ferried punishing loads from Tiyo Point down to their advance base camp on Shiva Saddle. Assuming the expedition's entourage of scientists, climbers, wives, park superintendent and naturalist, expedition photographer, writer, filmmaker, and pilots reached the summit of Shiva Temple, the packers would need to resupply the scientists undertaking a biological survey of mammals atop the sky island. In an Associated Press account dated September 16, 1937, the editor wrote: "An advance party will scale the sheer cliffs which have cut the summit of Shiva Temple from the outside world for centuries."

We scrambled off Tiyo Point and used on-site dead reckoning to follow the safest and fastest line of descent. We moved through broken cliffs, cockscomb fins, and crumbling limestone and sandstone ledges; climbed down chimneys and cat-walking ledges; and jumped down chest-high drops, postholing in the deep talus each time we landed. We slalomed and glissaded down loose stones and gravel through boulders and wind-bent trees, whirling up rooster tails of powder and scree, running and howling in wild abandon until we reached Shiva Saddle in a cloud of red dust that showered us with grit when we dug in our heels and hit the brakes. We were excited, but huffing and puffing from what had became an impromptu race off the rim, carrying loads of water that sloshed around like waves inside our packs.

Crisscrossing the saddle like hounds, we located two large, deep water pockets in a pygmy forest of piñon and juniper and dropped our packs to rest. I stood over the shimmering pool, cupped both hands, and splashed my face with the cold, sweet water. The precious pool sustained the lives of rotifers, fairy shrimp, spadefoot toads, painted lady butterflies, ringtail cats, mule deer, mountain lions, black ravens, and red-tailed hawks. Archaic peoples, Ancestral Puebloans, and Kaibab Paiute had roasted Anasazi agave hearts in stone hearths I saw nearby.

We were not the first to reach these natural cisterns in the tract below the 9,000-foot-high Kaibab Plateau. They brought to mind *El Tanque*, the pool, at El Malpais National Monument, which was used by ancient Pueblo peoples and later by

the Zuni, and by Spanish conquistador Don Juan de Oñate. Nor was the American Museum expedition the first to reach these water pockets, or the summit of Shiva Temple. Grand Canyon explorer and photographer Emery Kolb cached supplies here when he climbed Shiva Temple twice in the weeks running up to the American Museum's nationally publicized "first ascent."

Kolb's offer to guide the expedition had been rebuffed, so he climbed the coveted temple during his own quest for adventure. The faunal remains he discovered indicated that deer were the first large mammals that migrated from the North Rim to Shiva Temple, and they were trailed by ancient hunters who sought their meat, hides for buckskins, and antlers fashioned into awls used for weaving buckskins, moccasins, and baskets.

During their stealthy, first-recorded ascent of the temple, Kolb and his young partner Gordon Berger observed "evidence of rabbits, deer and possibly a mountain lion." William C. Suran, the Kolb brothers biographer, also wrote: "At one place they found the remains of two bucks (deer) who fought to the end, their antlers locked together in a bitter struggle of nature."

Who could have imagined the sight of two rutting deer stalking, snorting, circling, and charging one another in mortal combat, their racks of tree-sharpened antlers clacking like swords in Sherwood Forest atop a sky island in the middle of the Grand Canyon? They left irrefutable evidence of turf battles dating back to Ancestral Puebloans, who tracked their cloven hoofprints through thorny manzanita bushes and up chutes, rocks, and cliffs to the summit. The ancient Pueblo peoples dug their flint knapped arrowheads out of the rib cages of their fallen prey, cleaned the hairy hide with limestone scrapers, prized the heart, and roasted the meat. The women and children hung the remains in tree limbs to sun-jerk; collected piñon nuts, juniper berries, and herbs; and refilled their ollas with fresh rainwater.

The American Museum of Natural History expedition bore witness to some of these timeless relics. Seven members, wearing nailed boots and *Kletterschuhe* (climbing shoes), tied together on two ropes, climbed the temple in a long, perilous day of negotiating the 300-foot-high band of sandstone that led to the locked deer antlers Kolb had found earlier. Apart from the exposure and the

loose rocks that bloodied one climber's head, their greatest fear had been rattlesnakes: "A man climbing a cliff, with hands and feet fully occupied in maintaining a precarious balance," Harold Anthony wrote, "would be aroused in no great burst of enthusiasm if he pushed his face over a ledge to find a snake looking him in the eye."

In the era of Merian C. Cooper's jungle film *King Kong*, expectations ran high after the Associated Press filed provocative expedition reports from New York; Washington, DC; San Francisco; and the Grand Canyon. When the climbers finally topped out on the summit, they built a roaring signal fire for well-wishers sipping cocktails on the balcony of the El Tovar Hotel. The next day, the well-heeled spectators used their fashionable Leitz binoculars to view the barnstorming pilot Amy Andrews skimming above the treetops in her bright-red single-engine Stinson. Would the beautiful young aviatrix end up battling a Komodo-dragon-sized chuckwalla atop Shiva Temple, standing on its hind legs and tail, clawing at the airplane swooping by like a screeching red pterodactyl? The scene never appeared, but Andrews put on a head-turning air show, bombing the "Shiva Airport" with parachute drops of Phoenix Dairy milk cans filled with water and fragile eggs—without breaking a single eggshell, it was reported. In the end, the expedition was anticlimactic compared to the wild news coverage that riveted readers. Behind the headlines, expedition members spent ten days on the 275-square-acre summit, plinking, trapping, skinning, and preparing all manner of mice, ground squirrels, and other small mammals on a wooden table. This was where the most costly rodent skins in the Great Depression were harvested and prepared in the name of science.

Following the ancient Pueblo's deer trail to the summit later that afternoon, we knew we'd found the exact spot of the museum expedition's A-framed canvas tent camp when we spotted the remains of their wooden skinning table. A quarter century after museum scientists folded up their tents, two brothers made a remarkable discovery in one of the Phoenix Dairy milk cans that stood nearby. "Ironically, a spotted skunk, a species not recorded by Anthony," Joseph Hall noted on August 16, 1963, "was found drowned in one of these cans which had been half-filled by recent heavy rains." The two ten-gallon milk cans offered mute testimony to the

time and the place when men and women sought answers, adventure, intrigue, and glimpses of "strange creatures that survived from the days of the cave men" in the Lost World of Shiva Temple.

After coffee and oatmeal the next morning, we explored the mesa and located the limestone foundations of ancient surface ruins. They bore more of a resemblance to the rock-covered pioneer tombs that marked the Great Western Trails than the crumbly towers of Hovenweep's Little Ruin Canyon. Survival on Shiva Temple depended on the amount of water ancient Pueblo peoples carried in ollas on trump lines up from Shiva Saddle and on seasonal monsoon and winter rains. The precipitation recharged rim-rock water pockets that sustained them for weeks at a time. Huddling together in buckskin robes, staring at the cosmos of stars, comets, and constellations, they told stories about the "old ones" and planned for the next day's hunt, nibbling venison jerky, piñon nuts, and juniper berry pemmican.

We fanned out and searched the compass points of Shiva Temple, looking for the monuments that Emery Kolb had stacked with stones, but we'd either missed them or they were reclaimed by nature. We wandered over to the western edge of Shiva and saw the 6,613-foot Osiris Temple. Its ivory sandstone fissures were calling one of my partners. A year earlier, we'd climbed and named Siddhartha Temple, a pinnacle on the rim of Marble Canyon that overlooked the Colorado River. I followed him down the exposed ridge, wished him well, then returned to photograph our other partner standing on the edge of Shiva Temple, dwarfed by the immense scale of the great abyss. When American traveloguer John L. Stoddard visited the North Rim at the turn of the last century, he wrote his impressions of Shiva Temple decades before it was called a Lost World:

It is difficult to realize the magnitude of these objects, so deceptive are distances and dimensions in the transparent atmosphere. Siva's Temple, for example, stands upon a platform . . . from which rise domes and pinnacles a thousand feet in height. Some of

their summits call to mind immense
sarcophagi of jasper or of porphyry, as if they
were the burial-places of dead deities, and the
Grand Cañon a Necropolis for pagan gods. Yet
. . . one sees no worshipers, save an occasional
devotee of Nature, standing on the Cañon's
rim, lost in astonishment and hushed in awe.

I scrambled back up to the summit, lingered on the edge of time, and peered into the luminescent depths of the twilight-lit bays and amphitheaters, walls and ridges, and wind-scoured canyons and temples. I lay back on the soft rim rock and closed my eyes. It wasn't difficult to imagine a B-24 Liberator flying overhead, rumbling through the canyon's dark skies, and its four engines backfiring, sputtering, and suddenly dying. The WWII bomber glided like a bulldozer and three men jumped, hurtling through the midnight air screaming, when they suddenly heard the roaring sound of the bomber restarting its engines and droning farther and farther away. Helpless as they fell through a black hole in the earth, they pulled their ripcords. The parachutes popped open and swung them from side to side like pendulum clocks, but they couldn't see where their chutes were carrying them. When they hit, the chutes dragged and tumbled them across the rocky, hedgehog cactus–strewn hanging terraces.

Two of them came to a stop in piles of rocks, dust, cactus spines, and broken branches. The third man was left dangling by his parachute canopy and shroud lines over the edge of a cliff 1,200 feet above what sounded like a river. They were Lieutenant Charles Goldblum, Flight Officer Maurice J. Cruickshank, and Corporal Roy W. Embanks.

Through luck, instinct, training, or divine intervention, the trio survived their crash landing in the world's worst landing zone. Rescues were mounted from the South Rim via the Colorado River, but they failed to reach the stranded aviators who, like the imagined creatures of Shiva Temple, were truly cut off from the outside world. One national news headline read:

Raging Colorado Thwarts Attempt To Rescue
Airmen, Grand Canyon, Ariz., 29, 1944 (UP).
The Colorado River raging at flood stage
thwarted attempts of two rescue parties to
save three parachutists encamped on a
Grand Canyon plateau but . . . Ed Laws,
veteran ranger, and Dr. A. A. McCrae, expert
mountaineer . . . left the north rim of the
chasm yesterday and moved downward
through fissures in the rock toward the
marooned airmen's shelter.

The two men headed for the North Rim west of Shiva Temple and made their way down through the trailless corrugated terrain to the night jumpers. It was a remarkable twenty-hour-long feat of canyoneering and on-site dead reckoning. Laws and McRae were hailed by the press and NBC news coverage, along with the airmen. The needle-in-a-haystack rescue was made seven years after the American Museum of Natural History expedition climbed out of their Lost World. Of their Shiva Temple ascent, Dr. Anthony had written: "We had no knowledge that a white man had even climbed it."

TALL TALES

I turned in for the night, thinking of one of the canyon's other tales. No raconteur spun more-out-landish tales of the Grand Canyon than Captain John Hance, a Tennessee-born Civil War veteran turned prospector, trailblazer, and tourist guide. In the 1890s, he'd guided hundreds of people down his hand-forged, namesake rim-to-river Hance Trail. Among the guests who bunked and boarded at his chinked-log cabin on the South Rim were conservationist John Muir, naturalist C. Hart Merriam, and globe-trotting author and adventurer Emma Augusta Burbank Ayer. Guided by Hance, she became the first non-Native woman to journey to the bottom of the Grand Canyon in 1894. There was also world

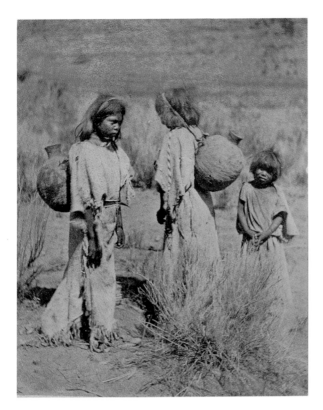

traveler, writer, photographer, and filmmaker Elias Burton Holmes. The traveloguer reportedly filmed the rumpled, felt-hatted, long-bearded Hance telling one of the greatest fish tales of all time this side of Herman Melville's *Moby Dick*.

As Holmes described the scene near the foot of the Hance Trail in the depths of the Upper Granite Gorge, Hance had tied his fishing line to his left foot, baited it, tossed it into the Colorado River, and dozed off without a care in the world. A giant pikeminnow, called a "silver salmon" back in the day, swallowed the bait hook, line, and sinker and dragged the startled trailblazer into Hance Rapids. The rapids were so dangerous that Major John Wesley Powell's 1869 Geographic Expedition was

forced to line (lower with ropes) their heavy wooden boats down the side of the bawling rapids on August 14. It was a long, fearsome, big-drop rapid that early river runners portaged around or nearly drowned trying to navigate. It was the kind of whitewater that prompted boatman George Flavell to threaten his only crewman, Ramón Montéz, not to abandon their one-boat 1896 river voyage from Green River, Wyoming, to Yuma, Arizona. "Fingering his gun," Flavell told Montéz: 'You can come along with me or you can float down dead.'"

Enter the inimitable Captain Hance at the end of his fishing line:

"I didn't mind the rapids or the rocks," Hance told his guests, "but I was afeard that when that darn old fish came to a deep whirlpool, he'd sink down to rest in quiet waters at the bottom, and I knew the line wasn't long enough to let me stay on top. And that's just what he done, pulling me down after him. Of course I didn't want to lose my line, so, seeing there was no other way, I climb down that line hand-over-hand till I reached Mr. Salmon. I whips out my knife, cuts off the line right by his mouth, and giving him a big kick square in the face, I swum ashore, and I never see that fish again."

Captain Hance often recounted this whitewater fishing adventure to visitors. One woman wrote her opinion of Hance's showmanship in his guest book on July 2, 1897: "Anyone Who Comes To The Grand Cañon, and fails to meet Captain John Hance, will miss half the show."

The water carriers. Two young *Kai-Vav-It* (Kaibab Paiute) girls with water vessels strapped to their backs live on the Kaibab Plateau near the Grand Canyon. *Stereograph by John K. Hillers, 1874. From J. W. Powell, 1874.*

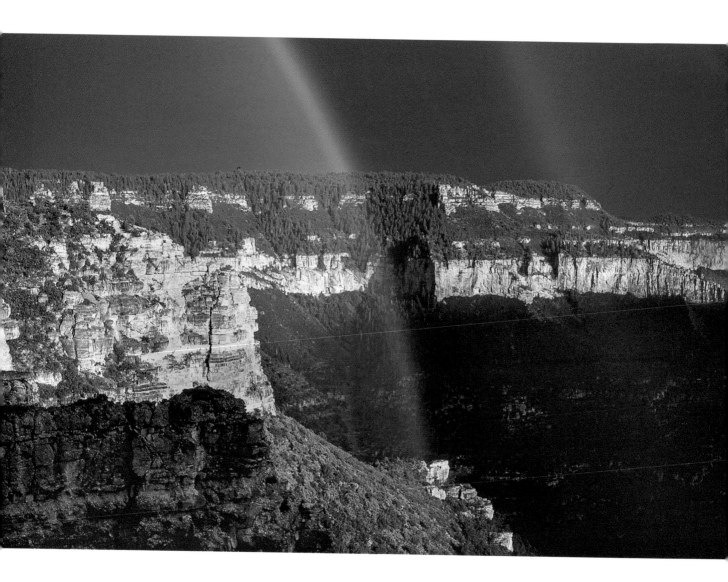

Twin rainbows arc over the cliffs of the North Rim's forested 7,762-foot Tiyo Point plateau.

Climbing the hundred-foot-tall Jacob Lake Lookout Tower was a daily ritual for author Edward Abbey, who worked as a fire lookout guarding the Kaibab Plateau's old growth forests. Inspired by his bird's-eye view of nature, Abbey wrote the novel *Fire on the Mountain* and his passionate book of environmental essays, *Desert Solitaire*.

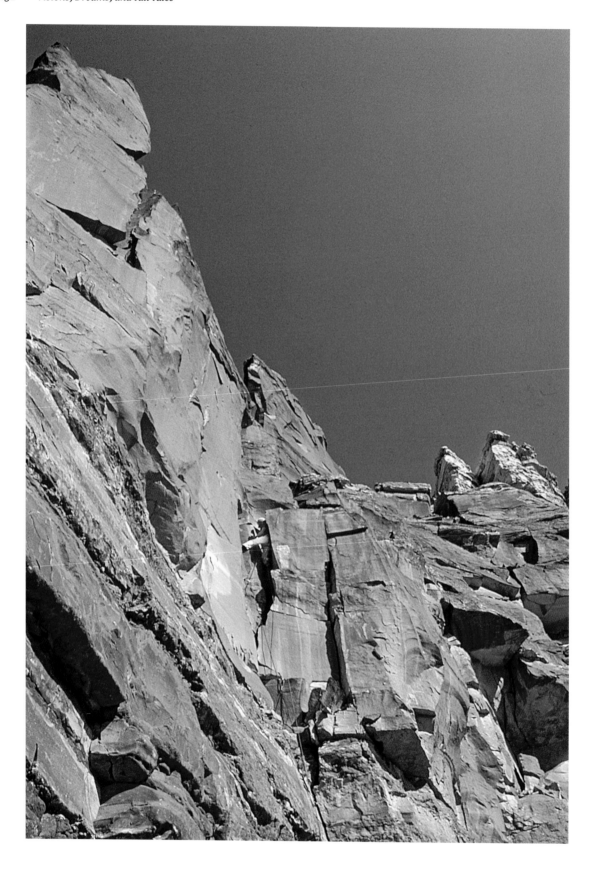

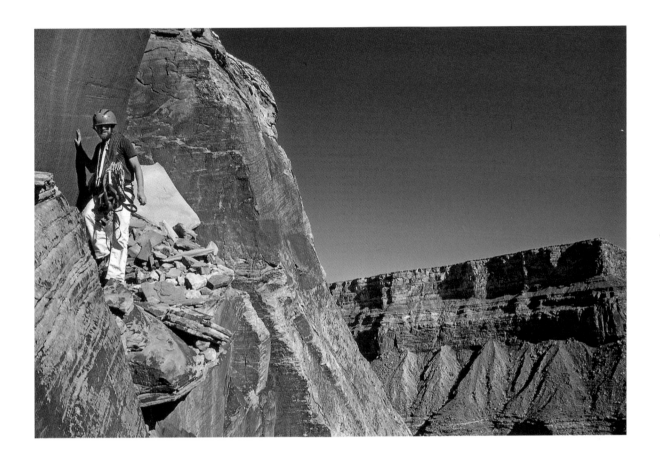

A canyon climber scales the heights of 4,989-foot Siddhartha
Temple on the east rim of Marble Canyon Gorge.

A climber traverses a perilous ledge of loose stones after making
the first ascent of the hidden Coconino sandstone temple.

Following: An Ancestral Puebloan storage granary hidden
below the North Rim offers mute testimony that Native people
roamed the canyon's most rugged and dangerous terrain.

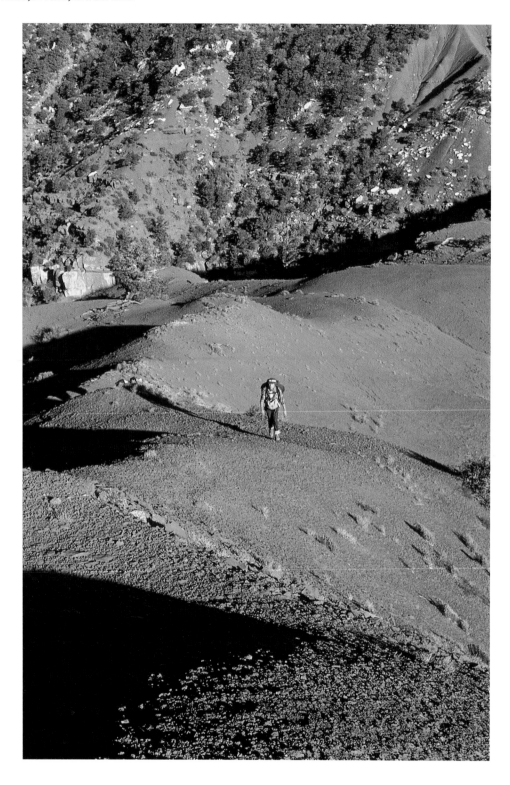

A climber traverses the loose scree of Esplanade sandstone beneath the Kaibab Plateau.

A climber stands on the brink of 7,646-foot Shiva Temple and peers into the great abyss.

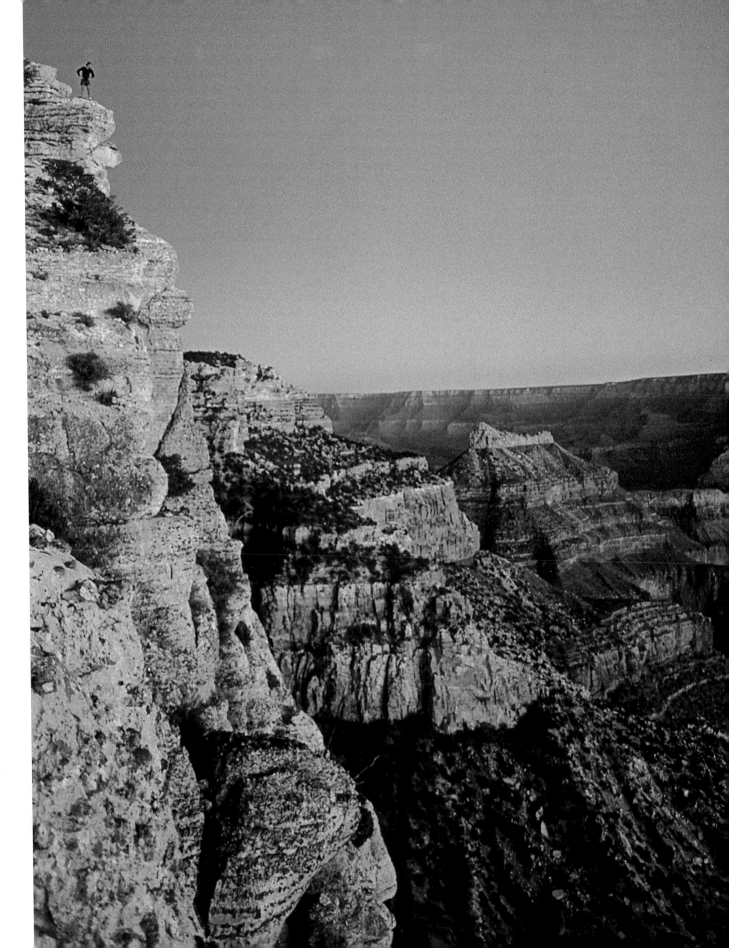

A deer antler sticks out of a Phoenix Dairy milk can used by the 1937 American Museum of Natural History Expedition to the "lost world" of Shiva Temple.

Mary Elizabeth Jane Colter looking out through the door of Twin Tower Ruin, Little Ruin Canyon, Hovenweep, Utah. *Photo by the Fred Harvey Company, ca. 1931. Courtesy of Grand Canyon National Park Museum Collection.*

Hovenweep Castle in Hovenweep National Monument, Utah, was built by Ancestral Puebloans on the rim of Little Ruin Canyon between 1200 and 1300 CE. It was one of numerous towers Mary Elizabeth Jane Colter studied, and inspired her design for the Desert View Watchtower.

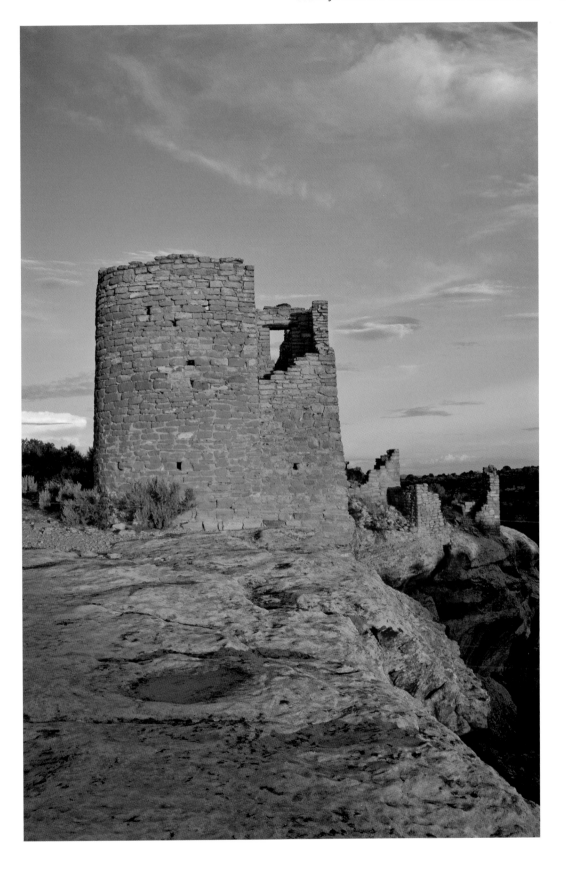

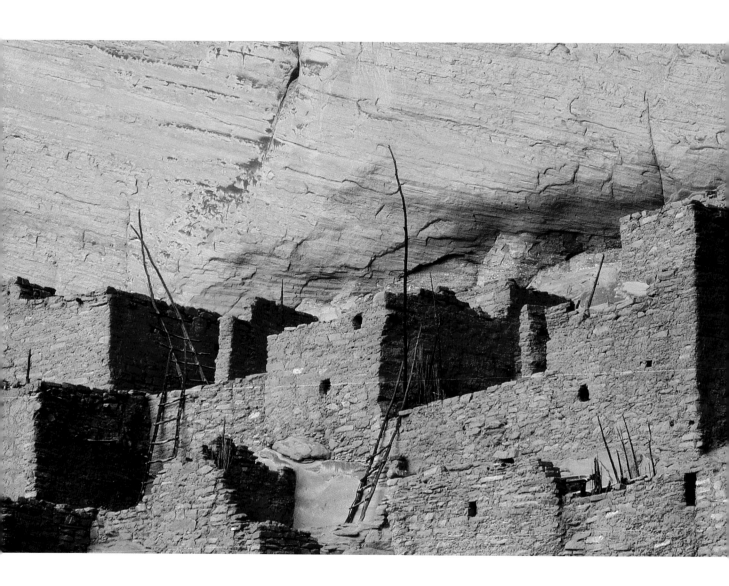

Betatakin Cliff Dwellings in Navajo National Monument, Arizona, were called *Kawéstima* (Village in the North) and were the ancestral home of the Hopi.

The Hopi *Kókopnyam* (Fire Clan) pictograph adorns the walls of Betatakin Cliff Dwellings, Navajo National Monument, Arizona.

Mary Elizabeth Jane Colter commissioned Hopi artist Fred Kabotie's War God mural at Desert View Watchtower. It was interpreted from the *Kókopnyam* symbol at Betatakin Cliff Dwellings. *Author image photographed, courtesy of National Park Service.*

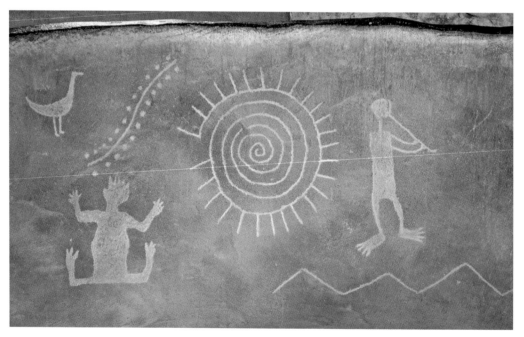

This hidden petroglyph of Kokopelli in the Painted Desert is representative of the *Kókopilau* (Humpbacked Flute Player), a Hopi *katsina* (spirit being) represented in Kachina figures hand-carved from cottonwood tree roots.

Fred Kabotie's Kokopelli mural at Desert View Watchtower was inspired in part by ancient pictograph and petroglyph symbols carved and painted throughout the Southwest. *Author image photographed, courtesy of National Park Service.*

Imagine a darn ol' giant fish called Mr. Salmon dragging
Captain John Hance by his fishing line to the bottom of Hance
Rapids, where the trailblazer was forced to cut the line off his
foot to save his life.

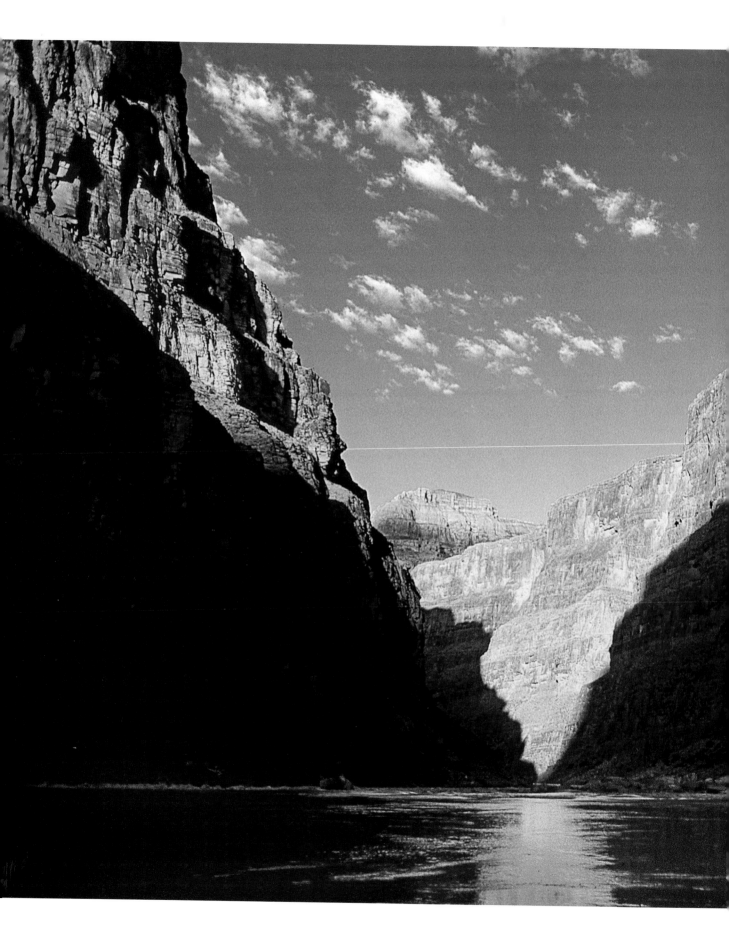

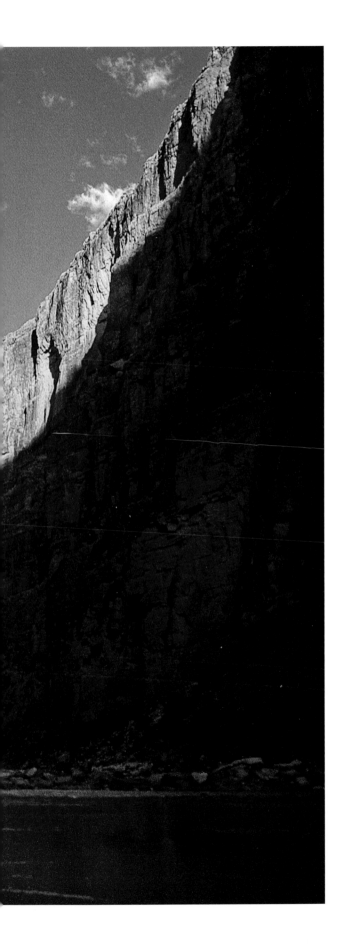

7

TRACING A LEGEND

In the Footsteps of John K. "Jack" Hillers

Once in a lifetime, if one is lucky, one so merges with sunlight and air and running water that whole eons . . . might pass in a single afternoon.

—Loren Eiseley, 1946, *The Flow of the River*

I was huddled in a small boat, shivering. Wind and rain lashed my head, neck, and shoulders, making it difficult to see beyond the rowing seat. My blistered hands clenched the handles of the wooden oars. My sunburned feet stewed in an inch of cold, gray water. And my weathered brown knees oozed with pink rasp marks from rubbing against heavy metal camera boxes. Between sheets of rain that sliced the air like saw blades, I peered down the storm-wracked corridor of stone. The serpentine river slid silently beneath the slippery skin of our boat, twisting and turning in the depths of an ancient canyon that roared with thunder. We were being pulled down the Grand Canyon's river of no return.

Big Cañon, the Colorado River at the confluence of Kanab Creek Canyon.

I crouched lower in my rowing seat, wondering if we'd be blown out of the water by a bolt of blue lightning or obliterated by a house-sized boulder exploding from the looming rim rock overhead. I turned to my partner, a gray shadow drenched in the deluge. He leapt from the oar frame, flew through a curtain of rain, and landed on the sandy riverbank. I ruddered with my left oar as he moved like a lynx through the mesquite, willow, and tamarisk. He heaved-ho on the bowline, then tied off our boat to a flimsy tamarisk tree.

"So what do you want to do?" he yelled. There was nothing to do but wait. We were a mile below Redwall Cavern, an immense limestone amphitheater carved by the Colorado River en route to Mexico's Sea of Cortez 674 miles downstream. Explorer John Wesley Powell bestowed the name Redwall Cavern on August 8, when he first navigated the "Red River" during his maiden 1869 Geographic Expedition and wrote, "the vast half circular chamber, which, if utilized for a theater, would give sitting to fifty thousand people."

"Let's wait for the Disney ending," I shouted back. A beam of heavenly light illuminated the weeping abyss near Hanging Springs with the false hope that the storm was about to break. In the blink of an eye, dark clouds smothered the light, and a black squall marched up Marble Canyon. A cacophony of thunder, lightning, and flash floods roared unseen in a deluge that nearly blinded us. One moment it was impossible to see where the storm ended and the river began. The next moment I watched pellets of rain lash the slick rock from rim to river, then ricochet like diamonds off the surface of the muddy river. Our boat tugged at the bowline and rocked from side to side in the eddy. I tried to control the shivering by folding my arms over my faded orange life vest, but the cold rain poured down my neck, arms, and hands. Thunder boomed, and the boat bounced. I bolted upright, expecting to see a hail of stones tumbling from the rim rock.

But it was my partner jumping on the boat. "We've both seen worse!" he yelled.

The guide, whom I'll call Eric, had spent years running big water in the American West: Idaho's Selway and Middle Fork of the Salmon Rivers; Oregon's Rogue River; Utah's Green, Yampa, and Colorado Rivers; and the Grand Canyon of the Colorado River. The flap copy for the book I'd urged him to write should include rafting the Katuń River in the Altai Mountains in Siberia, the Tatshenshini River in Yukon Territory, and the Big Bend of the Yangtze River in China. A forty-five-year river-running veteran, Eric ramrodded one of the most respected river outfits in the West. Tallying up my own river ledger included seasonal stints on the Green and the Yampa Rivers in Dinosaur National Monument and Cataract Canyon in Canyonlands National Park, both in Utah's slickrock country; the Forks of the Kern River, Golden Trout Wilderness in California's Sierra Nevada; the Rio Grande / Río Bravo del Norte in Big Bend's wild border country in West Texas and the frontier states of Chihuahua and Coahuila, Mexico; and, before Quartzite Falls was defanged by dynamite-wielding saboteurs, the Upper Salt River in Arizona's Salt River Canyon Wilderness. As memorable as those adventures had been, they were often overshadowed by the twenty-two Colorado River journeys I'd been fortunate to make through one of the Seven Natural Wonders of the World, Arizona's own Grand Canyon: five thousand miles of running some of the American West's most storied rapids, months of peaceful sleeping on a boat cradled by the mother river, tributary chasms spilling hidden secrets for my camera and pen, and canyon dreams shared with kindred spirits who'd also heard what western novelist Zane Grey expressed in the title of his 1924 novel, *The Call of the Canyon.*

To some, I was an old hand. Compared to Eric and other river guides with more than a hundred Colorado River trips behind them, I was just getting started in the Grand Canyon. After two days of rowing down Marble Canyon into the eye of the storm, I felt like a stove-up rodeo cowboy trying to climb back on a saddle bronc. I'd been away for a decade, chasing light with my camera and pen from the heights of *Picacho del Diablo* (Peak of the Devil) in Baja, Mexico, to the depths of Chihuahua's soul-stirring Barranca del Cobre, where I worked documenting indigenous ceremonies of the Tarahumara, Mountain Pima, and Guarijío. As I slid down the glassy tongue of river water into House Rock Rapids on day 1, and ran the gauntlet of rapids in the Roaring Twenties on day 2, one question dogged me: How long would it take to get back on my horse and really

ride? I knew my timing was off. Fortunately, the "river gods," as guides called that unseen force of the river, were kind—until the summer monsoon hit like a typhoon.

We had darted ahead of our main party through the sunlit gorge to reach an X on the map at mile 34.5 on river right. It was one of the historic locations that pioneer Grand Canyon photographer John K. "Jack" Hillers used when he photographed the Colorado River as a boatman on Major Powell's lead boat, the *Emma Dean*, during Powell's Second Colorado River Expedition in 1871–72. My quest was not only to row and photograph the canyon as Hillers had done, but to view what Hillers had seen from vantage points along the river corridor, called camera stations, and see how I would interpret the scenic river views.

On August 21, 1872, it was at camera station 850 where Hillers photographed two of the expedition's wooden boats that showed the immense scale of Marble Gorge in a stereograph albumen print card titled "The Cañon at Noon." As one of the first to photograph the inner canyon—and to dive into the thundering river to save Powell from drowning after he was swept overboard—Hillers had the rare opportunity to work with a "tabula rasa (blank slate)." His vision was unfettered by the stereoscopic views and large-format glass plate negatives of other pioneer photographers who later photographed the Colorado River and its canyons.

The ranks of photographers, explorers, and adventurers after the Civil War era who gave birth to the West's golden age of pioneer photography also included William H. Jackson, Edward S. Curtis, Timothy H. O'Sullivan, William Bell, E. O. (Elias Olcott) Beaman, George Ben Wittick, Frederick H. Maude, George Wharton James, Henry G. Peabody, and Emery and Ellsworth Kolb, among other distinguished lens men who probed the canyon's *terra incógnita* and documented its indigenous peoples. Hauling hundreds of pounds of wooden box cameras, fragile eleven-by-fourteen-inch glass wet plates, unwieldy tripods, portable dark room tents, and chemicals sloshing around in wooden boats, on pack mules, and on foot, they often risked life and limb scaling imposing cliffs, running and portaging impossible rapids, and canyoneering deep chasms to photograph the

least-inhabited, last-explored wilderness in the contiguous United States.

Although O'Sullivan took the first known photographs—four-by-seven-inch stereograph albumen silver prints—of the Grand Canyon at Diamond Creek during George M. Wheeler's US Geographical Surveys west of the 100th meridian in 1871, Hillers was the first to photograph the Colorado River from Lees Ferry down through the breadth of the Grand Canyon to Kanab Creek Canyon in 1872.

It was Hillers's river journey I sought to emulate first. Although mine was undertaken in the relative safety and comfort of a modern river adventure, Hillers's monsoon experience resonated with my own. He fared far worse, given the nature of the Second Colorado River Expedition and the challenges of navigating a river untamed by the 1950s-era Glen Canyon Dam. I recalled passages from Hillers's diary as I shivered:

"Came to a young Hell," Hillers wrote, "unloaded the boats. Here it commenced to rain. Being wet from head to foot anyway, but had to hunt shelter from the beating rain. Got in the river under the side of the boat. Rain over, we hauled our boats over [to shore]. In doing so I sprained my back. I sunk down, cursed my luck, and crawled to shore. Went into camp—everything wet. Laid down on the wet sand on damp blankets. . . heard an angel's whisper in the roar of falling water."

I sat in the stinging rain until I, too, heard the first clear whispers of falling water. I looked around. The thunder had silenced. The wind stood still. The rain stopped. I took off my sunglasses and stared at the mud-streaked stereoscopic reflections. My face was humbled by the tempestuous storm, but my eyes still burned with passion to rediscover a connection with the great river. I'd get my chance soon enough. I wiped my sunglasses with the wet bandanna that dangled from my neck as the first rays of sunlight

danced through the clouds and gazed in awe at the scene before us. As far downstream as I could see, terra-cotta waterfalls cascaded hundreds of feet over red-limestone walls into chocolate-brown river water some pioneers said was "too thick to drink, too thin to plow." We were floating in a living mural that brought to mind Jules Verne's imaginings in *Journey to the Center of the Earth* and Thomas Moran's seven-by-twelve-foot oil painting *The Chasm of the Colorado.*

Our six-boat party drifted beneath the rainbow-hued band of cliffs called Desert Facade and emerged from the mauve shadows of Marble Canyon two days later. We turned west into the hot sun at the confluence of the Colorado and the Little Colorado Rivers and craned our necks at copper-colored walls that peeled back from the silver river. Soon, the Palisades of the Desert's sheer stone rose nearly a vertical mile above us in shades of iris. In the seven-mile stretch of river between the Little Colorado River Gorge and Tanner Creek, more than five hundred years of Grand Canyon history could be read in a single sweep of the oars. It began long before Hillers stood on the banks of the Little Colorado River and took the first known photograph of it at camera station 885 on August 22, 1872. Hillers noted the experience in his diary: "Kept on running rapids. About 4 PM came to the mouth of the Little Colorado or Flax River, an awful muddy stream and so salt[y] that it cannot be used as a thirst quencher."

Dating back nearly ten thousand years, our downstream run offered glimpses of human history that included Paleo-Indian hunters, Spanish conquistadors, Hopi salt pilgrims, Navajo medicine men, pioneer river runners and trailblazers, and a rogues' gallery of two-legged varmints, horse thieves, and moonshiners who followed. More than a century after Grand Canyon photographers Ellsworth and Emery Kolb's expeditionary quest to photograph the Little Colorado River Gorge for *National Geographic* in 1909 with a cumbersome wooden Seneca five by seven foot glass plate camera, this history continues to be written. En route to taking hard-won black-and-white images that appeared in a 1914 issue of *National Geographic Magazine,* the Kolb brothers described the path they followed with their skittish burro, Jennie. "From this point on to the mouth of the Little Colorado," the Kolbs

wrote, "we slowly worked our way over one of the worst trails we have ever seen."

Tracing the Kolbs' treacherous course along scalloped cliffs of Tapeats sandstone, I could point our bow in any direction and read another page of Grand Canyon history. To the south, we could see Mary Elizabeth Jane Colter's seventy-foot-tall Desert View Watchtower. Across the river on the north, cowboy Jack Fuss and his outfit swam twenty-seven packhorses and mules across the Colorado River, one at a time, to support the Great Kaibab Deer Drive on the snow-battered North Rim in 1924. And to the east, one-armed Major John Wesley Powell, whom the Paiute called *Kapurats* (Arm-Off), scaled more than two thousand feet of broken cliffs up the Desert Façade to survey the uncharted river gorge to the west that his expedition was about to enter. It was Powell's record of navigating downstream in the towering waves that tantalized me most. We were about to enter the river's Big Drops [not limited to this stretch!] and somber depths of the 1.73-billion-year-old basement rocks of the canyon's Upper Granite Gorge. Was I ready?

I contemplated Powell's misgivings that night while our party grilled steaks during cocktail hour. His 1869 Geographic Expedition had survived on meager rations of campfire-boiled black coffee, hard biscuits, and rotting bacon. On the eve before entering the frightening abyss Powell called "the Great Unknown," he wrote:

We are three-quarters of a mile in the depths of the earth, and the great river shrinks into insignificance. . . . We have an unknown distance yet to run; an unknown river yet to explore. What falls there are, we know not; what rocks beset the channel, we know not; what wall rises above the river, we know not.

I shared Powell's trepidation of the Great Unknown, though it was some comfort that I'd run rapids named Unkar, Nevills, Hance, Sockdolager, Grapevine, Horn Creek, Granite, Hermit, and Crystal Rapids, and Lava Falls that had proved many river runners' undoing. Soothed by the starlit

river lapping against glistening boulders, I made a simple decision that night: "Just do what you used to do." I stowed my cameras the next morning, got back in the saddle, and rowed the Upper Granite Gorge, confident I could navigate the river again. Then Hermit Rapids reared its head.

Arguably the biggest and most-exciting wave train in the Grand Canyon, Hermit Rapids was known for its "fifth wave." Over coffee the next morning, I asked the guides what their last run was like. The consensus was "Hit it straight, or you're gonna flip!"

We hot footed to our boat across the scalding sand and past boulders too hot to touch. The dark walls of the Upper Granite Gorge created an oven. I was hot and drenched in sweat. I cinched down my life jacket and dunked myself in the cold river to clear my head. The bowline coiled; I pulled back on the oars, ferried the boat upstream, pivoted downriver, then pushed with my oars into the slick current. We glided easily, picked up momentum, then plunged through the first wave into the second. I started to lose my angle and began dropping sideways into the third wave.

I pulled on my right oar and pushed with my left to straighten out before we slid into the trough of the fourth wave. The boat climbed. But the moment we teetered over the crest, I stared at a wall of exploding brown water that dwarfed the bow of our eighteen-foot boat. Catapulted into a deep trough that blocked out the sun, we slid straight up the face of the biggest wave I'd remembered seeing since getting hammered trying to bodysurf Makapu'u in Hawaii and the Wedge in California during my teens. The haystack exploded, then collapsed over us like a falling roof. I clenched the oars even tighter and crouched deep in the well in front of my rowing seat. A ton of brown water, silt, and mud buried us. In slow-motion seconds, all I could see was a dark blur of bubbles. All I could hear was muffled gurgling. All I could feel was water running up my nose and wrenching my arms and shoulders.

The boat made a slow, steep climb. I planted my feet again and got ready. If the angle increased, I was going to bail under before Eric's body slammed into mine, one of us got knocked out, and the boat flipped on top of us. But we kept moving forward through the dark water and finally submarined through the backside of the wave into

daylight. I gasped for air and heard snippets of screaming from the shoreline as we shot down the streamline through the sixth and seventh waves.

Dripping with muddy river water, I was dizzy from the potion of adrenalin, excitement, and joy. It was a new world for me, and a new day. Everything was possible. Years ago, Eric and I had discussed the lure of river running—what kept bringing people back year after year. His words echoed in my memory as we splashed through the tail waves and riffles of Hermit Rapids: "You've learned from, and discovered, a connection with the very force and spirit of the river." When we pulled into camp that evening, I walked down the shoreline alone, stared into the great river winding through the chasm, and felt tears run down my cheeks. Turning toward a timid Grand Canyon pink rattlesnake that lay coiled beneath a beaver lodge near my feet, I knew I had rediscovered my connection with the one river I'd feared I'd lost forever.

The next morning, I would still need to reckon with Crystal Hole three and a half miles downstream. It was unknown in Hillers' and Powell's era. Just scouting it had always produced butterflies in my stomach, and I felt them again as I stood atop hot boulders eyeing the narrow river passage around the menacing-looking Crystal Hole and listened to the cacophony of booming brown water. When fourteen inches of rain pounded the Kaibab Plateau's North Rim between December 3 and 7 in 1966, avalanches of debris and an eighteen- to twenty-foot-deep, sixty-foot-wide mud flow "removed all evidence of previous floods" dating back to 1050–1150 CE. The torrent of water carried giant old-growth ponderosa pine timbers and tons of boulders, stones, pebbles, and "adobe mud" into the main channel of the Colorado River, where it pinched through the dark narrows of the Upper Granite Gorge between the Slate Fault and Crystal Creek. This created a seventeen-foot big-drop rapid that has struck fear in the hearts of river runners ever since. You don't run Crystal Rapids. You don't hit it straight. You run from it. Entire river parties did just that during the "high-water year" of 1983, when park helicopters rescued many passengers after 96,200 cfs (cubic feet per second, or one cubic foot of water moving past a given point in one second) nearly breached the cavitated spillways of the colossal Glen

Canyon Dam. This created a jaw-dropping rapid that flipped five thirty-foot motorized rigs carrying more than one hundred passengers, drowning one tourist and injuring many others.

I cinched down my life vest, walked down to the still pool of water above the rapids some guides called "Crystal Lake," and dunked myself in the cold water. Eric and I hopped back into our boat. I felt like I was about to jump off a cliff into a maelstrom. Our course would take us through the Grand Canyon's steepest and most constricted river gorge, through a portal of waves and drops and into a powerful recycling pour-over, creating a menacing "hydraulic jump" called the Old Crystal Hole. Compounding navigation were three curling holes and waves formed by boulders deposited by the historic Crystal Creek floodwater debris fan on river right and the whirlpool eddy at the mouth of Slate Creek and the cliffs of Vishnu schist on river left.

I stood on my rowing seat and looked for a marker rock downstream on river right that would guide me around Crystal Hole. The current accelerated, the riffles became small rapids, I pushed on my oars, and the whispers of nature writer Loren Eiseley captured those fleeting moments: "The sky wheeled over me. For an instant, as I bobbed into the main channel, I had the sensation of sliding down the vast tilted face of the continent . . . flowing like the river was flowing, grain by grain, mountain by mountain, down to the sea."

The main stem of the Colorado River picked up speed as I wove over boils and broke through lateral waves that crashed over the bow. The hair on my neck stood up when I saw the unfathomable hole. If I bumped the marker rock sticking out of the water, I could lose my angle and bounce into it and . . . there was no time to consider the consequences. "Just do what you used to do," I told myself for the last time. The boat-eating hole rumbled. I glanced over my left shoulder at its pulsating, pummeling fury and then pushed hard to the right and threaded the marker rock, rowed behind a glassy pour-over, and tucked down the right side of the Crystal Hole. Weaving and splashing through the Rock Garden, I pulled over on river right and joined the lead boats above Tuna Rapids. Whew!

Running the benevolent rapids named the Gems—Topaz, Agate, Sapphire, Turquoise, Emerald, Ruby, Jasper, Jade, Quartz, and Serpentine—

that followed was an elixir that soothed the adrenalin after running Crystal Rapids "right side up." Drifting through a golden corridor of reflections called Conquistador Aisle later that afternoon re-instilled the enduring river magic I'd hungered for. As our boat pirouetted through the hypnotic boils and eddies of Granite Narrows toward Deer Creek Falls, I realized I was rowing my way back home.

A white torrent of monsoon and subterranean spring-fed water spewing through a polished notch of Tapeats sandstone, 190-foot-tall Deer Creek Falls is one of the most beautiful cataracts on the Colorado River, coursing 1,450 miles between Colorado's snowy La Poudre Pass in the Never Summer Mountains to the blistering desert tidewaters in Mexico's Sea of Cortez. Hillers stopped at the foot of the falls at camera station 893 on September 5 or 7, 1872, to photograph what his mentor, former Powell expedition photographer E. O. Beaman, had christened "Buckskin Cascade." A New York photographer who'd grown disgruntled with Powell during the winter of 1872, Beaman was discharged by Powell on January 31 and later trekked down the length of Kanab Creek Canyon in the company of gold rush prospectors to photograph the remote, rarely seen waterfall. To do so, Beaman and his assistant, Samuel Rudd, needed to scramble, stumble, and haul their heavy load of camera, tripod, food, and gear up the torturous left bank of the Colorado River all the way to the foot of the falls, where Beaman became the first to photograph Buckskin Cascade. On April 16, Beaman wrote of their riverside trek:

And so, shouldering my camera I started, with one assistant, for a ten-mile climb over limestone and marble bowlders, I found the cataract fully equal to the description given it. The walls rise perpendicularly five hundred feet, and the fall is unbroken and magnificent. Passing around the falls, we encountered a granite wall projecting into and over the river, which we were obliged to scale. This would

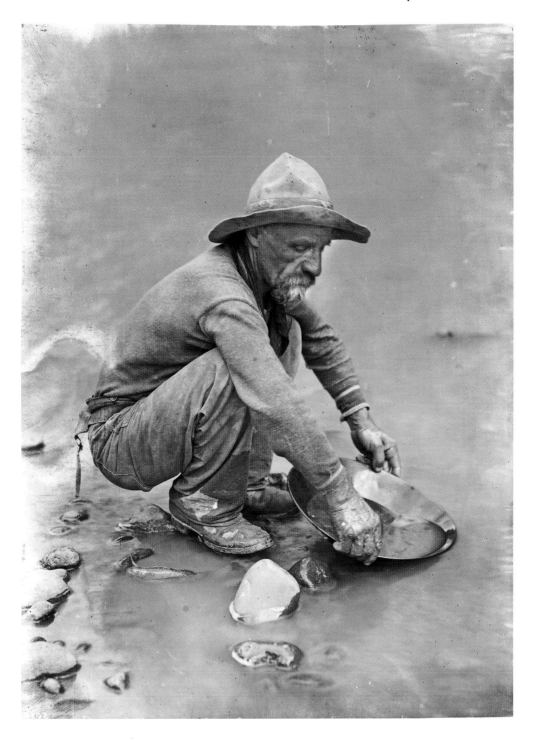

Placer miner on the Colorado River near Lees Ferry. *Glass photonegative by George Wharton James, 1898. Courtesy of California Historical Society / Wiki. From* In and around the Grand Canyon.

have been impossible of accomplishment but for our alpenstocks and ropes, but after two hours' work, we found ourselves in the very heart of the American Alps, twelve hundred feet above the river, and at a point commanding an extended view of the Grand Cañon.

The boulder-strewn trek to reach Deer Creek Falls was difficult, and Beaman's supplies dwindled. So he lashed together a driftwood log raft and the pair floated seven miles back down to Kanab Creek to retrace their arduous canyon route sixty miles to the last outpost of Pipe Spring, Arizona Territory. It was the same route Hillers followed four months later when Powell, fearing the weakened condition of their leaky wooden boats, ended his Second Colorado River Expedition at "Kanab Wash." On September 9, 1872, Hillers wrote, "Quite a surprise at breakfast this morning. Major told us that our voyage of toil and danger was at end on the river. Everybody wanted to praise God."

As I rowed through Kanab Creek Rapid, it dawned on me that, in some respects, my own journey had also ended there. In other respects, my river journey was just beginning. I had traced the routes of Hillers and Beaman on foot end-to-end down the length of the stupendous gorge to photograph Kanab Creek Canyon and elsewhere throughout the Colorado River corridor at Marble Canyon, Little Colorado River Gorge, Deer Creek Falls, Toroweap Point, and other landmark camera stations that led me in the footsteps of pioneer Grand Canyon photographers. Their vantage points had indeed inspired my own interpretation of the Grand Canyon.

By day 11, our river expedition had gazed on the starry heavens of the Milky Way, frolicked in the turquoise waters of Havasu Creek photographed by Civil War photographer Ben Wittick in 1885, listened to the mesmerizing canyon melodies of Fern Glen Falls, and rowed through a steamy cauldron of black scoria to the head of Lava Falls, one of the most daunting

rapids on the continent. Even before we discussed it, I'd pretty much decided to turn the oars over to Eric at Lava. There was nothing more I needed to prove to myself.

In his seminal book *A Sand County Almanac*, author and conservationist Aldo Leopold wrote:

It is the part of wisdom never to revisit a wilderness, for the more golden the lily, the more certain someone has guilded [sic] it. To return not only spoils a trip, but tarnishes a memory. It is only in the mind that shining adventure remains forever bright. For this reason, I have never gone back to the Delta of the Colorado [River, Mexico] since my brother and I explored it, by canoe, in 1922.

My memory of navigating Lava Falls as paddle captain with five trusting passengers turned paddlers in a small raft, nearly half the size of the raft I had just rowed at 33,000 cfs still remained bright.

Nothing I did that day could improve on that formative run of adventure, discovery, and camaraderie years earlier. I had returned to the canyon wilderness, and it had not been gilded. Thanks to a friend, I had rowed in the wake of pioneer, explorer, and photographer John K. Hillers, who'd faced many of his own days of reckoning, until the river brought me back home. The journey, friendships, and incomparable chasms had created new memories I would carry with me long after the calluses on my fingers and palms had peeled—until I heard the siren call of the Colorado River and the photographer explorers who first navigated it once again.

I cinched down my life jacket, took a perch on a wave-battered anvil of the Black Rock, and photographed Eric and our boats running the frothing brown water of the most storied rapid in North America. No one could have asked for more.

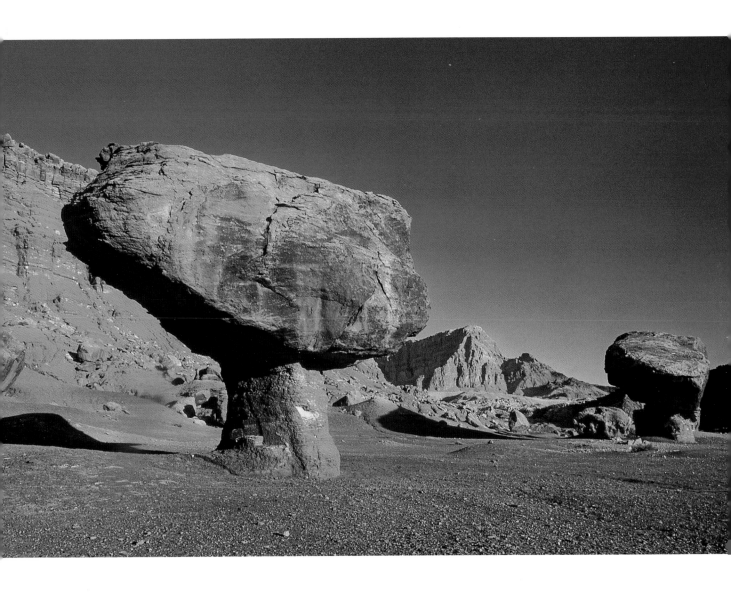

Balanced Rock, Vermilion Cliffs National Monument, Colorado River.

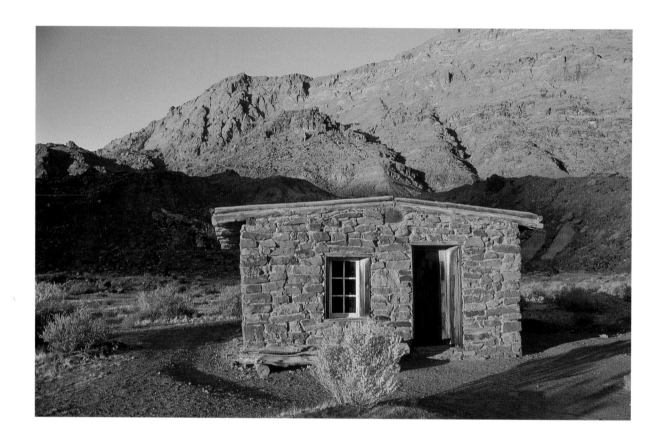

Lees Ferry Post Office, built in 1873, Colorado River, Glen
Canyon National Recreation Area.

A boatwoman wades through a pool of water at the mouth of
North Canyon on the Colorado River.

Morning idyll: a river expedition floats down the Colorado River
near Nankoweap Creek.

Following: Rephotography. Monsoon cascades, Colorado River in Marble Canyon. John K. Hillers photographed Major John Wesley Powell's boat, *Emma Dean*, here on August 21, 1872, at camera station 850. River mile 34.5.